# THE
# POWER
# *of*
# STYLE

ELSIE DE WOLFE

RITA LYDIG

MONA BISMARCK

# THE
# POWER
# *of*
# STYLE

BY
ANNETTE TAPERT
AND
DIANA EDKINS

DUCHESS OF WINDSOR

JACQUELINE KENNEDY ONASSIS

PAULINE DE ROTHSCHILD

DIANA VREELAND

MILLICENT ROGERS

# The women who defined the art of living well

DAISY FELLOWES

COCO CHANEL

CROWN PUBLISHERS, INC.
NEW YORK

Published by Crown Publishers, Inc., 201 East 50th Street, New York, New York 10022.
Member of the Crown Publishing Group.

Random House Inc. New York, Toronto, London, Sydney, Auckland

http://www.randomhouse.com/

CROWN is a trademark of Crown Publishers, Inc.

Manufactured in China

DESIGN BY JUSTINE STRASBERG

Library of Congress Cataloging-in-Publication Data
Tapert, Annette.
The power of style: the women who defined the art of living well/by Annette Tapert and Diana Edkins.—1st ed.
1. Women—Biography—20th century.   2. Celebrities—
Biography—20th century.   3. Fashion.   4. Fads.   I. Edkins, Diana.
II. Title.
CT3235.T37   1994
920.72—dc20                                                                                     93-31783
ISBN 0-517-58558-5

15   14   13   12   11   10   9   8

For Our Daughters,
Georgia and
Joanna

# ACKNOWLEDGMENTS

This book would not have been possible without the help of friends, research librarians, social historians, and observers of style on two continents. Some sat for interviews, others shared their memorabilia, and a few even opened their address books. To all, we are deeply grateful.

Cleveland Amory, Steven Aronson, Marisa Berenson, Bill Blass, Billy Boy, Nuala Boylan, Eugene Braun-Monk, Holly Brubach, Claus von Bülow, Fred and Daisy de Cabrol, Milly de Cabrol, Roger de Cabrol, Bob Colacello, Michael Conroy, Roddy Coup, Louise Duncan, Dominick Dunne, Jimmy Douglas, Lulu de la Falaise, Rosamond Fellowes, Hubert de Givenchy, Olivier Gelbsmann, David Grafton, Pamela Gross, C. Z. Guest, Shaun Gunson, Tony Hale, Bill Hamilton, Mark and Duane Hampton, Ashton Hawkins, Brooke Hayward, Reinaldo and Carolina Herrera, Nancy Holmes, Jean Howard, Fred Koch, Eleanor Lambert, Valentine Lawford, Jean-Louis de Faucigny-Lucinge, Elizabeth Mackey, Richard Mauro, Freddie Melhado, Suzy Menkes, André Oliver, Denise Otis, Mitchell Owen, Arturo Peralta-Ramos, Ghislaine de Polignac, Oscar de la Renta, Paige Rense, Lynda Resnick, Jacqueline de Ribes, John Richardson, Kathy Robbins, Jody Shields, Babs Simpson, Sharon Sondes, Marie Armand de Sparre, Leonard Stanley, André Leon Talley, Sara Vass, Hugo Vickers, Philippe de Vilmorin, and Giovanni Volpi.

We would like to express our deepest thanks to the photographers whose work is featured in this book and to the estates, galleries, and archives that represent the work of our deceased contributors.

PHOTOGRAPHERS: Slim Aarons, Henry Clarke, Oberto Gili, Horst, Patrick Lichfield, Dora Maar, David Massey, Derry Moore, Irving Penn, Priscilla Rattazzi, Snowdon, Deborah Turbeville. ESTATES, GALLERIES, AND ARCHIVES: Kathleen Blumenfeld; Pierrre Bonhomme of the Patronomie des Amis; Gregory Browner, Executor of the Man Ray Estate; Crosby Coughlin; Gep Durenberger and Charles Silverberg of the Elsie de Wolfe Foundation; Monica Dunham of the Mona Bismarck Foundation; George Dwight; Ann Ehrenkranz; Nicole Franks, Picture Administrator for Condé Nast Publications, London; Philippe Garner and Lydia Cresswell Jones of Sotheby's Photography Department, London; Beth Gates-Warren, Sotheby's, New York; Lawrence Karol; Fred Keith at the Condé Nast Library, New York; Marguerite Kramer, *Harper's Bazaar*; Marjorie Miller, F.I.T.; Scott Hyde and Georgina Newbery, American *Vogue* in Paris; Dr. Jeanne Newlin, Director of the Harvard Theater Collection, and Michael Dumas; Diane Nilsen of the Center for Creative Photography; Joanne Olian, Museum of the City of New York; Terence Pepper, The National Portrait Gallery; The Estate of George Platt Lynes; Madame Roger Schall; Irving Solero, The Design Lab, F.I.T.; Etheline Staley and Taki Wise, Staley Wise Gallery; Lucien Treillard; Guadalupe Tafoya, Millicent Rogers Museum; Frederick Vreeland, Thomas R. Vreeland, and Alexander Vreeland; Harriet Wilson, Condé Nast Publications, London.

———

A SPECIAL THANK YOU: To our editor, Betty A. Prashker, who instantly understood the concept for this book and never wavered in her enthusiasm and patience. To Rochelle Udell, whose vision is matched only by her remarkable generosity of spirit. To Justine Strasberg, whose remarkable design talent, combined with her meticulous attention to minutiae, made this book everything we dreamed of. To Mary Maguire, for her flawless attention to details. To Susan Train, Bureau Chief of American *Vogue* in Paris, for her invaluable assistance, advice, and support from beginning to end. To Cynthia Cathcart, Director of the Condé Nast Library in New York, for handling every request with grace and style. To Lisa Fine, our research assistant, whose love for this project became equal to ours. And to our husbands, Jesse Kornbluth and Philip Richardson, who tolerated many unstylish moments.

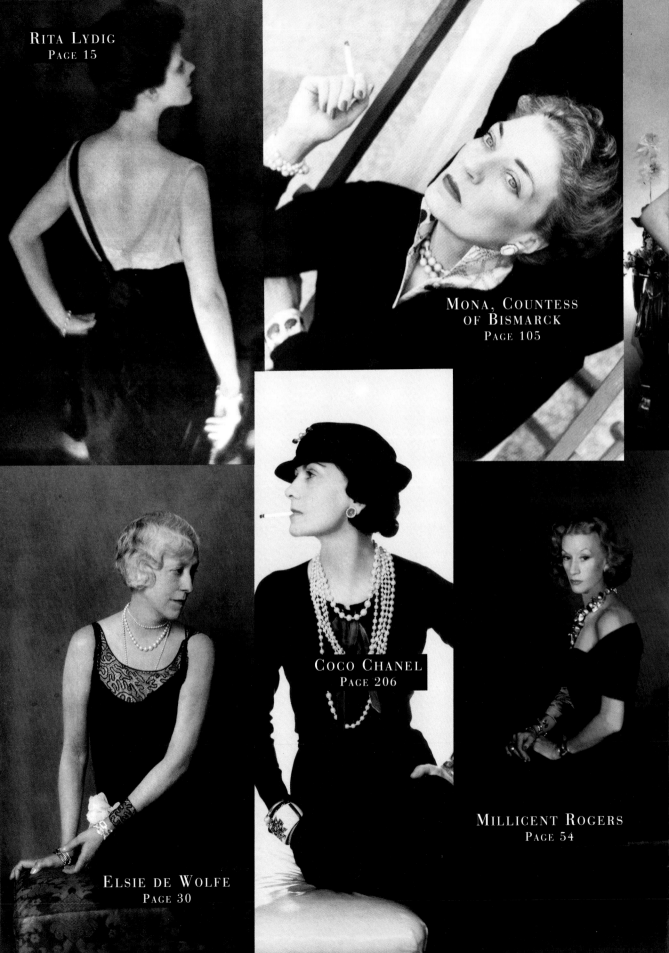

# INTRODUCTION

## *What is style?*

For some, it's just an advanced form of fashion, a kind of consistent rightness about clothes that distinguishes the would-be chic from the real elite. For others, it's a more general phenomenon, a heightened awareness of decorating and entertaining as well as of clothes. And for still others, it's the ultimate expression of character, a way of transforming the vulgarity of existence into a living work of art.

Defining style has long preoccupied not just those who don't seem to have it, but also those who have been celebrated for it. "Style is about surviving, about having been through a lot and making it look easy," C. Z. Guest told us. "Style is what makes you different," Jacqueline de Ribes suggested. But in the same city on the same day, Givenchy advised us that "with style, you must stay as you are."

Style, we suspect, is a subject with endless allure precisely because it can't be neatly defined. In its mystery lies its power. It's almost as if we perceive style instinctively, in much the same way Supreme Court Justice Felix Frankfurter recognized pornography—we know it when we see it.

In the 1950s, for example, Daisy Fellowes invited fashion designer Antonio Castillo to her house in the south of France. The two traveled together from Paris on the overnight luxury train, which was scheduled to arrive at Cap Martin shortly after dawn. Long before sunrise, Castillo was awakened by a commotion coming from the next cabin, where Daisy was ensconced. When she emerged from her quarters shortly before their arrival, he thought to ask why she had

awakened so early. Then he realized that Daisy was perfectly dressed and in full makeup.

"Is there a gentleman waiting for you at the station, Daisy?" Castillo asked.

"Only my driver," she replied.

"Then why are you so dressed up? Why not just a pair of sunglasses?"

"I did it for myself," Daisy explained. "It's a question of discipline, you see."

Discipline. Even when it looks like whim or folly, a purposeful adherence to a code of behavior does seem to be an ingredient of style.

Consider another story, this one about Diana Vreeland. The splendor of a lunch with friends at Maxim's in Paris was marred by a cockroach crawling across Mrs. Vreeland's plate. But the legendary empress of fashion did not scream for a captain and assail the management. Instead, she leaped up, struck a pose, and broke into a lively rendition of "La Cucaracha."

Whimsy, good humor, an appreciation of the unexpected—call it what you will, a healthy sense of the fundamental absurdity of life strikes us as another necessary element of style.

At another luncheon, this one at Château Mouton, Baron Philippe de Rothschild and his American wife, Pauline, were dining with the Duchess of Windsor. Like the duchess, Pauline de Rothschild hailed from Baltimore, Maryland; also like the duchess, she was renowned for her skills as a hostess. This day, Pauline served *poulet chaud froid*—spicy chicken served cold. The duchess loved the dish and was desperate to have the recipe. "Oh, yes, yes, I'll give it to you later," the baroness promised. The duchess knew better. There was no way her fellow American was going to share the recipe, just as the duchess had never given away any of her chef's gems. So she covertly sliced off a piece of the chicken, wrapped it in her napkin, tucked it in her handbag, and took it to her chef to have it analyzed.

Resourcefulness—in this case, the refusal to take a meaningless yes for an answer—isn't often thought to be an element of style. But the duchess knew what she wanted and knew how to get it gracefully. You might say, at least in this instance, that style is what kicks in when charm fails.

How important is money? Less important than you might think. A good example is Gloria Guinness's account of her years with only aspirations to keep her going. "When I was poor, I would buy a beautiful piece of jersey, cut a hole in the top, put it over my head, and tie an

attractive sash around my waist," she recalled. "And everyone asked where I bought my dresses."

So let us add originality and verve and a certain fearlessness to our list of vital ingredients for a stylish life. And although not every woman we consider stylish was born with money, let's not overlook the importance of money; most of the women in this book came to be viewed as queens of society, what the French call *le gratin*, and that life costs a pretty penny. But our interest lies less in the spending than in the getting there; we are endlessly fascinated by women who used their style to make their way.

Discipline, wit, resourcefulness, originality—these are the core qualities possessed by each of the fourteen women profiled here. But a great many women in this century have been beautiful and well dressed and have lived in extraordinary houses where they collected art and furniture and dinner guests galore. Why have we selected these few and ignored so many others?

In fact, we ignored almost no one. Four years ago, we started researching the Condé Nast archives, where we read old issues of *Vogue, House and Garden, The New Yorker,* and the first incarnation of *Vanity Fair,* as well as such non–Condé Nast magazines as *Harper's Bazaar* and *Town and Country.* We scoured rare book stores, building a personal library that focused on stylish women. It wasn't long before we had a list of a hundred women, ranging from great beauties and international trendsetters to film stars and royals. Each of these women, it was clear, had been adored and imitated and mythologized; each had left her mark.

But we wanted to produce a book profiling the essential women of style, not write an encyclopedia. As we struggled both to define style and to choose the women whose lives best exemplified that definition, we found the linking thread we'd been seeking—the women we found most enthralling all excelled at what is sometimes called "the art of living." This is not a novel skill; as soon as people moved into tents and caves, there were those who sought to make their shelters appealing and their domestic lives pleasant. But the twentieth century brought something new to this ancient quest: the media.

"Even the greatest hostess," George Painter observed in his landmark biography of Proust, "is forgotten when the last of her guests dies." In the nineteenth century, that may have been true. In the twentieth century, Painter's idea is archaic. For with the rise of popular magazines,

movies, and television, it has become possible not just to remember a life but to document it extensively. As it happens, the women with the greatest appeal to us either embraced the media wholeheartedly or came to terms with it. Their lives were thus recorded like none before.

The photographs we reviewed—of homes and jewels, of dresses and dinner parties, and most significant of all, of the style setters themselves—made women who have been dead for half a century as alive as women we know today. The photographs did something else. They forced us to compare these past women of style with those who aspire to be their successors. And here, although we have no bias against contemporary women, we found ourselves eliminating almost all of them from this book.

Why did we choose no movie stars? Because, more often than not, the stars whose names are synonymous with style really didn't have it; their influence extended no farther than fashion, and their look was generally created by costume designers. Why did we ignore nearly all the society women whose names we now read daily in the columns? Because although many of them are personable, most of them are too young to have proven that they are more than beautifully dressed embodiments of someone else's idea of style. Why do we exclude all fashion designers except for Chanel? Because only Chanel transcended fashion and created an image that inspired other women. Why, to be specific, do we profile Jacqueline Kennedy Onassis and omit Madonna? For us, Mrs. Onassis was influential because she had always been herself despite her public role. Madonna, in contrast, is a composite creation who takes her ever-changing identity, in bits and pieces, from the great stylists of the past.

In short, we came to cherish the originals, the first women in this century to use style to propel themselves out of anonymity and into the limelight. These women spoke several languages, translated poetry, made themselves into mistresses of conversation. They spied for their country, championed causes, and ran businesses. And they adored beautiful dresses, entertained fops, and married the wrong man time and again.

How do we reconcile their grandeur and their folly? We don't. Instead, we celebrate the rich diversity of their days and marvel at all they packed into their lives. And we can't help but envy the way they took their talents and refined them to the point that they didn't just shine, they glowed.

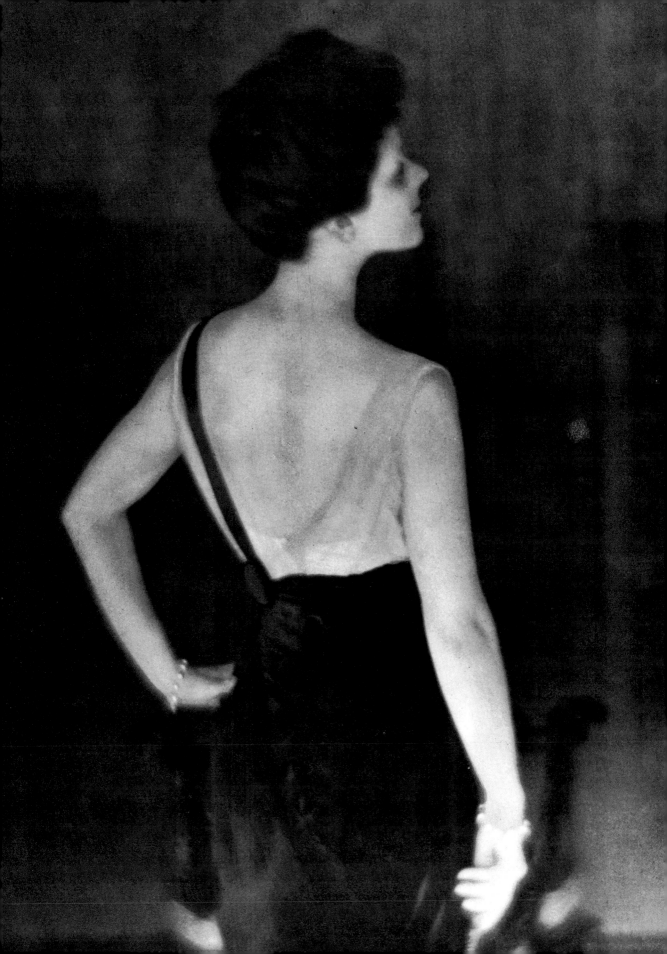

# Rita Lydig

**W**ITH HER BEAUTY, HER allure, her personal extravagances, and the long succession of tragedies that befell her, she was not, in her essence, a true embodiment of her time. She belonged, rather, to the days and to the novels of Balzac, to the pages of Turgenev, the stories of Maupassant.

That is how Frank Crowninshield, writer, social arbiter, and editor of *Vanity Fair*, described Rita Lydig in the 1940 catalog that accompanied an exhibit of her fantastically elaborate clothes. It is hard to imagine the

❧ R*ita wears one of her signature backless gowns in a photograph by Baron de Meyer taken in 1913.*

woman known as "the fabulous Mrs. Lydig" as a person of fact and not fiction. Yet Crowninshield didn't have to turn to a foreign nineteenth-century writer to give substance to his description. He had only to look in his own backyard. Rita may have seemed to walk out of the pages of a novel, but that book would very likely have been written by an American, Edith Wharton, a woman who, as it turned out, was very much aware of Rita.

Like a Wharton heroine, Rita was a wealthy, extravagant, beautiful, pleasure-loving creature who was considerably more complicated than she appeared. Wharton fans will at once remember two of the novelist's most famous women: the nonconformist Countess Olenska in *The Age of Innocence* and the tragic Lily Bart in *The House of Mirth*. Like those women, Rita Lydig was a legend among her set, revered for her beauty, individual style, and wit.

That Rita became a displaced person in the glittering world that had once embraced her made her an ideal model for Wharton. Even better, charting the fall of a character inspired by Rita may have given Wharton a certain grim satisfaction. For Rita was not just an acquaintance, she was a rival. Both Edith and Rita were living in Paris around 1908. And at that time, Rita was the more frequent companion of Walter Berry, who had been the great love of Edith Wharton's life for the last two decades.

Rita was a worthy rival for Edith. Although it seems like blasphemy to place the ephemeral Rita in the same pantheon as the one of the most influential and intelligent women of her time, these two women definitely had much in common. Both shared a lifelong commitment to beautiful environments. Both were enviable hostesses who filled their salons with only the most prominent artists and writers. Both came to realize that the world of the fashionable and rich was really a battleground where wealthy, unhappy people struggled for momentary social victories.

And both wrote about that world. Tellingly, Rita's version bore a title that telegraphed her point of view: *Tragic Mansions.*

Rita de Acosta was born in 1879 to Spanish parents who had settled in New York. Her mother was a descendant of the noble Alba family. Her father was a poet and a political exile who came to America after leading Cuba's student revolt in the fight against Spanish oppression.

Only Rita's birthplace marked her as an American. For inside the de Acosta house on West Forty-seventh Street, the atmosphere was totally Latin. Rita, the second of eight children, was brought up in the strict Catholic tradition. Only Spanish was spoken at home, all the de Acostas' friends were Spanish, and all the family's servants were Spanish.

Rita's beautiful and aristocratic mother—the product of a French convent education—raised her daughter exactly as she had been raised. If she'd had her way, Rita's interests would have revolved around her home, her children, and her religion. But as it turned out, the de Acosta household was too eccentric to turn out children that traditional. Because her father was a liberal-minded scholar, he instilled his thirst for knowledge in his children and encouraged them to develop their intellectual and aesthetic tastes.

These two opposing influences would shape Rita and make her an elegant exotic. And a fiery, tempestuous exotic at that. "With her deeply religious attitude, her tragic sense of life, her love of tradition, and her feeling for lace and fans, she was essentially and always Spanish," recalled her sister Mercedes de Acosta.

At sixteen, Rita adhered to the restrictions of her traditional Spanish upbringing and obediently married. Her choice of a husband, however, was light-years away from what her strict

Catholic mother envisioned. William Earl Dodge Stokes was a multimillionaire, a notoriously eccentric man-about-town, a racehorse owner, twenty years her senior, and, worst of all, a Protestant, who had fallen in love with Rita when he saw a picture of her in a photographer's studio. Rita's mother found all of this unbearably tacky. What distressed her most was not the religion of Rita's suitor but his vast wealth. She sensed that money would never bring happiness to her daughter.

Mrs. de Acosta understood something about her daughter's nature. A part of Rita, she knew, was genuinely attracted to power and extravagance. But Rita was a divided soul. She had another side that was very much a socialist who rejected wealth and privilege. "I think she was only at peace in the presence of beauty," Mercedes de Acosta recalled. "Then her dual nature ceased to battle."

Rita responded to Stokes by showing just one side of her nature; she believed that his glamour and wealth would open doors to the luxurious life she craved. Unluckily for Rita, she had chosen one of those rich men who turn out to be irritatingly frugal. Stokes loved nothing better than to wear the same overcoat until it "turned green with age." But Rita knew none of this when the newlyweds set off for Paris. Horse racing was her husband's passion, and Rita quickly became the darling of the fashionable racing set in Europe. She and Stokes were entertained by the best families on the Continent and were even fortunate enough to secure an invitation for the coronation of Russia's Czar Nicholas II.

Her mother's instincts proved correct. The marriage brought Rita great unhappiness and ended after four years. But divorce brought out unexpected generosity in Stokes. He gave Rita two million dollars, at that time the largest settlement ever granted. It was widely speculated that Rita's windfall was in return for giving up custody of their son, William, Jr. She waited twenty years to speak out and dispute this claim: "I had been too proud to contradict the lie in the past. I gave the boy back to his father so that he might inherit his father's estate, which he has."

Rita hardly seemed like a divided soul after her divorce. With her war chest in hand, and free of her parsimonious husband, she set out to buy luxury as though antique stores and couturiers would go out of business without her enthusiastic patronage. Marriage, divorce, maternal neglect, passionate consumerism—all these made Rita a much-discussed personage in New York social circles. But for all the gossip, no one could quite categorize Rita.

As a divorcée, she presented herself as a bold and accomplished horsewoman who drove her own four-in-hand in New York and Paris, bred horses in Kentucky, and showed her Thoroughbreds at Madison Square Garden. Three years later, in 1902, she married Captain Philip Lydig and shed her role as a sportswoman. Thanks to her marriage to the serious, socially prominent Lydig, Rita enjoyed the stability that the fashionable set required. But having gained respectability, she did not go out of her way to become like other society women. Just the opposite. She became an exotic social figure known for her individual style of dress, her remarkable salon, her intellectual pursuits, her unerring good taste, and her wanton purchases of art and furniture.

For the first twenty years of this century, Rita Lydig was one of the most dazzling personalities in New York. The way she looked and dressed, the way she entertained, the way she decorated her house—everything set her apart. Soon after her marriage to Captain Lydig, for example, she moved into a house on East Fifty-second Street built for her by Stanford White. She furnished it with sixteenth-century Spanish and Italian furniture, Flemish tapestries, Renaissance paintings, and a faultless collection of objets d'art. And then she began to entertain.

It wasn't her graciousness or the precision of

her taste in food, flowers, and decor that made her invitations so eagerly sought. It was who she had. No hostess of her time gained the affection of so many distinguished artists. Paderewski, Caruso, and Toscanini performed for her guests. Rita's house was a headquarters for writers, painters, and poets, and the New York meeting place for European artists like the Spanish painter Ignacio Zuloaga. It was Rita who arranged the first American exhibition of Zuloaga's work. And when she decided that the Duveen Galleries didn't meet her standards for the occasion, she paid for its redecoration.

Less shimmering hostesses could not fathom how she effortlessly filled her dinner table, her loge at the opera, or her music room with the uncontested creative geniuses of the day. Her sister did: "She had a quality—which I have never found in anyone else—of radiating artistic creativeness. Not only did she herself radiate it, but she had the ability to inspire art in anyone susceptible to it." Sarah Bernhardt agreed. The great actress so admired Rita's beauty and carriage that she had Rita give her lessons in walking. "One's weight must never be placed on the heels," advised Rita. "It is on the balls of the feet that the weight of the body must rest and even there not too heavily. One must feel a spring in the foot and be conscious of this spring as one lightly touches the ground with each step, feeling the sense of it in one's entire spine. Head held high, breathe deeply, and spring!"

Rita was equally welcome in Paris, where she spent part of each year. She would arrive at the Ritz with a hairdresser, masseuse, chauffeur, secretary, maid, valet, and forty Louis Vuitton trunks, and commandeer an entire floor of the hotel, including a pressing room and a trunk room. To insure continuity, she brought her own linens, books, silver, and objects. Ordering masses of white flowers—the only color she allowed—the servants miraculously transformed these rooms into a close resemblance of her house

in New York. In Paris, she joined ranks with musicians, artists, intellectuals, and philosophers, names like Rodin, Duse, Yvette Guillbert, D'Annunzio, Clemenceau, and Bergson. Impressed by Rita's innate creative spirit, Isabella Stewart Gardner, the great collector and creator of the Gardner Museum in Boston, once asked their mutual friend John Singer Sargent why Rita had never expressed herself artistically. "Why should she?" Sargent answered. "She herself is art."

Sargent, who had painted her, was not alone in his opinion. Other artists were enchanted by her appreciation of their work, and, more important, they were mesmerized by her beauty. Helleu sketched her and called her "the most picturesque woman in America." Zuloaga painted her, and Boldini was inspired enough to do fourteen portraits of her. Rodin sculpted her, as did Malvina Hoffman, who cast her likeness in alabaster to match the quality of her complexion that was so similar to the pale, smooth stone.

Rita's features were totally Spanish—dark and piquant, with black flashing eyes, full and expressive lips, waist-length shiny black hair that she brushed up into a loose Gibson Girl pompadour, and dead white skin that she enhanced with a dusting of lavender powder. Her diminutive figure was exquisite, and with her tiny feet and graceful walk she had the air of a Spanish dancer. "Rita was my first glimpse of beauty, and all through my life she symbolized beauty to me," wrote her sister. "I can truly say that I have known a number of extraordinary and beautiful women the world over, but Rita, considered objectively and without any prejudice in her favor, seemed to me more striking, more unfailing in perfect grace and beauty than any other woman."

*Boldini's portrait of Rita was frequently reproduced during her lifetime. It was not admired by her friends, who thought it made her look like an animated Gibson Girl.*

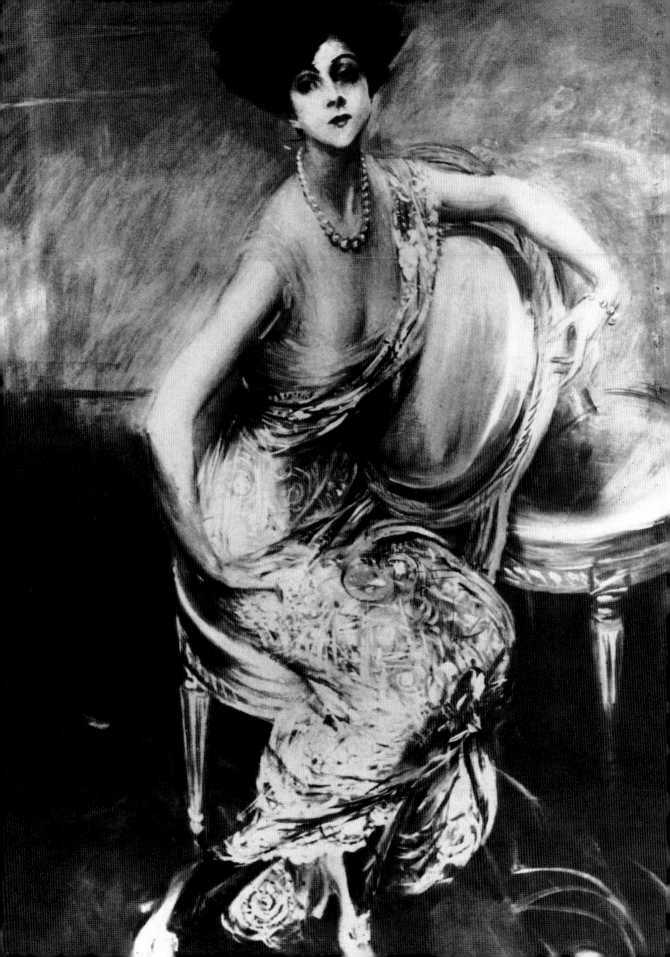

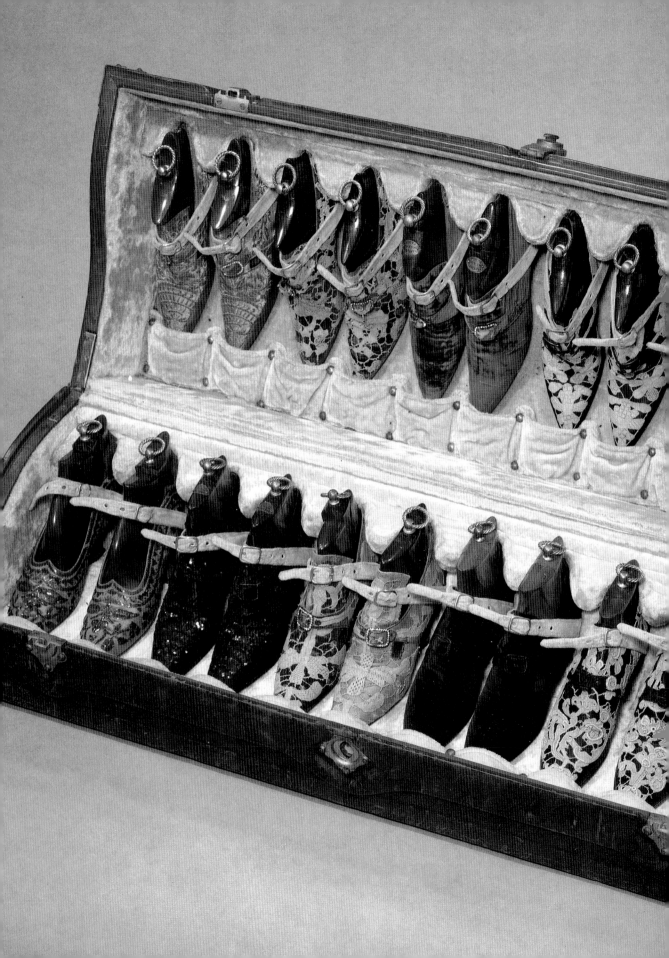

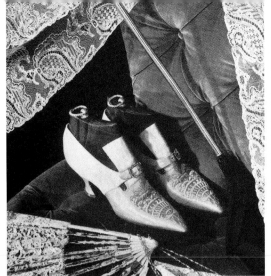

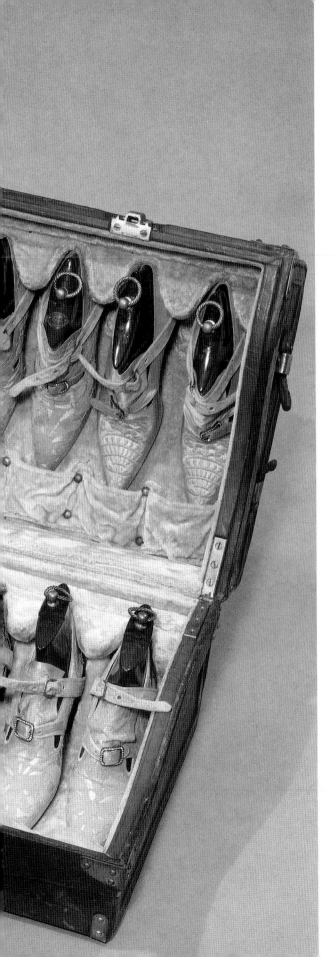

❧ ABOVE: *Rita's extravagances: Spanish fan, embroidered shoes, black diamond pendant, Binche lace handkerchief, Cartier umbrella with diamond-topped platinum shaft, Chantilly lace mantilla.* LEFT: *A sampling of Rita's 150 pairs of shoes made of antique velvet, lace, damask, and embroidery, all with exaggerated Louis-Quinze heels and long pencil-pointed toes, resting in custom-designed Russian leather shoe trunks lined with white velvet.* BELOW: *Two of Rita's forty-eight swan-necked blouses. Left, hand-drawn linen and Binche lace; right, all Venetian lace.*

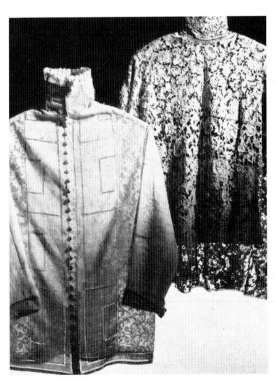

Mercedes de Acosta's view was not hyperbolic; everyone who met Rita was startled by her appearance. When Puccini came to New York for the premiere of his opera *The Girl of the Golden West*, he was invited to sit in the box belonging to a rich dowager who had given a lavish dinner in his honor before the performance. Upon laying eyes on Rita, the composer abandoned his seat and ensconced himself at the back of Rita's loge, where he remained transfixed on her provocative back.

What she really had, her sister recalled, was *glamour*, a word rarely used to define people at the turn of the century. "Her presence raised the vibration of the most commonplace event," described de Acosta. "For this reason she had a sort of magnetic appeal for all kinds of people. Without the advance publicity of a movie star, without the recognition which comes from films and photographs, she attracted people whenever she appeared in public. She rarely went into stores and never into a department store because crowds followed and surrounded her."

Rita's legend was fading into permanent obscurity when Diana Vreeland brought her to the public's attention in 1975 as a mannequin in her "American Women of Style" exhibition at the Metropolitan Museum of Art. As Vreeland told a reporter, Rita was the first woman to spring to mind when she conceived the show. Few who saw the Met's exhibition would forget Rita's tunics made from sixteenth-century altar cloths, the velvet and lamé Persian trousers, the ancient lace detailing on the dresses, and the thirty pairs of handmade shoes displayed in her trunks.

If Met visitors thought they were seeing a woman who had kissed reality good-bye, they were coming to the same conclusion that fashion followers on two continents had reached half a century earlier. Rita's clothes were items of endless interest, providing the newspapers with glamorous copy and galaxies of photos. It wasn't that the press regarded her as the embodiment of fashion. On the contrary, Rita was cherished for her eccentricity. Her allure lay precisely in the fact that her clothes deviated from what was "in fashion."

This attention amused Rita no end. "I should play a joke on these foolish sheep by wearing some monstrous costume," she told her sister. "They would all rush to copy it and then imagine they looked well in it." Her aim was to banish uniformity. To that end, she designed her clothes herself and had them executed by Callot Soeurs, the great French couture house that she financed.

Her most startling and memorable gesture was when she appeared at the opera wearing a gown open from her shoulders to her waist, revealing her exceptionally beautiful back. At the end of the first act, Rita's back was half-turned to the audience when the lights came up; the audience gasped and instantly raised their binoculars and lorgnettes in her direction. The next day, newspapers called Rita's attire "scandalous" and "indecent." Soon enough, though, the décolleté evening gown was copied by fashionable women all over the world. Here she was a trendsetter in the true sense of the word, for whatever she created or wore was copied by couture houses who sent spies out to see what she was wearing.

It's wasn't hard for them to spot Rita. She was forever recognizable by her black silk dresses, swan-necked blouses, lace stockings, fans, and her small three-cornered hats slanted romantically over one eye. But no one could really imitate Rita; her clothes were intensely personal works of art. These garments were, like all her possessions, extensions of her passion for collecting exquisite objects and her total love of beauty.

In certain areas—particularly her fondness for

rare antique lace—her devotion bordered on the obsessive. She used lace to adorn all her garments: blouses, coats, lingerie, handbags, handkerchiefs, and her seventy-five Spanish fans. The only difference between her eighty-seven black velvet coats was the lace that ornamented them. Her seventeen lace petticoats were reserved for mornings in her bedroom; her favorite was an eleventh-century piece that had cost her nine thousand dollars. Her handwoven linen handkerchiefs all required a four-inch lace border.

If lace was Rita's primary obsession, her passion for shoes ran a close second. All one hundred fifty pairs—some of them destined never to be worn—were custom-made by Yanturni, the East Indian curator of historical shoes at the Cluny Museum in Paris, who had a magical gift for making footwear so light and supple that it gave the impression the shoes were molded to the wearer. Yanturni's clients were a discerning few, not surprising given that it sometimes took him three years to make a pair. Rita's shoes were constructed from the finest silks or ancient velvets, satins, and laces. They lived in Russian leather trunks lined in cream plush velvet, exactly twelve pairs to a case. Each had its own little home in the trunk, with its own number, its own handmade shoe bag, and its own shoe trees exquisitely carved from the delicate wood of violins with "Rita" stenciled at the top.

While men adored her, women found her difficult. More often than not, Rita found other women exasperating; they rarely lived up to her standards of good taste. She loathed slang and prohibited it in her presence. But it was harder to avoid bad taste, and when she found herself in an ugly room, she felt as if she had been pierced by a knife. Such was her desire to keep ugliness at bay that when she discovered Philip Lydig had a mistress in Paris who dressed in dreadful taste, Rita was quite direct with him. "I can't have you going around with a creature who looks like that," she told her husband, and then she swiftly sent the woman off to Callot Soeurs.

Her fabled calm and fragility concealed an extraordinary temper. Once in Newport she drove her electric car to the ferry to meet an ex-beau, who announced he'd come all the way from Egypt and that if she wouldn't have an affair with him he was going to end his life. "Very well," said Rita, "we'll die together." With that, she revved her car up to full speed and ran it into a telegraph pole. The car was totaled and her admirer was sent to the hospital. Rita walked home unscathed.

Beneath this impractical, romantic, and materialistic social shell was a woman of enormous complexity. Rita could, in rapid succession, be adventurous, melancholic, and devout. During the last fifteen years of her life, she metamorphosed dramatically from a gay social animal to a tireless worker for charity. In return, she was rewarded with a series of illnesses, romantic heartbreak, and the loss of her fortune. And yet, despite her sorrows, this tiny woman who was so feminine, who seemed so helpless and delicate, continued to radiate a spirit and soul that was rich in color.

World War I was the watershed event for Rita. In 1914, plagued by intestinal tuberculosis, she dismantled her Fifty-second Street mansion, separated from the unfaithful Captain Lydig (she divorced him in 1919), and moved to a smaller, Georgian house on Washington Square. There she auctioned off the majority of her paintings and furniture, keeping only her Titian, one beautiful rug, and her Flemish tapestries.

Having simplified her life, Rita entered a more serious phase. She espoused the cause of women's suffrage, became an active participant in the Equal Franchise Society, and fiercely championed birth control. During the war she was a member of the Mayor's Committee of Women on National Defense. Despite her chronic ill health, she devoted much of her time to the crusade against narcotics and received a humani-

tarian award for her work. (Ironically, she became dependent on morphine a decade later to ease the pain caused by her intestinal problems.)

In addition to her good works, Rita was also seeking to attach herself to some kind of organized religion. Although she had been a devout Catholic before she married Stokes, she left the faith after the Church refused to sanction the marriage. While working as a volunteer for the Church of the Ascension, one of the most important Episcopal pulpits in New York, she found more than just a religious haven. She fell madly in love with the parish's liberal-minded rector.

The Reverend Dr. Percy Stickney Grant knew that a romantic relationship with the twice-divorced Rita would present a problem. But long before he met her, he had locked horns with the Protestant Episcopal Church's House of Bishops when he conducted a radical forum in the parish house; the liberal views on divorce he expressed there did not please his superiors. Still, he pressed forward with Rita, announcing their engagement in 1921. At once, the bishops denounced the pending nuptials. "Bishops Warn the Nation," read the headline on the front page of the *New York Times.* For three years, Grant and his bishops were deadlocked.

All the commotion made Rita a notorious woman once again. She was more than equal to her notoriety. Shortly after the engagement announcement, a sketch entitled *Lady Vibrating to Jack-in-the-Pulpit* was shown at an exhibition at the National Arts Club. It was clearly a caricature of Rita sitting attentively in church. Rita's response was to purchase the drawing before the exhibit opened, so it would bear a label that said "Sold to Mrs. Lydig."

Rita's confidence in her reverend was towering. By 1924, it was clear to her that the bishops

❧ F*or this Baron de Meyer sitting, Rita chose a house dress made from antique red velvet.*

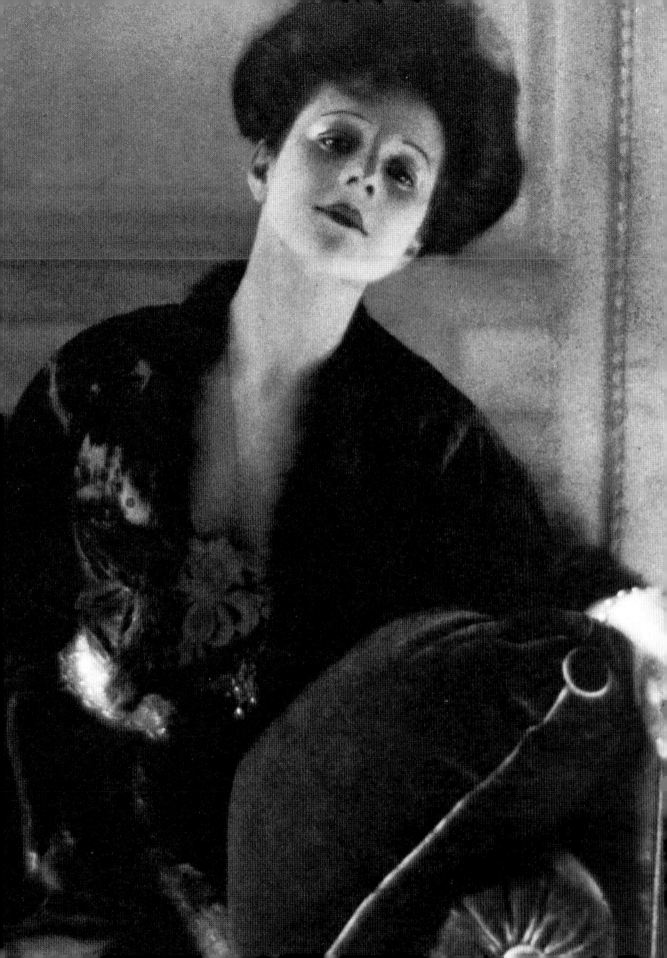

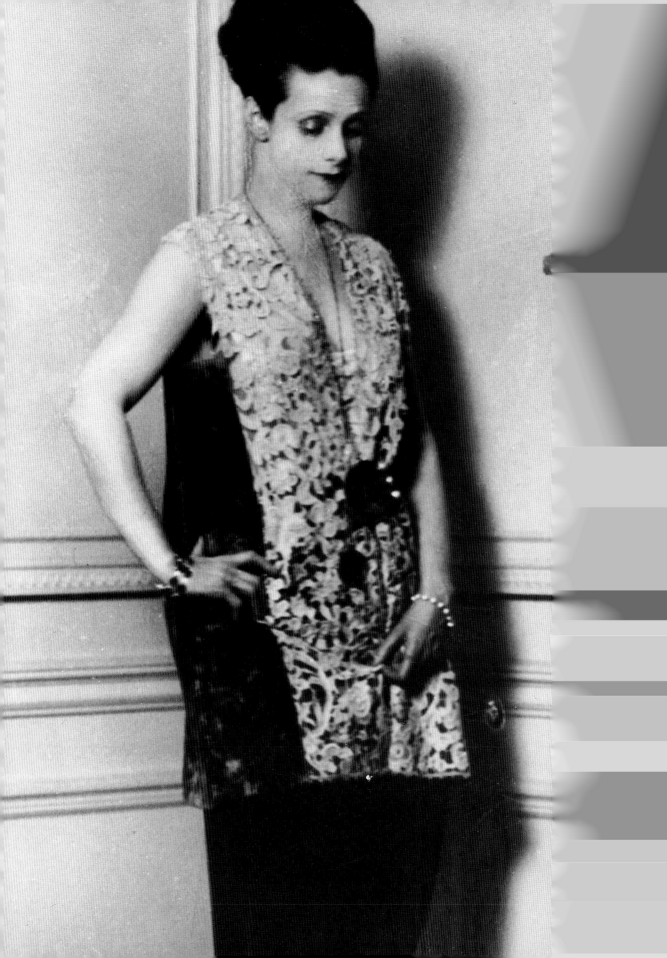

would never sanction the marriage, but she believed that Grant would have the courage to leave his parish. In her devotion, she saw him as the head of a liberal religious movement. Unfortunately, Grant couldn't live up to Rita's spiritual expectations, much less summon the courage to break with the Church. He called the engagement off and, a month later, resigned his pulpit on the grounds of ill health. Although Rita was heartbroken and disillusioned in spirit, she declined to comment in public and was equally silent in private about her doomed romance.

After ten years of fiscal probity, Rita returned to extravagant spending in an effort to escape her unhappiness. This time, however, her spending bordered on madness. She would spend sixty thousand dollars, without a moment's hesitation, on a rug that she had no place to lay in her house. In Paris, she carried loose emeralds and sapphires in her pockets and distributed them to the shop vendeuses in return for their help. "What do you expect me to give these wonderful women if I don't give them emeralds?" she asked her sister defensively. "Surely you don't expect me to insult them with money?"

Never one to be bothered with business or practical affairs, Rita began having trouble paying her bills. Her sister tried to help her manage her expenses but to no avail. Once as she looked over the monthly outlay, Mercedes de Acosta discovered that Rita was spending one thousand dollars a month on white cyclamens, lilies, and gardenias and suggested she cut out the luxury. "Why should you take away that one beautiful thing from me?" Rita cried. "I can go without

*❧ Photographed in her velvet and lamé Persian trousers with a damask and velvet tunic, one of her favorite evening costumes.*

food. You must cut out the butcher for me, but I will not be without my white flowers."

Fortunately for Rita, a charming and well-known writer named Harvey O'Higgins was besotted from the moment he met her. Fascinated by her superior mind, he was only too honored to provide her with the care and attention she so desperately needed. When she decided to pen *Tragic Mansions*, her fictional account of the pathetic personal lives of Newport's golden age millionaire families, he volunteered to be her ghostwriter.

But by 1927, nothing could camouflage Rita's own truth—her life had become a pathetic house of cards. The first upset of the new year was the death of Dr. Grant. Although she hadn't seen him since their break and had managed to find comfort in O'Higgins, Rita was completely unhinged by his death. She became seriously depressed, and her chronic illness flared up. A month later, she went into the hospital for a stomach operation. While Rita was under the knife, an electric pad she was lying on short-circuited and burned the base of her spine so deeply that until her death she was only able to stand or lie down.

As if grief and illness weren't enough, she was now forced to confront her financial ruin; she owed $95,000 to her creditors. She auctioned off her belongings, but they only brought in $50,000. Now the ultimate humiliation—Rita was forced to declare bankruptcy.

For one final time, Rita became meat for the news columns. The press provided juicy coverage of the bankruptcy hearing, printing detailed accounts of what she wore as well as lists of her principal creditors and the amounts she owed: $10,000 to Callot Soeurs and $12,000 to the decorator Elsie de Wolfe. There might have been financial gain with the publication of the eagerly awaited *Tragic Mansions* in April of 1927, but when de Wolfe's attorney told the court he would attach any income from the book to settle Mrs.

Lydig's debt, the chance for profit evaporated.

Although she was incensed at the gross humiliation of the bankruptcy proceedings, Rita had the strength of a conquistador. She filed a suit for $500,000 against the *Daily News* for what she said was its inaccurate account of her bankruptcy hearing. Meanwhile, the combination of her financial ruin and her thinly disguised work of fiction, which many felt was a betrayal on her part, prompted society to drop her.

Through it all, Rita was absolutely stoic. Although she now resided in the banal Gotham Hotel, she still surrounded herself with her beloved white flowers. As ever, her dresses were of black silk and old lace, her Spanish fan was in position, and her elaborate slippers were impeccable. Cecil Beaton recalled a visit in 1928: "Her skin was still smooth as that of a gardenia. I was surprised to see that even during the daytime she wore the bodice of her black velvet dress cut audaciously low, revealing a considerable portion of her pearly, globose bosom. I remember that her movements were sharp and brittle, that she had the rare quality to shine, reminding me of a large china cat."

The irrevocable blow to her psyche occurred when Harvey O'Higgins died suddenly in August 1929. Rita locked herself in her hotel room, refusing to see anyone. By the time her sister Mercedes could cut short a trip and return to New York, Rita was desperately ill.

Two months later, on October 20, 1929 Rita made the front page of the *New York Times* for the last time: "Mrs. Lydig Dies Unexpectedly at 50."

The death of the "fabulous Mrs. Lydig" made the front page of a great many other newspapers around the world. An editorial in the *Paris Herald* by Constant Lounsbery, a great patroness of the arts, suggested that Rita receive the Legion of Honor for her artistic patronage and service to French artists. Even better was the eulogy written by Frederick MacMonnies, the noted sculptor, in a New York paper:

> *Rita Lydig's quality was so unusual in type, that it is difficult for us, in our habitual acceptance of standardized forms of service, to recognize its greatness. . . .*
>
> *This great lady, courageous, free, and triumphant, lived her own life in her own beneficent way, heedless of criticism.*
>
> *A fiery champion of every beautiful thing, she jeered at pretense and no hypocrisy escaped her fleet of mocking wit—her slogan must have been not unlike Whistler's: "Why put up with anything?"*
>
> *Marvelously made up by nature for the part she was to play by her gifts and great natural beauty, she had a magnificent start in life, but the final product—the result of years of infinite patience and study, enhancing, correcting, eliminating—was as different from the original as a work of art from the raw material.*
>
> *She became a perfected personality, radiant, individual, of consummate style and judgment, in fact, a masterpiece of civilization.*

Rita's last hours were spent peacefully with her sister by her side. She had reconciled with the Catholic Church and felt spiritually at ease with dying. But her final thought was not turned toward God or the heavens. Instead it was her wish that as the lights on her life were swiftly dimming, she be surrounded by beauty and perfection. To make her last moments as comfortable as possible, Mercedes gently fanned Rita's fevered forehead. In a state of delirium, she asked her sister what she was doing.

"I'm only fanning you," Mercedes told her.

And with that, Rita de Acosta Lydig uttered her final words: "Is it a Spanish fan?"

*Cecil Beaton photographed Malvina Hoffman's alabaster sculpture of Rita.*

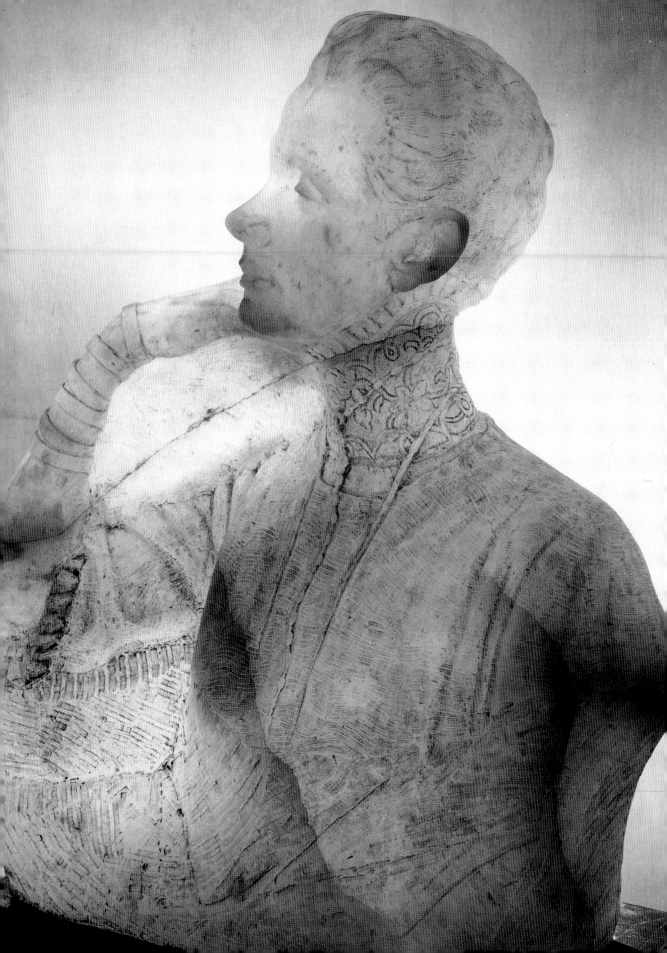

Even when she spoke French, Elsie de Wolfe retained her distinctly New York accent. "Roo Laroo" was Franglais for her house on the rue Leroux, just as,

# Elsie de Wolfe

in New York, she would direct friends to an address called "Toity-toid" Street. Day in and day out, she wore three strands of "poils." The large objects she

❧ Elsie believed in simplicity of dress. "I always take one thing off before leaving the house," she said.

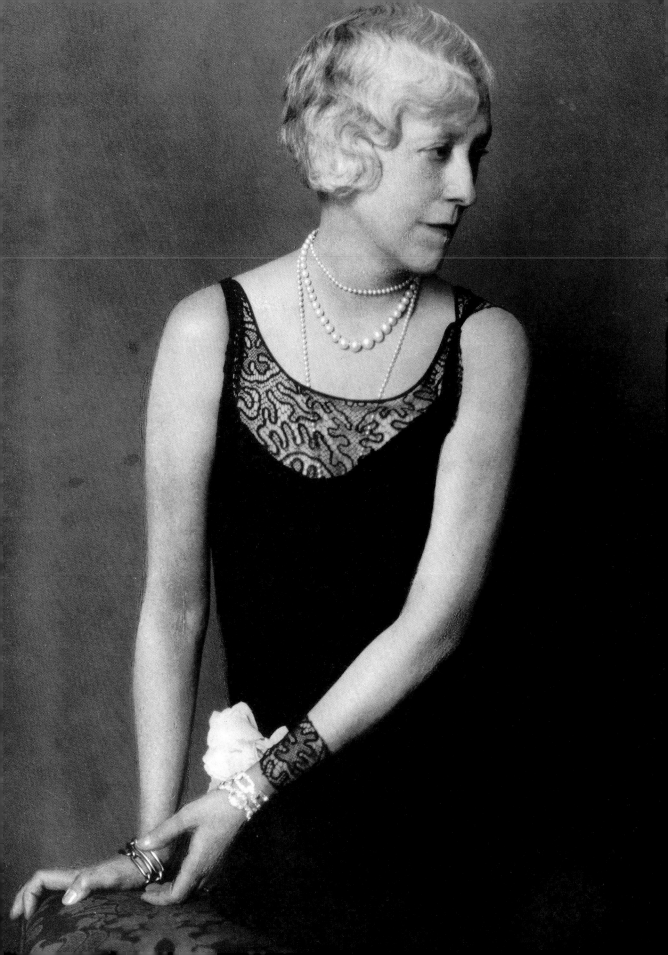

might buy for her clients were, to her, "foini-ture." And her manner was just as direct and unreconstructed as her speech. At the start of their first phone conversation, the Prince of Wales thought to put her at ease with a breezy "Hello, Elsie, this is David." To which Elsie, in disbelief, snapped in her high, grating voice, "And I'm the Virgin Mary."

For a social climber of dubious background who hopes to be admitted to the upper ranks of European society, such speech patterns and gaffes are out of the question. But they weren't for Elsie de Wolfe, the American who is now generally credited as the twentieth century's first interior decorator. Not only did she have charm to spare, she was, very simply, the most *sensible* American woman of style that the fantastically rich and bored Europeans and their sovereigns had ever seen. Like Elsa Maxwell, she was a phenomenon, a whirlwind, a force, a peppy "goil" who made things happen.

Although Elsie de Wolfe is usually described as the first lady of interior design or as a legend-ary hostess, she really belongs on the roster of great inventors. She was responsible for introduc-ing more tasteful and stylish ideas into American homes than any other woman. Today, her inven-tions are considered the standard, traditional American forms of decorating and entertaining.

The next time you walk into a room, flick on the light switch by the door, and the lamps snap on, thank Elsie.

If you are reading this in bed using an uphol-stered bed rest with arms, think of Elsie.

An armchair that pulls out to make a chaise longue: Elsie patented it decades ago.

The vanity dressing table that opens in front to reveal drawers? Elsie again.

Parquet floors? Unknown before Elsie.

The first person to enclose radiators with cabi-net covers? Alas, Elsie.

Elsie popularized small pillows embroidered with words of wisdom: "Never Complain, Never Explain," "Today is the tomorrow you worried about yesterday," and "There are no pockets in shrouds."

Elsie convinced Americans that the best and most comfortable shapes in furniture were to be found in English and French eighteenth-century antiques—if you couldn't afford the real thing, a copy would do.

Elsie's longest-lasting and most famous con-tribution to the American masses? Cheap and cheerful chintz.

The Chintz Lady, as she was known, didn't limit her imagination to just decorating. As a hostess, she had more ideas than most women have guests. She was one of the first to popularize cocktail parties, where she liked to serve her own concoction, the Pink Lady—$1/3$ gin, $1/3$ pink grapefruit juice, $1/3$ Cointreau. Women all over America heeded her rules for entertaining: "Plates should be hot, hot, hot; glasses cold, cold, cold; and table decorations low, low, low."

There are a hundred Elsie pronouncements like that, and a hundred stories like her telephone conversation with the Prince of Wales. All are piquant, all somewhat mystifying. Far from illu-minating her character, these unlikely anecdotes return us, again and again, to the central ques-tions about Elsie de Wolfe: Who was this thirty-five-year-old woman who entered the twentieth century as if she'd lived it all before and instinc-tively knew what Americans would want before they knew it themselves? Who was this five-foot-two-inch dynamo who turned cartwheels for her guests and stood on her head every day until she was in her seventies? Why did she go so much further than her equally talented competitors? And finally, how did this inherently delicate and feminine woman become so wise about that quintessentially American talent—marketing?

Before Elsie ever started offering her services, she had learned something key: if she was going

ᐈ E*lsie photographed by de Meyer in the 1920s.*

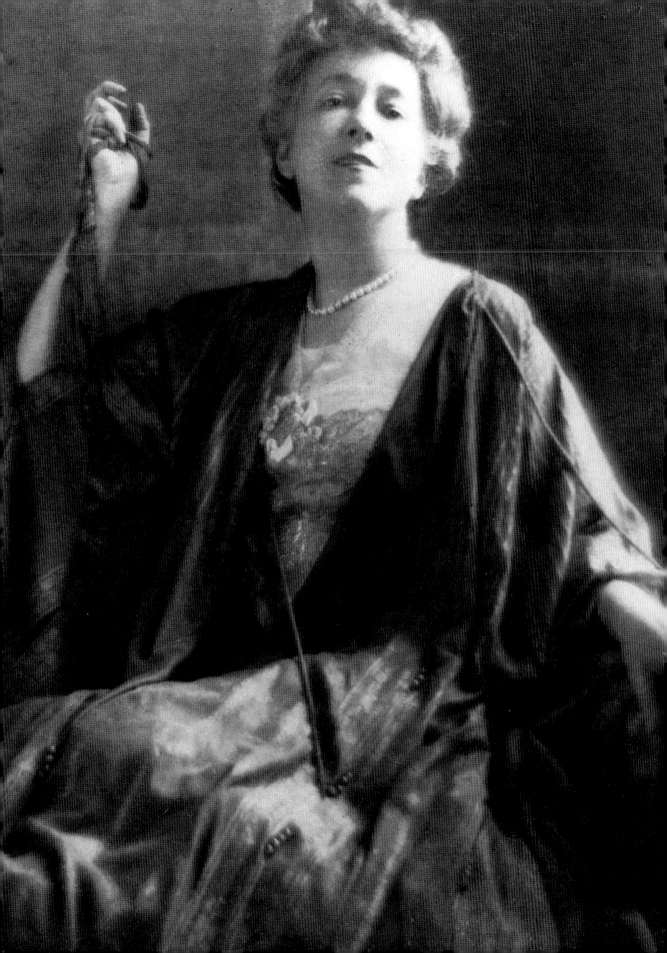

to get anywhere in life she had to figure out how to sell herself. Elsie's rise as a trendsetter, woman of style, and tastemaker was a result of mind over matter, a triumph over circumstance, which in her case was her physical homeliness.

Elsie de Wolfe was born sometime around 1865 in New York City. Her father was a doctor who came from a notable New England family that could trace its ancestry to colonial times; her mother was from a Scottish family of scholars and lawyers who had settled in Nova Scotia. Their collective brains and breeding would have been neatly finished off by money, but the de Wolfes were merely middle-class professionals, stranded on the fringes of New York society with five children to provide for. In their lives, money was the missing ingredient; its absence would play a significant role in the shaping of Elsie's character.

Elsie's childhood consisted of yearly moves from one identical New York house to another. "These dismal brownstone buildings are so alike without and alas! so alike within, that one wonders how their owners know their homes from one another," exclaimed Elsie. Years later, she would blend all these residences into one single dwelling—the house that stood on the future site of Macy's. "I grew up in the front door of Macy's," she would say, sacrificing literal truth for the pleasures of a great one-liner.

Although she was not blessed with beauty, Elsie did inherit the best characteristics of each parent. Her mother passed on a Scottish sense of thriftiness and practicality; despite Elsie's insistence that she could add only if she used her fingers, she could account for every penny she earned and spent. Her father, meanwhile, imbued her with his love of luxury and beauty.

As if supporting a large family at the height of the Gilded Age were not challenge enough, Dr. de Wolfe put considerable effort into schemes that would allow him to indulge his expensive tastes. Inevitably, reports of the fortunes made

in stock speculation lured him into the financial markets; unsurprisingly, he was soon a victim of the sharpies. As a result, Elsie's childhood was colored by the financial uncertainty brought on by her father's fleeting gains and ongoing losses.

For a child, it must have been scarring to have a beloved father announce that he was broke, that the servants had to be dismissed, and that the family must move to a more modest house. And it must have been equally unsettling when these dreadful pronouncements of doom failed to come true, because more often than not, Dr. de Wolfe found a way to make up for his losses. And then, of course, he went on to gamble again.

That kind of economic uncertainty might easily explain why a young girl would grow up determined to become financially and personally independent. As a child, however, Elsie's greater concern was her looks. "I was an ugly child, and I lived in an ugly age," she wrote in her memoirs, *After All*. "From the moment I was conscious of ugliness and its relation to myself and my surroundings, my one preoccupation was to find my way out of it. In my escape, I came to the meaning of beauty."

Skinny, with a sallow complexion, a thin mouth, and small black eyes, Elsie seemed to have been blessed with only one cosmetic asset, her teeth. But when she broke one of them, her father told her that her one decent feature had been shattered. This incident inspired her "revolt against ugliness," and she spent hours scrutinizing her face in her mirror, searching for some glimmer of hope. She found none; these sessions ended with Elsie throwing herself on her bed in frustration.

And so, for Elsie, vanity turned into ambition. Instead of focusing on beauty, she would discipline her body and make it as vital as possible. Her equation of beauty and health put her far ahead of her time: "In my struggle to lift myself out of the rut of ugliness and mediocrity, I did everything I could to keep fit." For Elsie, who

was just ten years old when she made this pledge, that meant abstaining from childhood indulgences like candy.

Elsie's biggest revelation occurred in 1885, when she was twenty. Three years earlier, she had been sent to live with relatives in Scotland so she could complete her education, which, in addition to classroom studies, included finishing school lessons in manners and deportment. The grand finale to this course of study was an introduction into London society—topped off with a presentation to Queen Victoria at court. That dazzling four-month whirl of castles, balls, and aristocrats convinced Elsie that this was the kind of life for her.

In addition to the grandeur, her debut meant that Elsie would no longer have to wear her drab-colored wool schoolgirl frocks. Now she was fitted out in silk, linen, and cashmere dresses in the creamiest, most delicate shades of white and pastels. With that new wardrobe, Elsie learned another useful lesson: clothes may not make the woman, but they sure do help. "The white satin dress which had been molded around me revealed a figure which I scarcely recognized as my own," she recalled. "I was *not* ugly. I might never be anything for men to lose their heads about, but I need never again be ugly. This knowledge was like a song within me." Suddenly, it all came together: if you were healthy, fit, and well dressed, you could be attractive.

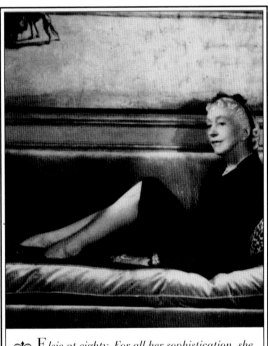

*Elsie at eighty. For all her sophistication, she never lost her childlike quality.*

Armed with her newfound confidence, Elsie set out to prove herself. But a good attitude and one delicious taste of the high life didn't necessarily insure a place for her in New York's fashionable set. The "right" friends were crucial. Here, Elsie shone. She had an aptitude for cultivating friendships with people who mattered. In London, she became the inseparable companion of Cora Potter, an American socialite and a reigning beauty of the day. When they returned to New York, Mrs. Potter made Elsie her protégée. As a result, she was invited to accompany the glamorous Mrs. Potter to the festivities that heralded New York's social season of 1885.

Cora Potter was not just any old socialite. She was the founder of the Amateur Comedy Club, one of New York society's most exclusive groups; in its amateur theatricals, she was a featured actress. As luck would have it, she invited Elsie to join. Was Elsie a thespian? Well, she had an appreciation of theater, she deeply admired Lillie Langtry, and she had appeared—in the presence of English royalty—at a benefit performance for charity. Other than that, her credentials were few.

Still, Elsie heartily accepted Mrs. Potter's invitation. Her reasons had little to do with a desire to express herself; she saw an opportunity and seized it. Without Cora Potter, she feared, she would never be admitted into society's inner sanctum. As a member of one of the most exclu-

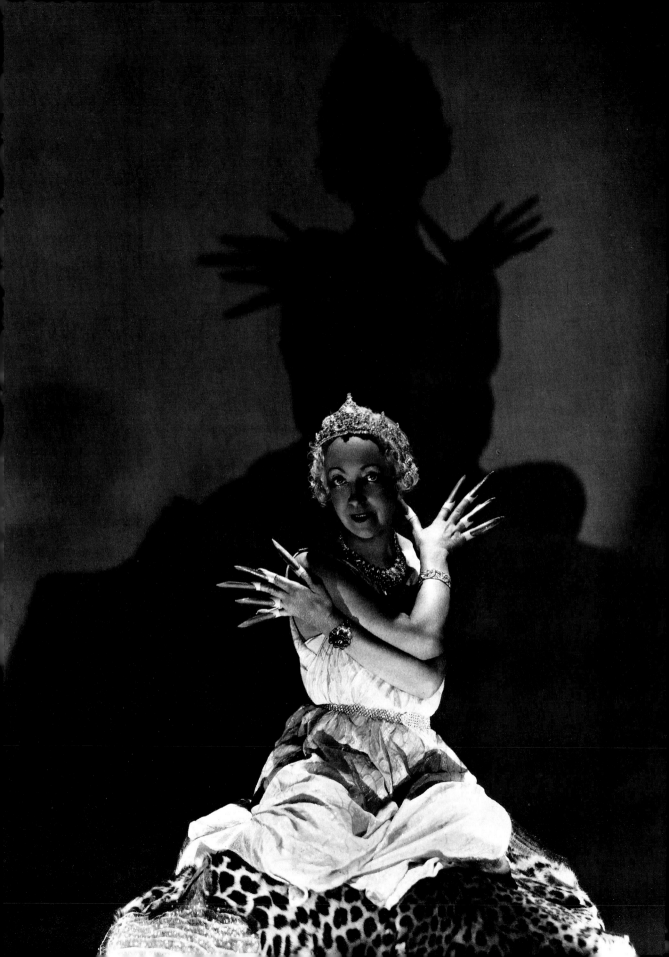

sive social clubs, however, she'd get an entrée into fashionable society.

Just as Elsie dreamed, she was soon invited to perform in the amateur productions at the newly founded and highly exclusive Tuxedo Park. She starred in the first play, *A Cup of Tea*, and thrilled the elegant audience with a fainting scene that featured a double roll off the couch onto the floor. Most everyone felt that she was the best of the amateurs. And everyone also agreed that Elsie had enormous energy and charm.

Elsie was soon getting regular mentions in "Town Topics," society's weekly bible. Eager to advance in society, she threw herself into more amateur theatricals. But although she had by now been bitten by the acting bug, she knew her limits. No matter how much she loved the theater, no matter how enthusiastically the swells applauded her, Elsie realized she could never become a professional actress and still be society's pet. She must remain an amateur, she knew, or she would be considered a woman of questionable character, which had, in fact, been the fate of her mentor, Cora Potter. Cora had fallen from grace when she daringly formed her own professional company, employed herself as the leading lady, and fell in love with her leading man.

What Elsie needed was not another mentor, but someone who could secure her place in society. For other women, that meant a husband; for Elsie, it meant a Pygmalion, who turned out to be Elisabeth "Bessie" Marbury, ten years older than Elsie.

Bessie and Elsie seemed like exact opposites. Elsie was slender, graceful, feminine, and vivacious. Bessie was plain, heavyset, and deep voiced. She wore her hair pulled severely back into a knot and wore unadorned and utilitarian clothes. She looked, in short, like a stereotype of a lesbian—which she was. But because her fam-

🐦 Posing for Hoyningen-Huene in 1931 at Count Etienne de Beaumont's Colonial Ball.

ily was a pillar of New York's Four Hundred, no one said a peep.

Although no one used the term in those days, Bessie was a precursor of modern feminists. Highly intelligent, cultivated, independent, and a born leader, she was then looking for the best outlet for her keen mind. In time, she would have a brilliant career in the theater and become influential in politics and the Catholic Church; when she met Elsie, however, she was so far removed from the world of the theater that she was trying her luck as a poultry breeder. It didn't bother her that society wouldn't understand such a barnyard vocation. She had long ago rejected the social status that Elsie aspired to.

What was the attraction? On Bessie's part, it was definitely physical, but she also sensed there was more to Elsie than her facade suggested. For Elsie, Bessie was more than the sum of her social connections. She was a reminder that personal and financial freedom might be even more important than social acceptance.

Bessie and Elsie didn't play house—they played theater. Bessie first served as manager of some of the productions that Elsie starred in, and then became a playwright's agent who specialized in bringing French and English plays to America. Elsie was more conflicted. For two years she desperately wanted to go professional; even as she denied it, she was secretly taking drama lessons. Then her father died, leaving her no money. Without a way of supporting herself, Elsie felt that the choice had been made for her. She declared herself a professional and was immediately offered two hundred dollars a week, an enormous sum at the time. "Elsie, like caviar, is an acquired taste," her new producer explained. "Acquired tastes come high."

Elsie's career spanned ten years. She toured

America, she played Broadway. Ethel Barrymore was her understudy. But if Elsie was a star, it wasn't because of any great acting talent. In fact, the critics thought her abominable. No, Miss de Wolfe was famous for her personality, her mannerisms, her ability to give the press a witty quip, and most of all, for her clothes. Onstage, as in her real life, she wore Paris creations designed by Doucet, Worth, and Paquin. Because she looked so elegant, people came in droves, enduring her mediocre acting in order to gawk at her up-to-the-minute fashions.

Like trend-setting society women since the beginning of time, Elsie got her clothes from the couturiers at reduced rates. So many professionals came to her Saturday performances and would sit in the front row, sketching feverishly, that these performances became known as "dressmakers' matinees." By 1900, *Harper's Bazaar* had labeled Elsie "the best-dressed woman of the American stage." But when she was asked about her flawless taste, Elsie gave an unexpectedly honest answer. She chose her clothes, she said, for their practicality. She didn't feel comfortable wearing the standard, overdone stage designs, she explained. Her primary fashion concern wasn't to portray her character, but simply to wear what suited her looks and figure.

Elsie and Bessie settled into a cozy little town house on Irving Place, on the periphery of chic Gramercy Park. Although their liaison was al-

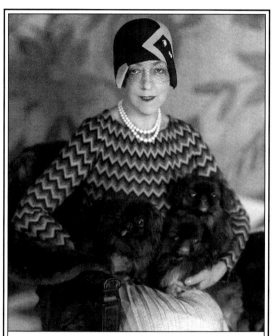

*Posing with her three Pekingese. Her dogs accompanied her even on shopping expeditions.*

most universally considered peculiar, it lacked scandal; very soon, they were known as the Bachelors. That was a misnomer, for, if anything, Bessie and Elsie had assumed traditional husband and wife roles. Bessie held down the fort and preferred lively discussions centered around literature, politics, and fishing. Elsie's interests were clothes, jewelry, parties, and decorating their new home.

Irving House, as it was named, soon became the scene of one of the most exciting salons in New York. Because of Bessie's far-reaching connections, she and Elsie created the first salon that mixed the artistic, social, and political powers of New York. In their drawing room, you might find pillars of society like the Astors and the Hewitts conversing amiably to historian Henry Adams, art patron Isabella Stewart Gardner, actresses Maxine Elliot and Ethel Barrymore, or the visiting Sarah Bernhardt. Bessie's European clients Oscar Wilde and Victorien Sardou made Irving House their first stop when they passed through New York. For the performers, Elsie and Bessie's salon had a unique charm: the hostesses didn't expect them to perform. Rather, the emphasis was on conversation, the more brilliant the better.

For Elsie, life was moving at a glorious clip. When she wasn't performing or entertaining, she was vacationing in France with Bessie. There, she marveled at the effortless combination of so-

ciety, the arts, good food, and fashion. And there, feeling at last at home, she became a card-carrying Francophile.

On one of these trips, Elsie met Robert de Montesquiou, then France's most famous arbiter of taste. When he introduced her to eighteenth-century decorative arts, she became a committed pupil and was soon reading reference books and collecting furniture of the period. "Long before I could understand why," she wrote in her memoirs, "I reacted against the dull rigidity of the [Victorian] era, with its uncomfortable chairs and sofas on which one could do nothing but sit upright, and its red, green, or saffron upholstery— all invariably arranged against a background of wallpaper on which colors that should never be allowed out together made faces at one another."

In the pale colors, painted wood, and open space of eigh-

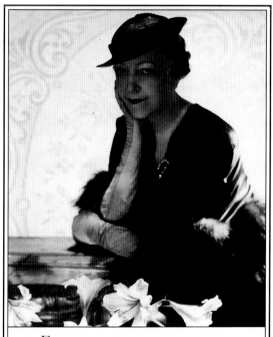

❧ Elsie captured by Hoyningen-Huene in her signature gloves.

teenth-century rooms, Elsie found the aesthetic harmony she had long been seeking. By 1897, she had cleared away all traces of gloomy Victorian decor at Irving House, replacing dark woodwork and densely patterned wallpapers with paint in shades of white, cream, and pale gray. She discarded heavy furniture, velvet draperies, gaudy ill-matching oriental color schemes, and the Victorian penchant for crowded rooms, and replaced them with clean, open surfaces, delicate French eighteenth-century furniture, and color-coordinated fabrics.

This renovation was not just aesthetically pleasing, it was—Elsie's favorite word—*practical*. The furniture offered well-upholstered comfort. And because there were fewer pieces around, Elsie found that entertaining her ever-increasing roster of guests was becoming so much easier. What she had done, she realized, was create an environment that was compatible with her style of life.

Elsie's contemporaries were sophisticated, but this concept of interior design was completely foreign to even the most discerning of them. Irving House was not, for them, an adaptation of an eighteenth-century house—it was completely modern. All New York was agog.

Elsie continued to act until 1905, when she turned forty and experienced a flop of epic proportions. It was time for her to do something else. What would that be? Well, for eight years friends who had admired Irving House had been asking for free decorating advice. She had gladly provided it. Now, at Bessie's suggestion, she was going to have them pay for it. She sent out cards with the emblem of a wolf with a flower in its mouth and, though the profession didn't exist, announced herself as an interior decorator.

Small jobs started coming in. Several months later, she landed herself a major commission: the decoration of the Colony Club, America's first exclusive private women's club and a counterpart to the well-to-do man's traditional establish-

ment. Although Bessie was a founding member, awarding the commission to Elsie wasn't such an easy decision for other members. They were well aware of her taste, talent, and originality, but they had reservations about giving such an important job to someone with no formal experience, particularly because that someone was a woman. Stanford White, the club's architect, was consulted. His reply: "Give the job to Elsie, and let the girl alone. She knows more than any of us."

The Colony Club opened its doors two years later. Elsie would later claim that what she had done inside the Colony was so instinctive she didn't realize how dramatic it was. Everyone else, however, knew right away it was brilliant. Elsie had set off a design revolution that would set a new tone for tasteful decorating in America.

Even though ten years had gone by since Elsie did away with her Victorian clutter, the fashion in houses was still dark, gloomy Gothic interiors with bulky, carved furniture and heavy curtains —usually two sets—that blocked out the light. "I opened the doors and windows of America, and let in the air and sunshine," she would say years later.

Elsie's rooms were painted in light fresh colors or wallpapered in delicate chinoiserie patterns. The furniture was eighteenth-century French and English, and when an original was too expensive she had it copied. Bedrooms were furnished with unpretentious four-postered beds, simple painted furniture, a comfortable chaise longue, and a delicate writing table—the forerunner of the classic bedroom in resorts and clubs.

There were two big hits that overshadowed everything else: the tea room lined with green painted garden trellises to give the effect of being outdoors and Elsie's unprecedented use of chintz, which lavishly covered everything from soft furnishings to curtains to walls. This simple glazed patterned cotton fabric that the English had been using for years was cheery, inexpensive, and easy to work with. It quickly made its way into homes all across America and would remain there consistently for four decades.

Newspapers and magazines across the country were soon featuring detailed descriptions of Elsie's Colony Club interior. And just as quickly as her trends began to circulate, nearly every woman in America wanted to adapt the Chintz Lady's look in her home. As a result, Elsie became not just the first interior decorator, but twentieth-century America's first arbiter of taste. "Instead of giving people what they thought they wanted, Elsie gave them what she felt they ought to have, and taught them to want it," Jane Smith wrote in her biography of Elsie.

"I believe in plenty of optimism and white paint!" Elsie proclaimed. And, as if they were on a fumigating spree, Americans stripped off those ugly wallpapers and applied crisp color to their walls. Bad pictures and cluttered walls were traded in for mirrors to give the effect of space. Down came the velvet portieres at the windows. Up went thin muslin, framed in chintz. Fake Renaissance furniture was replaced with eighteenth-century pieces or good copies. And coarse, oversized torture seats were replaced with comfortable, upholstered easy chairs.

Elsie was not the first person to champion this philosophy, she just happened to be the one whose ideas trickled down to the masses. In the same year that Elsie renovated Irving House, her friends Edith Wharton and Ogden Codman published their landmark book, *The Decoration of Houses*. Wharton, who had closely studied the applied arts in Europe from the Renaissance to the eighteenth century, and Codman, a gifted architect, had taken as their inspiration some of the same great European houses that had so impressed Elsie. In their book, they urged readers to purge themselves of "superficial application of ornament" and bid farewell to deep-tufted furniture, hideous bric-a-brac, stained glass,

potted palms, and oriental rugs. What Wharton and Codman endorsed was the return of classicism: architectural proportion and harmonious decor.

Though Elsie never admitted it, she must have been influenced by *The Decoration of Houses*. Fortunately, Wharton and Codman were interested only in an audience of their own kind—the rich, cultured, and well traveled. The examples they showed in their book were photographs of the interior of palaces in France and ducal villas in Italy. Although Elsie was certainly interested in those people, she understood some things that Wharton and Codman didn't. For one, she had no problem with commerce. And secondly, she could translate her ideas into realities for people without palaces.

The Colony Club put Elsie on the map, and big private commissions followed. She was soon decorating the homes of the wealthiest families in America from New York to Chicago to San Francisco. On a personal level, these new clients moved Elsie into the rarefied social world she had always worshiped. Because of her refined taste, the elite considered her more than just "one of them"—Elsie was now their guide.

Beyond her decorating talent, clients were dazzled by Elsie's personal independence, her international social life, and her chic fashion sense. And then there were those clients who had wealth, but no social credentials. For them, Elsie was the real thing. By hiring her, they thought they had also arranged their entrée into fashionable society. Because Elsie knew that she was giving them more than just beautiful interiors, she made them pay dearly. In addition to her fee, she tacked a 30 percent commission onto the cost of the antiques she found for them.

The ultimate offer, and the one that made Elsie a wealthy woman (although she took only a paltry 10 percent), came when Henry Clay Frick, the steel magnate, asked her to design his brand-new Fifth Avenue mansion. Frick, who was the leading art and antique collector in America at the time, didn't have much use for the hungry dealers who constantly pursued him, so he hired Elsie to do the shopping and ferret out the most beautiful representations of eighteenth-century French and English furniture that his millions could buy. Frick soon owned quantities of period furniture that Elsie acquired from the magnificent Wallace collection in Paris.

As Elsie became America's darling of interior design, it was only natural that a magazine would engage her to write a column offering decorating advice. And so the *Delineator* and later *Ladies' Home Journal* hired Elsie to produce articles that would appeal to their large, middle-class audience. These articles were eventually interwoven into Elsie's famous tome, *The House in Good Taste*, yet another first.

Until 1913, books about the home were still carryovers from the nineteenth-century household management volumes. Elsie went much further. She advised the homemaker with limited funds on how to make her home more appealing. She offered such do-it-yourself tips as suggesting that the reader paint garlands on a simple pine bureau, or that a dining room in a small dwelling could double as a library. She explained how to decorate effectively with mirrors. And, best of all, she cleverly personalized her advice. She included photos of her own houses, recalled her early more-dash-than-cash days in the cramped quarters of Irving House, and laced her writing with anecdotes.

What really sold the book, however, was the enticing packaging. Bound in pale gray, its cover was a sketch of an elegant drawing room in mauve, white, and gold. Inside, the book was illustrated with photographs, including a Baron de Meyer portrait of Elsie in a fur coat posing by

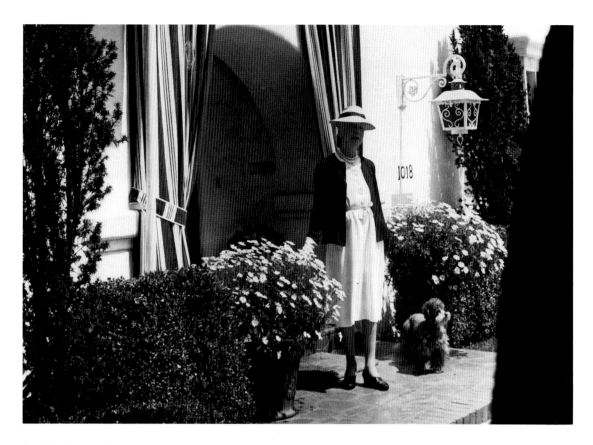

the fireplace in her New York town house. The book's single failing was that as much as Elsie tried, she was totally out of touch with families who lived in small quarters. "If your apartment has two small bedrooms, why not use one of them for single beds, with a night stand between, and the other for a dressing room," she suggested, never considering that more than two people might live there. Nevertheless, *The House in Good Taste* was well received, with new editions churned out until 1920, when Elsie was even more entrenched in her role as the guru of domestic interiors.

While Elsie was spending on behalf of her rich clients, she was also creating her own perfect retreat in Europe. On one of their trips to France, she and Bessie had discovered a deserted villa on the grounds of Versailles Palace. They bought the Villa Trianon in 1906 and began a renovation that would be a never-ending work-in-

progress for the rest of Elsie's life. For her, it was more than just a haven, a place for her treasured collection of priceless furniture and art—it was also her design lab. It was here that she experimented with trompe l'oeil and developed the ideas that would become her signature, like the leopard fabric she used on everything from footstools to carpets to banquettes.

Elsie's summers were spent at the villa, where she indulged in her favorite pastime of playing hostess. Her Sunday lunches became an institution; invitations to her glittering dances were coveted. Timing and rhythm were her specialty. When Wilbur Wright came to France, she made sure she was one of the first women to fly with the famous aviator. Later, although she was pushing fifty, Elsie jumped into the swing of pre–

☙ *These photographs from the 1940s capture Elsie's quintessential chameleon quality.*

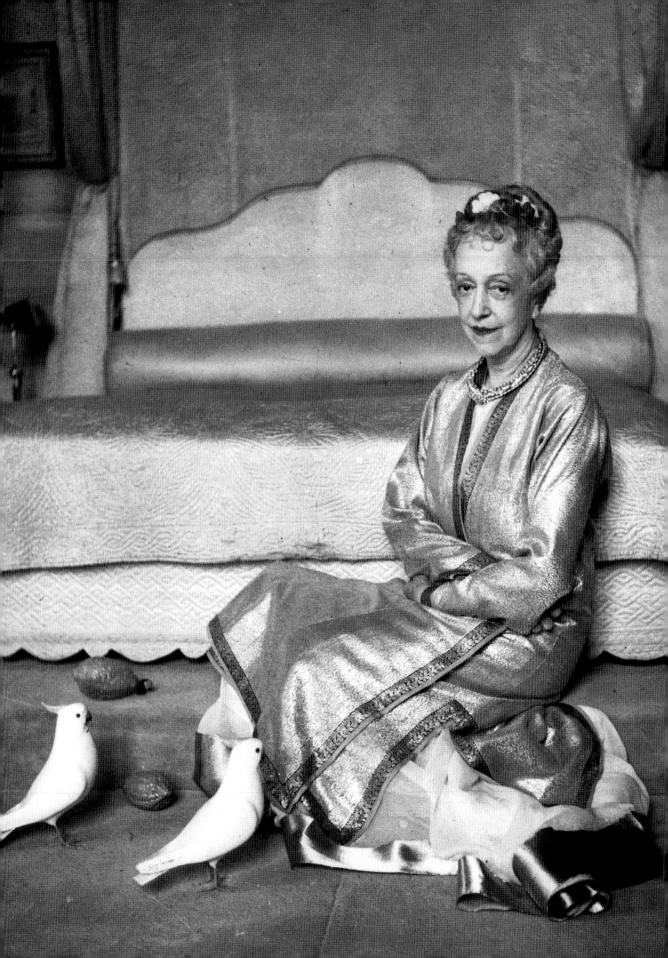

World War I Paris. She was the first to champion the fox-trot, and when Vernon and Irene Castle danced their way to Paris doing the Castle Walk, their first stop was the Villa Trianon. Elsie was so delighted by their charm and talent that she became the backer in their business venture to open up dancing clubs called Castle Houses.

This singlemindedness carried over into fashion and beauty. Inevitably, her innovations resulted from her quest for comfort and freedom, or her ongoing battle to camouflage an unattractive feature. In the summer of 1912, she started the fashion for walking suits when she had the hem of her skirt raised six inches off the ground: "I'm tired of sweeping the streets," she told her dressmaker. "I'm dressed in a practical manner, one which the world, if it were sensible, would copy." At the time, this hem length was considered scandalous, but by the end of the summer it was all the rage. Shorts, another one of her practical ideas, were created because she wanted more freedom to move when she did her daily exercises; she had Molyneux design her a pair of black satin ones, and the fashion world promptly adopted them for beach wear. In later years, she would add face-lifts, pearls, the now classic "blue rinse" tint as an alternative to gray hair, short white gloves—to hide her ugly hands—and even the fashion for toy poodles to her roster of trend-setting ideas. And the press followed each and every bit of minutiae.

 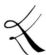

For a woman who seemed to concern herself with only material beauty, Elsie was no hothouse flower. When World War I interrupted all the fun, the Villa Trianon was turned over to the French government as a base for hospital supplies, and Elsie traded in her couture creations for a nurse's uniform. Suppressing her renowned distaste for the sick and the suffering, she became interested in the latest treatment for third-degree burns, learned how to administer it, and volunteered to nurse soldiers in hospitals on the front lines. Of course, even in wartime, Elsie still made sure she had a modicum of luxury—she had her French maid accompany her throughout the war.

She was awarded the Croix de Guerre for bravery under fire, and the Legion of Honor in 1922. The latter honor provoked a rare display of the sentimental side to Elsie's character. In the middle of the main square in Strasbourg, a diminutive figure stood quietly while a military band played the "Marseillaise" and a French regiment lined up in front of her at attention. When the French general stepped forward and tapped her shoulder with his sword, she burst into tears.

After the war, her life quickly resumed its luster as if there had never been a four-year hiatus. She discovered that despite her absence from America, her business—which had expanded before the war into furniture and fabrics—had turned a profit. She did more than just put the glittering mosaic of her life back together. The era between the two world wars was Elsie's real heyday, and it is for what she did during those years as a slick, smart, eccentric, and lively tastemaker that she is best remembered.

In her decorating, she responded to the surrealism in art and life that was so predominant in Paris. Though never abandoning her fondness for eighteenth-century proportion and comfort, she blended modern accents that gave her interiors an eclectic but luxurious air of informality rather than the former restrained elegance. She replaced her famous cabbage-rose chintzes with subtle patterns of feathers and ferns. The cream and gray palettes were discarded for stark black and white. She introduced long low sofas, zebra skins, and fur throws as blanket covers in her rooms.

In the spirit of the twentieth century, her tastes were also in flux. Black and white gave way

to neutrals. "It's beige! My color!" she exclaimed when she first laid eyes on the Parthenon. Beige was eventually abandoned for forest green walls with white rugs and black lacquered floors. Her interiors embodied that new twentieth-century word: *chic.*

As it turned out, the bathroom in her Paris apartment was the heart and soul of this new look. Larger than a normal-sized bedroom, it was like a glamorous movie set with its zebra skin–covered sofa, mirrored cocktail table, white velvet rug, silver tissue curtains, and mother of pearl light fixtures. The bathroom became such a conversation piece that at dinner parties she served coffee there. Elsie loved it as much as

everybody else. "I have had such joy out of my bathroom that it is difficult for me to speak of it in measured terms," she gushed in her memoirs.

Until 1926, Elsie was still purely famous as an interior decorator. All that changed when she married Sir Charles Mendl, the press attaché for the British embassy in Paris and six years her junior. Everyone who knew her—most of all dear Bessie, who was said to be crushed when she heard the news in New York—was startled that this sixty-one-year-old, self-confirmed bachelorette would do something so out of char-

acter. But Elsie, always up for a new experience, claimed it was one of the few things in life she hadn't tried.

There was a little more to it than that. Despite all her personal and professional success, Elsie was still quite conscious of her place in society. Now that she bore a title, she had achieved a new position. And it was as Lady Mendl that she became as famous a hostess as she was a decorator.

Elsie's ideas for entertaining were as original as her interiors. Her weekend houseguests at the Villa Trianon were lavished with extravagances unknown to Europeans at the time: each of the guest bedrooms was thoughtfully supplied with stationery, cigarettes, unused tubes of toothpaste, fresh bars of soap. Weekend visitors were surprised to find their favorite cocktail brought up to their bedroom as they dressed for dinner. She was the first to show movies at home, and introduced the parlor murder game that became the rage for chic house party weekends. Masses of white flowers filled every room, and the subtle aroma of perfume emanated from lamp shades.

Most miraculous of all was that this level of entertaining was executed by a woman whose income was considerably less than that of most of her guests. The only thing that wasn't extravagant was the food. Although it was expertly prepared, there was just never enough of it. Guests who came to Elsie's legendary Sunday lunches knew to eat before they arrived. Anyway, the focal point was not the food but the guests.

In Europe, Elsie's influence was solely as a hostess. The Continent had never seen such ingenious combinations of unlikely but exciting people. Titled Europeans mingled with American tycoons, movie stars, well-born gigolos, couturiers, and artists of all kinds. Elsie invented café society. Unlike her days with Bessie at the villa when she entertained European writers, philosophers, and members of the Comédie Française, Elsie's new group was not defined by great intellect but by attractiveness, fame, superficial clever conversation, and, of course, money.

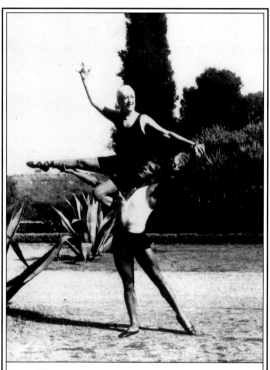

*Elsie posing airily on the shoulder of her fitness instructor in the south of France.*

"Money, rather than family, is the watchword which now opens the gates," wrote Elsie. "If one wishes to be in society one must have money and spend it— let society feed on it, drink it, and gamble with it. Then one can be anything, go anywhere, and do almost anything one wants. For the truth is that today society is bored with itself."

But for a woman who had accomplished so much, who was so capable, it was in many ways a frivolous life. "Among the fashionable friends who know her best," wrote Janet Flanner, "there's a feeling that she could have done more with herself than go around with them."

Yet by then, a Paris season wasn't complete

without a Mendl ball. The most famous of these fetes was the Circus Ball. In her dance pavilion —newly built for the occasion—harlequin-costumed acrobats, elephants, three orchestras, and a merry-go-round entertained the guests. When Shetland ponies performed, it was Elsie who appeared as the whip-cracking ringmaster. Another impressive party was her Gold Ball, held at the Ritz and given for the purpose of raising the spirits of those who had lost money in the crash of '29. Yards of gold covered the walls, the tables were draped in gold lamé, gold champagne was served, centerpieces were gold Christmas ornaments, ivy leaves were used as place cards, with the names of guests written in gold leaf.

For all the studied effort that went into Elsie's artful mode of living, it still retained a healthy dose of eccentricity. One such novelty was leaving her address book as bedside reading for her guests. Another was the placement of her leather-bound checkbook on a rare Italian altarpiece that was elevated; when she wrote a check, she had to literally mount the altar.

For all her quirks, Elsie was businesslike about her role as a hostess. She created a cross-referenced filing system that included notes on each dinner party, who came, how many times a guest had been invited, what was served, and a description of the menu and table setting. If she served a new sandwich that proved to be a hit, she made sure *Vogue* got the information. "Entertaining for Elsie was both an art and a business," recalled Elsa Maxwell. "In her line, one never knew: the guest of today might well be the client of tomorrow." So when prospective clients came to the Villa Trianon and saw Elsie in action, their decision to hire her was based as much on the image she projected as hostess extraordinaire as on the splendid decor of the villa itself. "Lady Mendl was so successful," wrote Cecil Beaton, "that she became a living factory of chic."

During the last fifteen years of her life, Elsie's

marketing skills reached epic proportion. It was Elsie who backed the Chicago-born Main Bocher when he came to Paris to become a couturier. When Mainbocher—as he soon christened himself—opened his salon, it was decorated à la Elsie with zebra rugs, leopard-skin fabric, and mirrored mantels. And because she made it a point to tell her many interviewers she was wearing Mainbocher, the designer expressed his thanks with a 6 to 12 percent annual dividend.

Another of her gifts to American women was to export Erno Laszlo, the Hungarian skin-care specialist. She sold her name for endorsements on Pontiac cars, Gulistan carpets, and although she was a health and fitness nut, she even consented to lend her name to a campaign for Lucky Strike cigarettes.

Like tens of millions of others, Elsie was not immune to the financial repercussions of the Depression and World War II. Elsie's definition of a financial pinch hardly made her one of the neediest cases—she felt poor when her income wasn't keeping up with that of her very rich friends and clients. Always concerned with maintaining her reputation, she didn't want her customers to find out she was short of cash, so she entertained in restaurants and managed to have the owner give her the dinner for free in exchange for bringing in a well-heeled prospective clientele. In New York, the hotel bills were exchanged for decorating services, while restaurant checks were reduced because of the publicity her name generated. A finder's fee was always waiting when she took customers to a favorite antique dealer. But she also turned her economy-saving program into amusements, like the time she gave a dinner party at the Automat in New York and sent Charles Mendl's valet to set the tables with her own linen and china.

A more tasteful money-making venture was the publication of *Elsie de Wolfe's Recipes for Successful Dining*. Elsie's favorite dishes were just one aspect of the book. It also included sug-

gestions for table setting and short essays on the secret to being a brilliant hostess. At a time when decorating was not on the minds of most people, this book was designed to keep Elsie's name etched in the minds of potential clients. Like her decorating book twenty years earlier, this slim volume was amusing, delightfully written, and totally impractical. Recipes that supposedly fed "from eight to twenty" really only fed one or two. The dishes required hard-to-find French ingredients, and for table ornaments she suggested such esoteric decorations as antique porcelains or rock crystal displayed on a silver lamé cloth.

World War II forced the Mendls to leave Europe. They took refuge in Beverly Hills, where the movie community greeted Elsie with unusual enthusiasm. For the fantastically successful producers, directors, and actors who now had the money to buy taste, world-renowned Lady Mendl brought an elegance to their social life that was severely lacking in this culturally barren city. Her title, her old-fashioned good manners and totally un-Hollywood, understated clothes made her a star. Her written invitations always specified cocktails at seven forty-five, dinner at eight o'clock, a rather confident demand considering that she was dealing with a crowd notorious for no-shows and lateness. But once again, Elsie had the most important names showing up right on time.

Her house on Benedict Canyon Drive, which she named After All, was once considered the ugliest in Beverly Hills. But by using her favorite green-and-white color scheme, black lacquered floors, and tented awning-striped rooms throughout, she transformed the house into an appealing blend of the witty and chic. Her fondness for amusement now took precedent over her quiet elegance. A formal dining room was turned into a cocktail lounge complete with leopard-skin banquettes and a bamboo bar with high stools. She fashioned the living room after a ballroom

with the furniture pushed against all of the walls.

Elsie was fond of saying that there were only two good houses in Los Angeles, hers and Jack Warner's. "One is all good stuff, the other is all junk," she said. "Mine is all junk." She had managed to decorate the entire house for less than the cost of a single piece of furniture at the Villa Trianon. It bothered her not a bit that After All was merely a deceptively stylish stage set, for she knew that when the war ended she would go back home to France.

When she returned to Europe in 1946, she

ELSIE DE WOLFE'S

*Recipes*

FOR SUCCESSFUL DINING

*By Elsie de Wolfe*
(LADY MENDL)

D. APPLETON-CENTURY COMPANY
INCORPORATED
NEW YORK          LONDON
1934

❧ *Even during the war, Elsie published recipes for elegant entertaining.* OPPOSITE: *A lamé tablecloth, a rock-crystal ship, and candlesticks set the mood for dinner at Elsie's Paris apartment.*

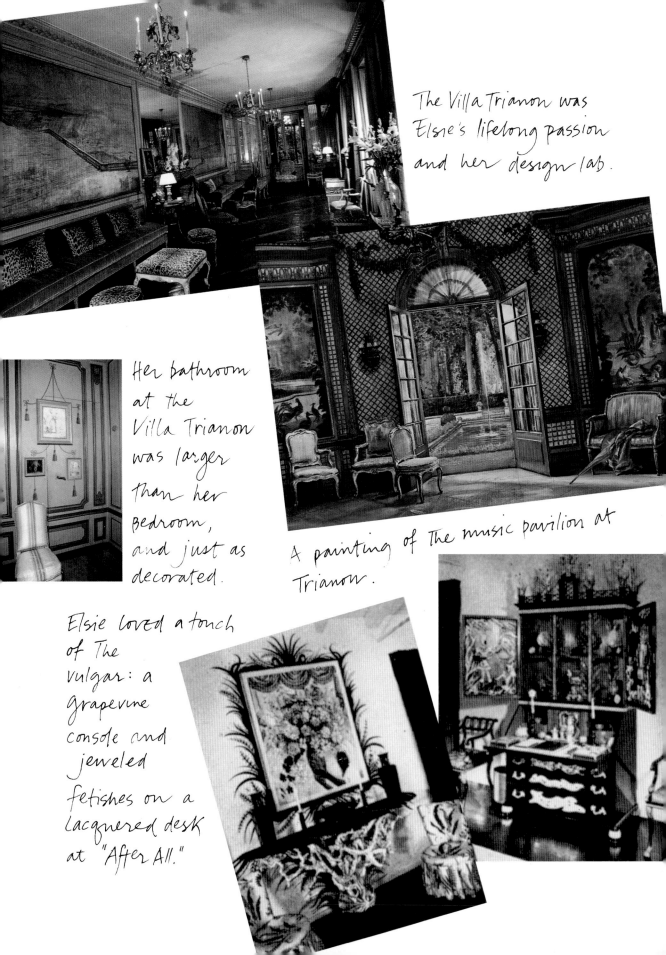

The Villa Trianon was Elsie's lifelong passion and her design lab.

Her bathroom at the Villa Trianon was larger than her bedroom, and just as decorated.

A painting of the music pavilion at Trianon.

Elsie loved a touch of the vulgar: a grapevine console and jeweled fetishes on a lacquered desk at "After All."

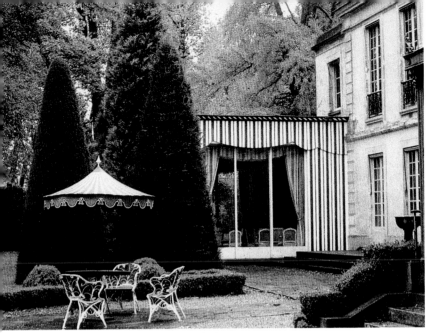

The octagonal
sitting room
at the
Villa Trianon

The striped tent pavilion, the setting
for her extravagant parties.

Elsie wearing Mainbocher in this
1935 watercolor by Cecil Beaton

Postcard directions to Trianon.

was over eighty, frail, and used a wheelchair to conserve her energy. Her first stop was the Ritz, where she was wheeled through the Place Vendôme. Saleswomen rushed out from the exclusive shops to greet her, as if her presence were the final stamp that the war was over.

Her beloved Villa Trianon had suffered terribly; a German Panzer corps had used it as a headquarters. But despite her poor health, she found the energy to restore the villa to its former grandeur. By the following summer Elsie was once again receiving monarchs, movie stars, and the glamorous international set.

Elsie had reached that final stage of a fashionable life; she was now a living legend. The decorating and fashion magazines regularly paid tribute to her, and although she had outlived most of her cronies, she still held court at the villa for a new generation of swells and admirers. By 1949, spinal deterioration had left her crippled, her mind tended to wander, and her eyesight was poor, but oddly enough, in old age she was finally rewarded with the quality that had always eluded her. "Elsie is certainly prettier—prettier than she has ever been before," wrote Cecil Beaton. She was, at last, delicately feminine in a fairy-tale childlike way, with her little jeweled evening jacket, organdy butterflies sprinkled in her blue-tinted hair, her short snow-white gloves, and dainty silk ribbons woven through her diamond bracelets.

"I've outlived my time," she told Beaton shortly before her death. "I'm too old now. I ought to have died before the war; I've just been hanging on since then, and for someone who's led such an active life as I have, it's terrible to retire and take things easy, and try to preserve a little vitality." For all that, she still did not want to die. If death were to come, however, the formidable hostess wanted to be prepared for it. She made detailed instructions for the final disposition of her treasured objects. She selected from Cartier the stationery that Sir Charles was to use

for answering condolence letters. Curiously enough, for a woman who loved ceremony and entertaining, she wanted no funeral, no flowers. "I want their memories of me to be in their hearts. If I have been of any help to any living being, let them think of that the day they hear I am dead."

The woman who had made a business championing the decorative styles of Louis XIV, XV, and XVI would have undoubtedly approved of one newspaper's headline: "The Last Queen of Versailles Has Passed Away."

More than forty years after her death, Elsie de Wolfe's influence is still with us, but not necessarily because of her innovative decorating ideas. There have been decorators who have been as influential as Elsie: Jean-Michel Frank, Madame Castaing, Nancy Lancaster. Elsie endures because she was the inventor of the twentieth-century notion of marketing taste. She was the first person to sell what is today called "lifestyle." And more important, what she understood best when it came to selling that ephemeral commodity was the art of self-promotion; in the end, she was her own best product. For all her love of life in Europe, in this respect she was totally American: a self-invented woman who knew that with discipline, hard work, and ingenuity she too could achieve her dreams.

And so, when you see the all-encompassing worlds being marketed by Ralph Lauren or Martha Stewart, think of Elsie.

*"I was born with the courage to live. Only those are unwise who have never dared to be fools."*

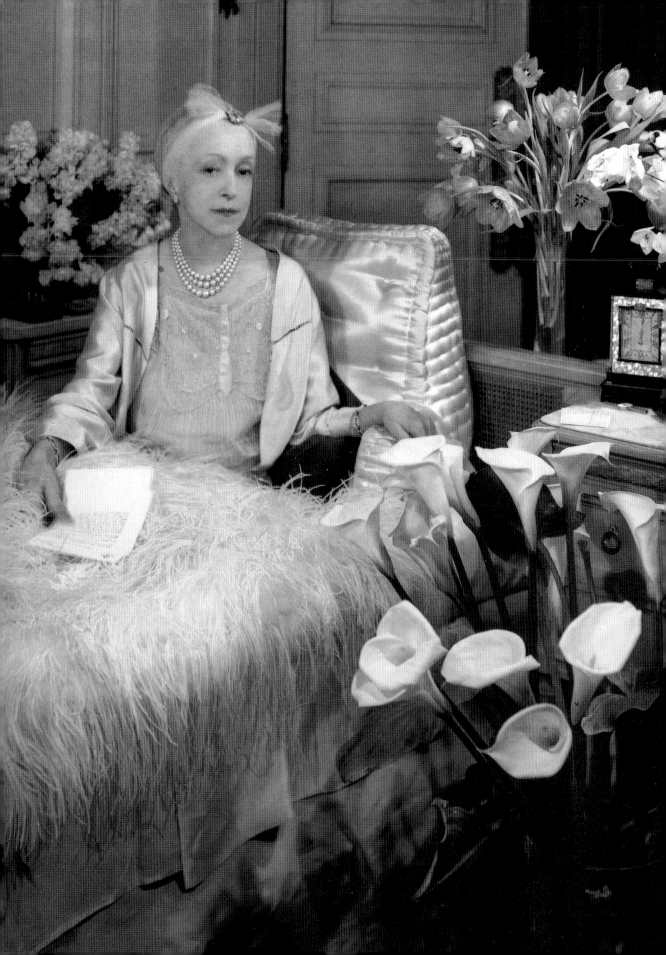

# Millicent Rogers

It takes most collectors a lifetime to find, buy, and edit enough work even to consider starting a museum to house their collections. Not Millicent Rogers. The woman the world knew as an heiress and fashion icon moved to Taos, New Mexico, in 1947. Although she was in poor health, she was not idle. In five years, she not only designed and made some of the most innovative jewelry ever created in America, she bought some five thousand of the most distinctive nineteenth-century native American artifacts available. In 1953, when she was just fifty, she died. Eleven months later, one of her sons dedicated the Millicent Rogers Museum.

The possessions of the great hostesses and fashion leaders traditionally become the mainstay of the auction houses; their original owners achieve

*Millicent, dressed by Charles James and wearing antique Navajo bracelets and a gold necklace she made.*

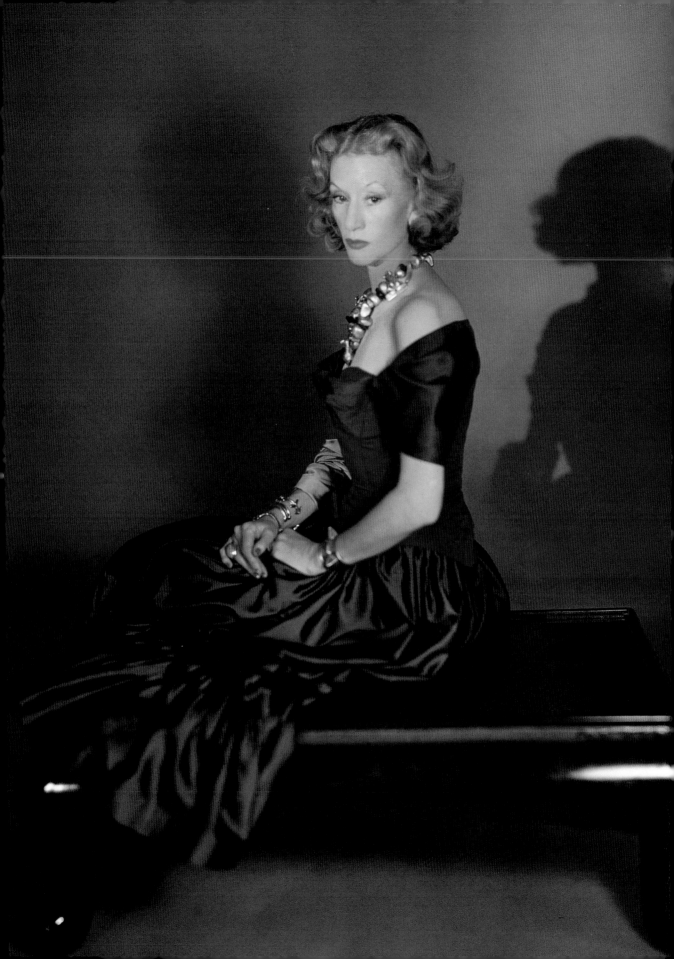

the gloomiest immortality, as footnotes dangling from the wrists, walls, and coffee tables of the next generation of social aspirants. So the Millicent Rogers Museum is a unique memorial. No other American woman of style assembled a collection of anything that still remains intact.

For those who visit this museum and savor its impressive collection of southwestern jewelry, textiles, pottery, and painting, there is little to remind one of the fascinating story of its benefactress. Nothing suggests the remarkable journey that led her, near the end of her life, to a place so completely alien to her upbringing. Here, the focus is on the aesthetic purity and the spiritual power of the artifacts which, as we are only now coming to understand, represent great artistic achievement. At a time when press agents and museum directors very often make collectors seem more noteworthy than their collections, how very like the son of Millicent Rogers—in perfect tribute to her unerring eye and in acknowledgment of her special character—to take the focus off the woman and place it on the often-anonymous native American artists.

Millicent Rogers would have applauded her son's choice of a memorial. She might have been less enthusiastic about her inclusion in the pantheon of stylish women. And she would have had good reason to feel that way. Celebrated even as a child, notorious in her twenties, she spent the rest of her brief life retreating from public life. It is as if she never wanted her fascinating life story to be told.

❧ *Millicent Rogers as she appeared in 1919, dressed for a fantasy ball.*

As a child running around Central Park, she was already a legend. Like Princess Leia in *Star Wars*, she wore her hair braided like large macaroons over her ears. Her face was curiously arresting. Her wide eyes had a mandarin slant, her legs were correctly thin, her clothes were exquisite. And if she was beautiful at nine, she was even more ravishing at fourteen, and was astonishing when her mother took her to London and the social set raved about the new "dollar princess."

These are the characteristics for which Mary Millicent Rogers will be remembered. But the driving force behind her inimitable style wasn't a hunger for recognition but a passion for life's aesthetic pleasures, inspired by a nearly fatal childhood bout with rheumatic fever.

On the surface, she was the quintessential American heiress. Her grandfather was Henry Huttleston Rogers, known as the Hellhound of Wall Street. As the mastermind behind U.S.

Steel and Anaconda Copper, he was one of the most powerful financiers of his time. And if that wasn't enough, he became John D. Rockefeller's partner in Standard Oil—a partnership that would bring his fortune to about $300 million and cause his granddaughter to be known as the Standard Oil heiress.

Millicent's parents were a stylish, socially prominent, and highly cultured couple. Her mother was Mary Benjamin Rogers, whose correspondence with Mark Twain was immortalized in *To Mary, from Mark.* This was a woman to whom many men would have been happy to write, as she had terrific taste and a remarkable fashion sense.

Mary raised her children in New York City and on a large Southampton estate called the Port of Missing Men. With its tiled roof and stucco exterior, this Long Island mansion, modeled after a Tuscan villa, stood out from the neighboring white-shingled Victorian "cottages." When the Rogerses tired of New York and Long Island, they rented castles in Scotland. In their elite social circle, they were considered style setters and cultural adventurers.

Millicent was blessed once with superior intelligence and blessed again by a family environment that nourished her artistic and literary sensibilities. This combination of brains and aesthetics saved her from the poor-little-rich-girl syndrome and the fate of another beautiful American heiress, Barbara Hutton. As a child, Millicent used her invalid years to learn several languages, among them French, German, and Spanish. She became an accomplished translator of Rilke and learned Latin and Greek after concluding that some of the most important work in those languages had never been translated.

For all that Millicent had, there was, in addition to good health, one thing she lacked—cash. Her father, Colonel Henry Huttleston Rogers, was one of four heirs to a fortune that would have been considered significant in any era. He

not only kept his share intact, but increased his net worth. When it came time to consider his children, he applied sound business principles. While he felt his son was sensible, he decided that his generous and artistic daughter would be set upon by fortune hunters. To keep her from squandering her inheritance, the colonel changed the terms of his late father's will so that when he died all taxes would be paid immediately. He controlled Millicent's income better than he had planned—the taxes were so crippling that Millicent, far from being secure, was often faced with financial problems.

For a while Rogers seemed wrong about the character of Millicent's suitors. When the Prince of Wales made his famous American tour at the peak of the Jazz Age, Millicent danced her way into His Majesty's heart, becoming his ideal of the American girl. The prince was followed in her affections by Serge Obolensky, the dashing exiled White Russian prince who divorced his wife to be near her. "We got unofficially engaged, but I could never be sure of her. She had too many beaux. She was apparently a past master at keeping one dangling," Obolensky recalled. "Millicent was terribly attractive, one of the most beautiful girls I have ever known. She was an exotic creature, with a curious languid manner. Even her voice, soft and pensive, was that of an Oriental, and she generally dressed the part."

After keeping Obolensky guessing as to when they might marry, she took off for Europe and fell in love with the Duke d'Aosta, the youngest son of the king of Italy. He proposed marriage but the colonel wouldn't give his consent. By the laws of the Court of Savoy, Millicent would have been considered a commoner. To get even with her father, she told him that if she couldn't marry the duke she would marry the first attractive man who asked her.

And then she met a middle-aged Austrian count.

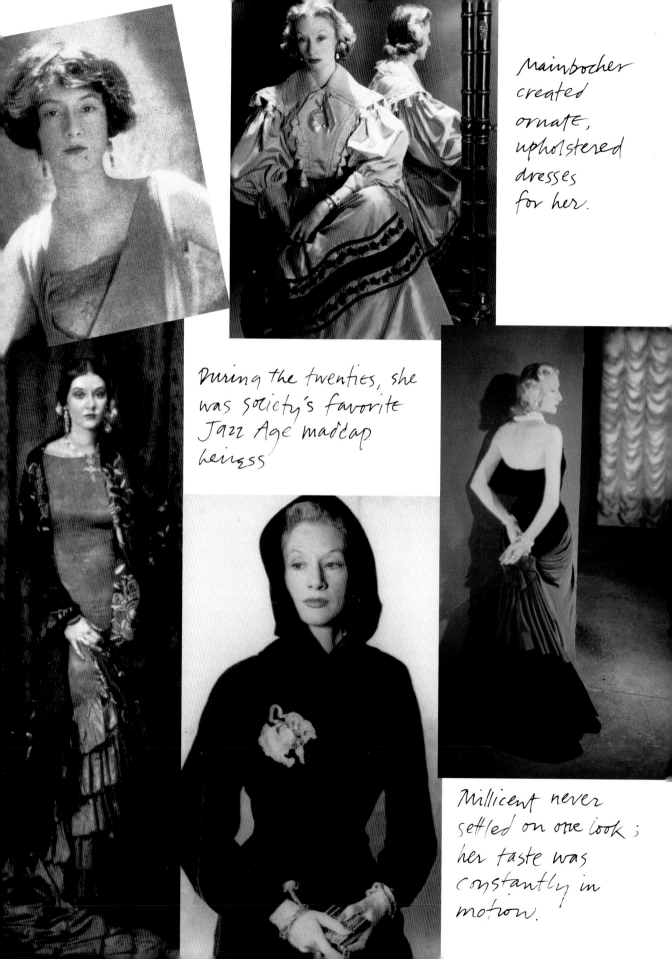

Mainbocher created ornate, upholstered dresses for her.

During the twenties, she was society's favorite Jazz Age madcap heiress.

Millicent never settled on one look; her taste was constantly in motion.

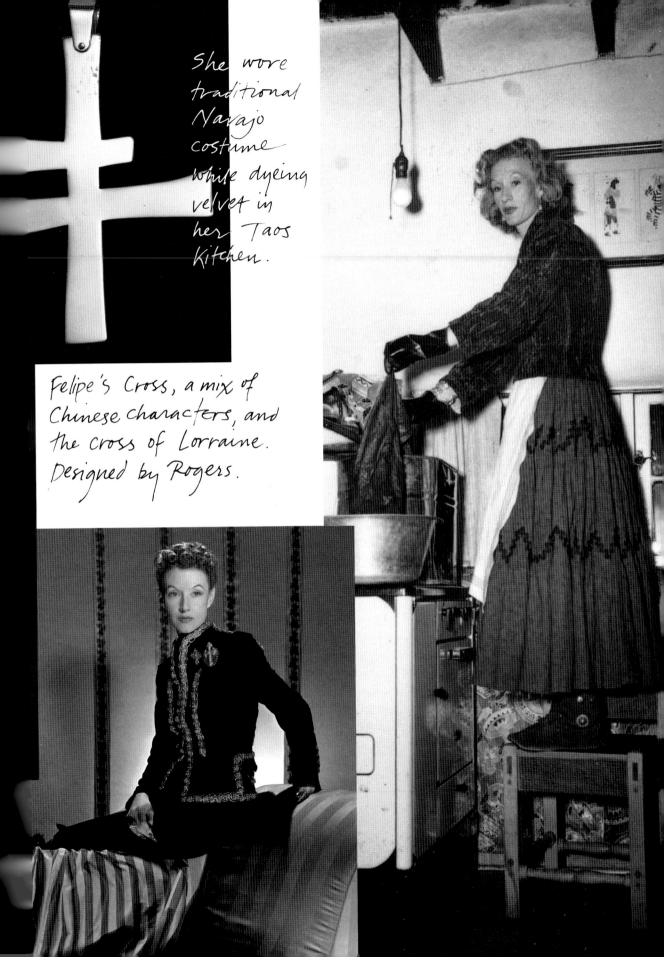

She wore traditional Navajo costume while dyeing velvet in her Taos kitchen.

Felipe's Cross, a mix of Chinese characters, and the cross of Lorraine. Designed by Rogers.

Ludwig Salm-Hoogstraten was a playboy, a Davis Cup tennis champion, an antique dealer, and a sometime motion picture actor. But his real career, some thought, was the ardent pursuit of a fortune. Colonel Rogers was appalled by his twenty-one-year-old daughter's choice of a rebound. For that reason, they kept their engagement secret and were married quietly in January 1924 at city hall in New York without informing her parents. Two weeks later, without contacting her family, they sailed for Europe.

The colonel's retribution was swift—and financial. Millicent's allowance was reduced to just enough to allow her and the count to lead a simple life. The rumor spread quickly that the couple was in such financial straits "they were forced to dance in Paris cabarets."

Salm may well have known what he was up against, for he worked fast, impregnating his wife on their honeymoon. By May, their marriage was in ashes. "Salm Off to Vienna; Countess Sails Home," trumpeted the front page of the *New York Times.* "One Report Says $100,000 Passed to Count's Family as a Settlement."

That fall, their son, Peter, was born, rendering the inevitable divorce more complicated. Salm followed the Rogerses to their winter residence in Palm Beach and obtained a court order giving him visitation rights. It took until 1927 for the divorce hearing to be scheduled; just before it began, the inevitable out-of-court settlement was reached. "Both the count and the countess were present at the final hearing," the *Times* reported, in yet another front-page story. "They showed no bitterness toward each other. In fact, she smiled sweetly at him when the decree was announced." Salm returned to Europe some $300,000 richer, and Millicent resumed the use of her maiden name.

She didn't keep that name long. Three months later, she was engaged to a wealthy, aristocratic Argentinian, Arturo Peralta-Ramos. And three months after that, they were married at her father's house in Southampton. The press speculated that this marriage was also affected by the colonel's curious philosophy regarding inherited money. When he died in 1935, he left five million dollars to his grandson Peter, but made no provision for Millicent's two sons by Ramos. Five months after her father's death, Millicent's second marriage was over.

In her third and final marriage, Millicent at least made a fresh mistake. "The chances for happiness for an American girl are greater if she marries a man of her own nationality," she had told friends a decade earlier. Now, in January 1936, just a month after her divorce from Ramos, she married Ronald Balcom, a New York stockbroker.

No sooner had they married than Millicent left Manhattan, put her three sons in a Swiss boarding school, and settled into an Austrian chalet in the Arlberg valley. "She follows the snows with the seasons and spends almost seven months of the year on skis," wrote *Harper's Bazaar* in 1938. "She travels with not one but seven dachshunds." Her European period ended with the start of World War II. She returned home in 1940. In March 1941, her divorce from Balcom became official.

She had learned her lesson. She was too dramatic, restless, and imaginative—and far too liberated—to be bound by any one relationship. "Marriage was stagnation and complacency for her," explains her son Arturo Ramos. "Her biggest problem was that she was smarter than most men."

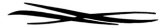

She endured three failed marriages and shared the standard passions of wealthy women—houses, clothes, jewelry. But beneath the surface of what looks like a superficial life is the story of a woman who didn't just consume style, but created it. Millicent Rog-

ers, who seemed so frail and died so young, turns out to be one of the most authentic American mistresses of style.

"She was totally creative," Diana Vreeland recalled in 1984, describing Millicent. "She left an imprint on everything she did. Forty years later, hers is a look that is totally of today."

Millicent was often dressed by the leading couturiers of her day —Schiaparelli, Mainbocher, and Valentina. She had the unique ability to get designers to make clothes for her exactly as she wanted them. It was that talent that allowed her to go beyond the current fashions to create her own style.

Her association with Charles James, the uncontested genius of American haute couture, is the most memorable. James, a master of construction, cut, and color, was temperamental, rebellious, and, like his premiere customer, a relentless perfectionist. It is not without irony that the woman who inspired him the most was also the one who would take his designs and alter them to suit her own whims.

These two headstrong individuals often collided, but the clothes that James created for Millicent were a result of a true collaboration. James, who executed fewer than a thousand designs in his forty-five-year career, was in no rush to present his creations. Diana Vreeland once said he "would rather work and rework a beautiful dress

*❧ No matter what fashion she embraced, Millicent was a thoroughly modern beauty who always looked slightly ahead of her time. This photograph was taken in 1947.*

ordered for a certain party than have that dress appear at that party." Even James, however, found Millicent's attitude toward clothes perplexing.

James once put considerable time and effort into making four dozen identical blouses for Millicent. While he was delighted to have the business, the experience left him discouraged. He knew she'd never wear all of them and sensed that many of them would be forever packed away in storage. Shortly thereafter, Millicent's maid telephoned for yet another order. "Why, Mrs. Rogers is nothing but a hoarder," he complained to her. "Not a hoarder, Mr. James, a collector," the maid replied.

It was James's good fortune that his client was just that. Millicent saw James as a sculptor, an architect. And like any good patron, she supported his efforts by paying him in advance for work she wanted done. The pinnacle of their collaboration came in 1948, when the Brooklyn Museum presented their exhibition "A Decade of Design," showcasing clothes James had created for her in the past decade.

A year later, when James was at the peak of his career, he spent a month at a sculptor's studio making clay forms on which to base a dress dummy that would correspond to what he believed was the new outline of the modern

association with James. In her final years, when she was confined mostly to her bed, he designed flowing striped silk peignoirs for her. Only then did she make a large donation of James's original garments, muslin models, and paper patterns to the Brooklyn Museum's costume institute.

James never forgot his muse. Shortly after Millicent's death, he wrote a tribute to her in the *New York Journal-American*, praising her as an inspiration and guide who "knew as no one else did how to bring out the best of my talent as a creator of fashion."

woman. After doing an in-depth study of 150 years of costume to see how body measurements had changed, he based his new measurements on Millicent's proportions.

By this time, much had changed in Millicent's life. She was now living permanently and quietly in New Mexico, her physical condition deteriorating. But she didn't let any of that diminish her

But Millicent's intensely personal style extended far beyond what any designer created for her. As early as her debutante days—when she made headlines wearing mandarin robes, a Chinese headdress bought in Chinatown, and her long fingernails

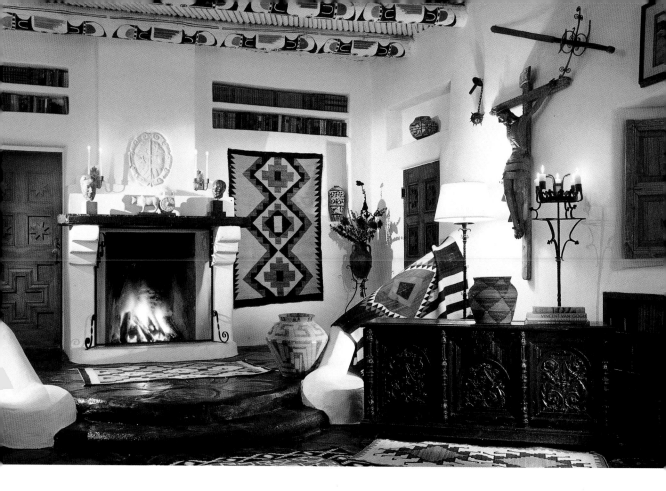

painted bright red—she had a passion for costumes. Later, she became famous for adopting a style of dress to correspond with her environment. She could be seen in the pages of *Vogue* or *Harper's Bazaar* just back from Europe and looking like Anna Karenina: swathed in sable or a moleskin cape, muff, and hat she had dyed a shocking red. When she lived in Austria, she adapted her wardrobe to the national dress of the Tyrol—dirndls, aprons, embroidered vests and jackets, and peaked Tyrolean hats. Absolute authenticity was one of Millicent's traits, and it didn't suit her to buy native wear in a shop. She went directly to the peasant costumes on display at the museum in Innsbruck, made sketches, and had her village tailor execute the designs.

But she wasn't content to wear the Austrian attire on its own. She effortlessly combined the look with sweaters and skirts made by Schiaparelli. The fun for Millicent was to take an unlikely item and put her stamp on it. She was the envy

**Millicent's** *historic adobe on a plateau in Taos, New Mexico, which she was still renovating when she died. It was once a seventeenth-century fort. Her son, Arturo Peralto-Ramos, and his wife, Jacqueline, completed its restoration and renamed the property La Mancha Farms. They have not only preserved her collection of furniture and Native American objects, but expanded them.*

of many well-dressed women in Paris when she'd arrive wearing a sleek Schiaparelli suit with one of her peasant blouses and a Tyrolean hat, or when she'd reverse that look and wear a dirndl skirt and a very smart city hat. Her Austrian look inspired other well-known fashion leaders of the day like Wallis Simpson, who commissioned Schiaparelli and Mainbocher to make Tyrolean outfits for her honeymoon, and Princess Baba de Faucigny-Lucinge, who opened a shop in Paris specializing in Austrian clothing.

"Paris stood up and took notice when Millicent Rogers arrived. They thought she was the first real American woman with any style," the photographer Horst told me. "She probably brought as much beauty and dignity to the Schiaparelli era as any of Schiap's loyal followers," noted Bettina Ballard, the Paris editor of *Vogue* in the late 1930s.

Like an actress, she got right into every part. When she moved to Claremont Manor, the colonial estate in Virginia that she filled with her museum-quality Biedermeier furniture, she had Mainbocher make dresses for her in the period of Louis Philippe. And at Taos, her final destination, she went barefoot and wore full Indian skirts with layers of petticoats, native American blouses, shawls, her neck bathed in turquoise and coral, her arms weighted with silver jewelry made by the Indians. When Diana Vreeland, then fashion editor at *Harper's Bazaar*, returned to New York after visiting Millicent in Taos, this look inspired a trend among her colleagues. Polly Mellen recalls going with Vreeland to have an enormous black cotton sateen skirt made: "That year we all wore a black sateen skirt with ten petticoats."

With her extraordinary Byzantine beauty and perfectly proportioned slender body, Millicent could wear anything. "She could pick up a rug off the floor, don it, and look ravishing," a close friend once observed. But as Diana Vreeland said, "I'm not interested in the dress, I'm inter-ested in the woman inside the dress." And as for Millicent, Vreeland correctly understood that "her costumes would have been only that if it hadn't been for her overwhelming personality—sensitive and vulnerable on the one hand, lusty and provocative on the other."

Millicent's finely drawn face, high cheekbones, arched eyebrows, alabaster skin, and long slender hands gave her a quality of aloofness that defied her personality. "Millicent was seductive beyond discipline," Vreeland observed. Others admired her double nature; she was a sensualist, but she thought like a man. "She was so strong, but so feminine, so very female," recalls Arturo Ramos. "And yet she demanded a brain out of the men in her life." Of her known lovers, the most frequently mentioned is Ian Fleming.

But if Millicent liked bright men, she also had a high appreciation for beautiful men like Clark Gable (although Arturo Ramos insists that Gable was actually smarter than he ever got credit for). Millicent met Gable when she was in her midforties, and according to Gable's biographer, Lyn Tornabene, "stalked him relentlessly, even to courting Jean Garceau, Gable's secretary. She took Jean to lunch and sent her some of the twenty-four-carat jewelry she had made. She was madly in love with him, and it was this obvious much-reported fact that did her in after only a year in Clark's favor."

When the romance ended Millicent sent him a soul-baring farewell letter.

*You will always be a measure by which I shall judge what a true man should be. As I never found such a one before you, so I believe I shall never find such a man again. . . . The love I have for you is like a rock. Now it is the foundation upon which a life is being built. . . . I followed you last night as you took your young friend home. I am glad you kissed and that I saw you do it, because now I know that you have someone else close to you*

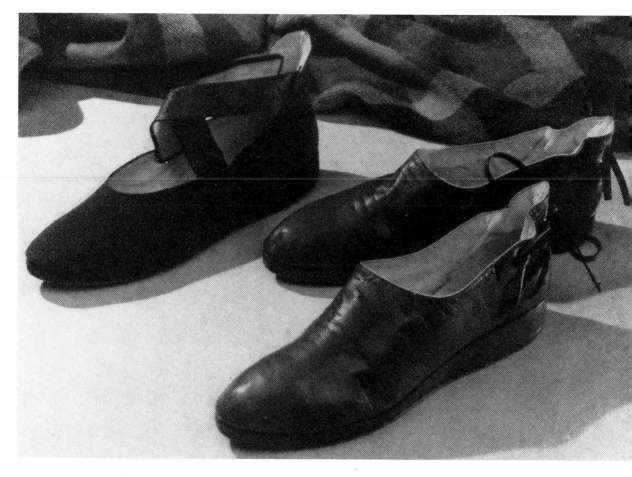

*and that you will have enough warmth beside you. Above all things on this earth, I want happiness for you. . . . You told me once that you would never hurt me. That has been true, even last night. I have failed because of my inadequacy of complete faith, engendered by my own desires, my own selfishness, my own inability to be patient and wait like a lady. I have always found life so short, so terrifyingly uncertain. . . .*

There was an eerie twist to this heartfelt letter: Gable was not the only recipient. Millicent also sent a copy to Hollywood gossip columnist Hedda Hopper.

What drew Clark Gable—and so many others —to Millicent? Her presence, for one thing.

*The shoes Millicent wore when she lived in Austria's Tyrol valley.*

"Her clothes were spectacular, her sense of humor infectious, and her gossip was riveting," remarked her friend Esmé Hammond. Millicent had a dry wit which she exposed without change in inflection or expression. Her delivery was generally succinct and on the mark. Once, a Hollywood star famous for tiresome monologues asked, "Am I boring you, Millicent?" She politely replied, "Not yet."

In addition to her staggering beauty, her unexpectedly quirky personality was also irresistible. Lanfranco Rasponi remembers that Millicent loved the theater but never saw the first act of a show. One evening after seeing *The King*

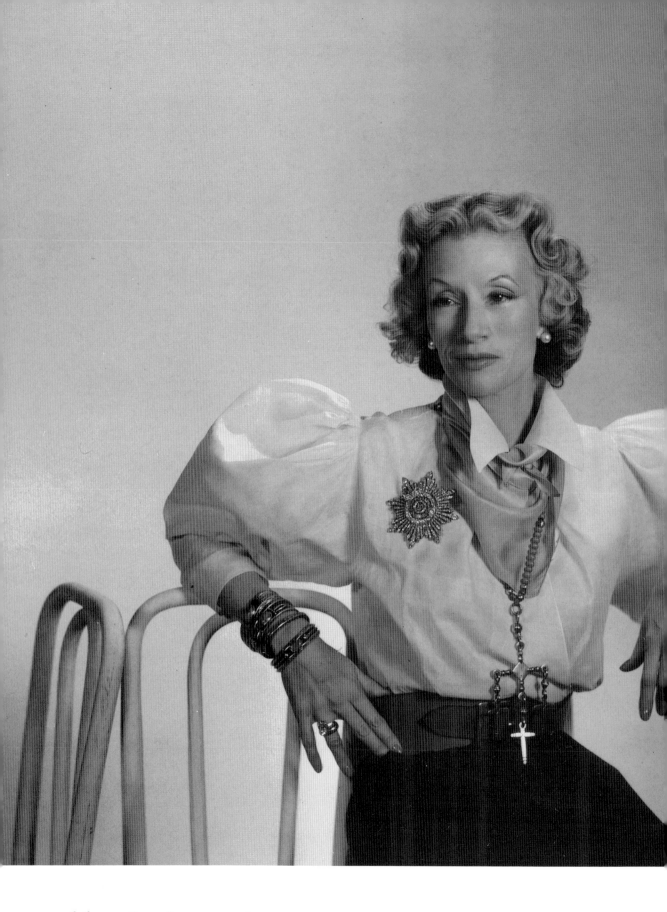

*and I,* she and Rasponi had dinner with Yul Brynner. With total seriousness, she told Brynner, "I have a marvelous idea for you. The number of people, like myself, who cannot avoid being late is such a large one that twice a month you should advertise the inversion of the two acts. All of us would return to see the initial act, and then you could eliminate performing the second one, for during the first half, the theater would be empty."

As early as 1925, *The New Yorker* reported that she went to Hickson's, an exclusive New York dress salon, and began to conduct her business in flawless French. Unfortunately, the French-speaking saleswomen were at lunch. Millicent lapsed into English long enough to tell the staff that she would only do business in a civilized tongue. A messenger was dispatched to the restaurant to summon a French-speaking salesperson. Happy at last, Millicent bought six gowns.

When wartime gas rationing made it difficult for her to have a car and driver, she stumbled upon an original solution. Upon meeting Irving, a colorful New Yorker who drove a checkered cab, she hired him on a permanent basis and used the taxi as her limousine. Another time, when she couldn't find a car that she considered aesthetically pleasing, she had a Delahaye custom-built with one streamlined fin running down the back.

While she lived for a brief time in Hollywood, she fell in love with a pet monkey belonging to her friends the actress Janet Gaynor and her husband Adrian, the dress and costume designer. Millicent soon bought one for herself and went everywhere with the monkey perched on her shoulder or casually draped around her neck.

Once while lunching at Romanoff's in Holly-

*Although captivated by the American southwest, she never abandoned her love of the eclectic. Here she mixes a Russian brooch, modern rings, as well as Indian bracelets.*

wood, Clark Gable's secretary was more than surprised when the stylish beauty pulled out a long, delicate gold toothpick at the end of the meal and actually used it.

Unlike many great beauties, she wasn't the slightest bit egotistical. She had a keen awareness of her weaknesses, and more than anything reveled in self-mocking humor. And she was far more generous than others of her set: even during her frequent financial crunches, she had a habit of giving away many of her treasures. Often she would donate a painting to a small museum that lacked financial support.

"My mother was the least judgmental person I've ever known," Arturo Ramos says. "She was totally accepting of people. She saw them as a child sees them. I always thought that was because her view of the world had been formed by books during her childhood illness. She lived with the idea of death and that fueled her incredible thirst for knowledge and total flair for living. My mother resolved that she wasn't going to die, and she fought with every breath."

"Her periodic photographs in *Harper's Bazaar* and *Vogue* made her an object of great fashion curiosity," Bettina Ballard recalled. "Had she attached any importance to being a fashion leader, she could have led them all. Hers was a true natural elegance."

But although Millicent, in her early twenties, attracted a great deal of media attention, it was not her style to court the press as she grew older. She was chronicled in the fashion magazines for her taste and beauty, she was on the best-dressed list, but she was not a great social figure. In fact, she led a relatively quiet existence. "As children, my brothers and I grew up with books written and illustrated by her," Arturo Ramos remembers. "They were incredibly imaginative

and unusual for their time, very similar to cartoon creatures today. She created whole volumes for us."

Millicent's interests lay in pursuits that were outlets for her artistic ability, originality, and taste. Jewels had always been one of her great passions, and she collected significant antique jewelry as well as contemporary pieces from Cartier, Verdura, and Boivin. "Jewelry embarked upon a whole new trend when she picked up a leaf, stuck a pin through it, and gave it to Boivin to copy in gold and diamonds," Cecil Beaton recalled. But by the 1940s, other designers' work no longer satisfied Millicent. Inevitably, she came to feel that the only way to get the jewelry she wanted was to create it herself.

She was inspired by her friend Maria Martins, the distinguished Brazilian sculptress, who encouraged her to focus on the sculptural aspect of jewelry. Soon, she was not only designing jewelry but learning the craft of making the pieces and setting up her own bench. Her pieces were predominantly abstract forms which she called "sculptured jewelry." They were executed by her in eighteen- and twenty-four-carat yellow and green gold because she liked the feel and weight of these heavy metals.

But there was another, more interesting reason why she wanted heavy jewelry. And it had little to do with style. "At one point, my mother had suffered from paralysis in her neck and hands," Arturo Ramos explains. "The heavy gold necklaces and bracelets that she was so famous for were designed to hide her paralysis. The weight of the jewelry kept her head and hands in place so no one would notice."

Millicent's tastes and quest for artistic expression required constant exercise. The most obvious outlet was in the decoration of her houses. After her return to America in 1940, she traded the Austrian Tyrol for the genteel pace of Tidewater, Virginia, and one of the state's most historic colonial houses. She turned Claremont

Manor into a working farm so she wouldn't be dependent on rationed wartime food. Only then did she proceed to renovate the house, but just on the inside.

"I consider it a desecration in Virginia to change even one single architectural detail," she told Billy Baldwin. "Inside, you can do whatever you want because that is entirely up to you; you're going to see it, and you're responsible." From St. Anton in Austria, she brought decorative porcelain stoves. From France, she imported her Watteau, Fragonard, and Boucher drawings. This house became a jewel box filled with treasures that reflected her eclectic taste—her collection of antique clocks, a desk that once belonged to the poet Schiller, empire and Biedermeier furniture, the latter being a true novelty at the time.

"Millicent was more of an acquisitor than a serious collector," recalled J. Watson Webb, Jr., whose maternal grandparents, the Havermeyers, gave their outstanding collection of Impressionist paintings to the Metropolitan Museum. "But she had the enormous advantage of unassailable taste, so that whatever interested her, whether the Impressionists, Indian blankets, or Fabergé, became an assembly of the very best kind."

Millicent was among the first to buy works by nineteenth-century American artists like Winslow Homer and Shin. Billy Baldwin remembers going to art exhibitions with her. "The one picture that you were drawn to, almost as if it had been specially lighted, was on loan from Mrs. Huttleston Rogers, the name Millicent took after her divorce. I never knew it to fail."

During the war years Millicent divided her time between Virginia and her New York apartment. In addition to creating superb settings in both places, she also devoted her energies to wartime causes. She offered Claremont as a rehabilitation center for shell-shocked navy pilots, inviting four men at a time to the farm. Millicent believed that by surrounding them with children, comfort, and beautiful things they would recuperate much faster from their combat experience.

Back in New York, she organized the Medical and Surgical Relief Committee. In 1940 alone, she raised one million dollars for medical supplies to be distributed in European and Asian war zones. "My mother had intense dedication to this project," recalls Arturo Ramos. "What no one knew, however, was that the organization was also a front for smuggling food and supplies to the French underground."

After World War II, with Claremont Manor finished to perfection, Millicent had sucked up all the honey from this flower and was ready to move on. This time, she chose California. It was while she was living there that Janet Gaynor invited her along on a visit to Taos, New Mexico.

Earlier in the century, such artists as Marsden Hartley and Andrew Dasburg, patroness Mable Dodge Luhan, and D. H. Lawrence had discovered the majestic village that had been isolated for centuries in the Sangre de Cristo Mountains. It was in this "region of magic" that Millicent found the final oasis for her romantic heart. With its scenic beauty, tranquillity, ideal climate, and native American culture, Taos was the spot where she could put her hectic wanderings behind her and surrender totally to the earthy side of her nature.

"In retrospect, I realize my mother was way ahead of her time," Ramos says. "She was an intelligent hippie. Before she moved to Taos, she had been in perpetual search of the right environment where she could totally be that person."

In the rambling, sunlit adobe house which she designed and called Turtlewalk, Millicent grew into an accomplished designer and craftswoman. She was so influenced by the art and symbolism of New Mexico's Navajo and Pueblo tribes that she adopted their metalworking techniques.

Working in gold, silver, and copper, she created jewelry that was akin to the work done by the ancient Incas, Aztecs, and the Ashanti tribe of West Africa.

The writer Edith Sitwell has recalled the necklace Millicent made for her. *Figures of Growth*, as Millicent named it, was made of uneven gold beads from which hung large, flat, plant-shaped forms. "She sent it to me and the British Museum kept it four days and thought it was pre-Columbian," Sitwell wrote, "though they couldn't figure out how the gold could be stiffened in a way that wasn't in existence in those days."

Of all the attractions of the Indians, the greatest, for Millicent, was their simplicity. "She compared the Indians to poetry—they were souls that had not found their bodies," recalls her son. Once again, her passion took the form of dedication to a cause. At that time Indians were not registered as citizens but merely by numbers. Along with the writers Lucius Beebe and Frank Waters, Millicent went to Washington—at one point bringing some Indian friends with her— and crusaded for their citizenship. Relying on contacts in Washington, she was instrumental in getting the government to change its policy.

On an aesthetic level, Millicent saw the southwestern Indian culture as a precious part of America's heritage that had to be recognized and preserved. With her newfound knowledge of Indian craftsmanship and her unerring eye, she amassed a superb collection of Indian jewelry, textiles, and artifacts. "She was one of three or four collectors who had the vision and conviction to gather southwestern Indian material during the 1940s and 1950s—pieces representative, distinctive, and not to be found today," Neil Letson wrote in *Connoisseur*.

In 1952, Millicent suffered a fall that only exacerbated her already frail health. "I give up," she told her son. "I'm tired of fighting." Six months later, in January 1953, Millicent Rogers died. She was buried in a small cemetery in her beloved Taos. The entire Pueblo community, wrapped in their colorful native blankets, entered, for the first time, a white man's cathedral to pay their respects to this dauntless, free-spirited "gringo" woman who had understood, appreciated, and helped them.

In 1954, Cecil Beaton wrote that if Millicent "had not suffered from ill health, she might have laid the ghost of her money, becoming a serious artist in one field instead of a dilettante who dissipated in a delightful way her talents by illustrating books for her children, making acres of needlework carpets, and designing jewelry." Elsa Schiaparelli, who loved and admired Millicent, shared Beaton's sentiments: "Her jewels were of rare beauty and strange design, and I hope that one day we shall see them reproduced. If she had not been so terribly rich, she might, with her vast talent and unlimited generosity, have become a great artist."

Only a year after her death, it was too early to predict her legacy. Forty years later, it is easy to recognize that she was instrumental in popularizing the rich culture of the American southwest. Recently, the Millicent Rogers Museum reproduced a collection of jewelry that she designed during her Taos years. The jewelry "reflects today's return to American roots," wrote *Vogue* in 1992.

It is interesting to speculate on the turns Millicent's life might have taken if she had lived. Would her quixotic spirit have remained content in Taos?

"She was a dreamer, a visionary, always looking ahead of what she wanted," her son says. "At the time of her death she was moving toward Eastern ideas and becoming interested in Asia. Knowing my mother, she would have undoubtedly ended up in Japan."

⚜ M*illicent Rogers in 1945, during her sleek, streamlined phase.*

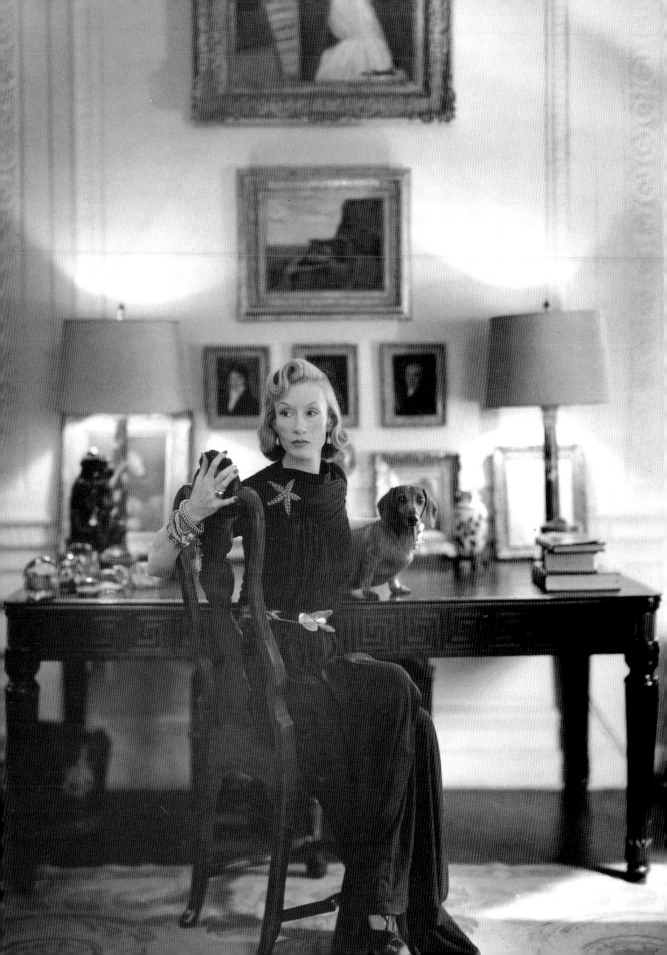

# Daisy Fellowes

**S**OMETIME BEFORE the First World War, Daisy de Broglie commissioned Jacques-Emile Blanche, a well-known society portrait painter, to immortalize her. When he finished the work, his subject came to his studio to collect it. Daisy looked long. Daisy looked hard. At last, she spoke: It's my responsibility to pay for the canvas. And I will pay for it. But I don't want it. And you must promise me that you will never show it to anyone.

*Cecil Beaton snapped this picture of Daisy on her yacht,* The Sister Anne, *in 1931.*

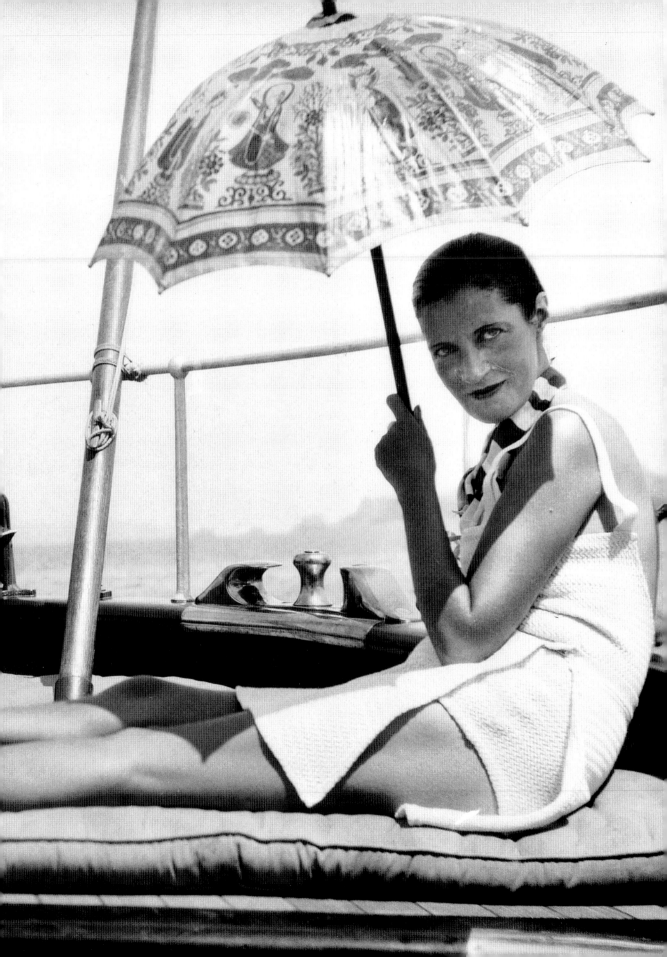

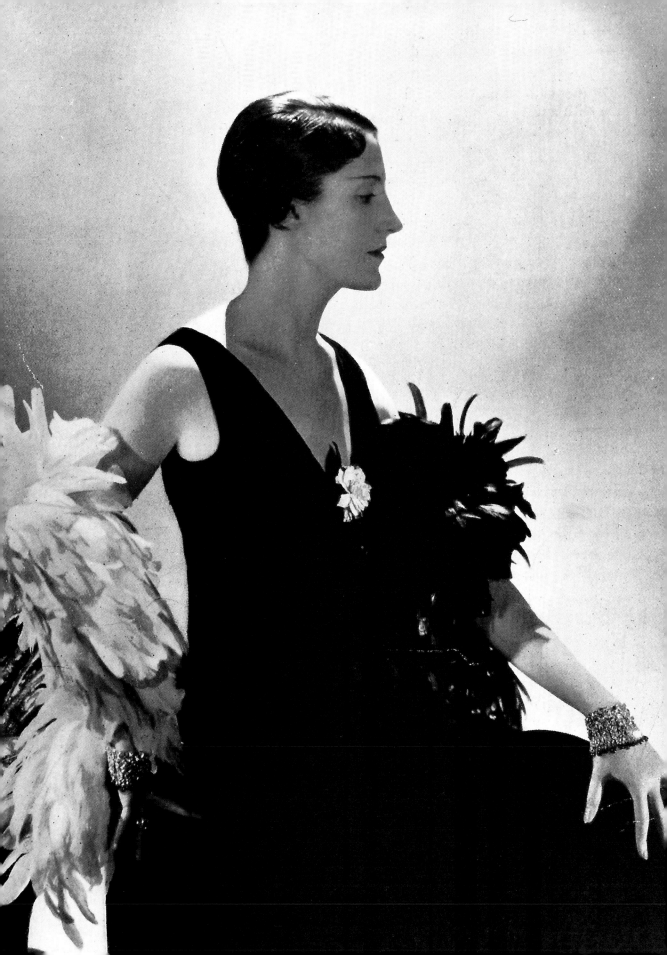

In that moment, Daisy became an astute critic —not of art, but of herself. She recognized that she was the woman of that canvas: plain-faced, with a long but far from classical nose. More powerfully, she recognized that her inner reality was so far from her fantasy that accommodation was impossible. And so she set out to become that chimerical woman.

Her first move was backward, into complete retreat. She remodeled her nose, cleared out her wardrobe, and found a better hairdresser. And then she began her real transformation. She read, day and night. She went to the theater regularly. Art galleries and museums became like second homes.

At last Daisy reemerged. And now she proved herself a great portraitist, for she had taken the dull canvas of her looks and personality and painted there a dazzling and irresistible creature, a living work of art. Daisy was now a chiseled classical beauty, possessed of a sleek and immaculate elegance, sharp-as-a-tack intelligence, and a superb, barbed wit.

Self-invention is always fascinating. What makes Daisy Decazes de Broglie Fellowes compelling is that her self-invention was, on one level, absolutely unnecessary. Her grandfather was Issac Singer, inventor of the sewing machine. This self-made American millionaire launched his family into European life, successfully marrying his beautiful daughter off to the Duke Decazes, the scion of a wealthy and noble French family. Daisy was thus an heiress twice over, a girl destined to be sought out by fortune hunters and aristocrats alike.

Little is known of Daisy's early life. She was born in France in 1890. Four years later, her mother committed suicide. She was raised by her mother's sister, Winaretta Singer, who, through marriage, became the Princess Polignac and was

one of the great patronesses of the arts. If Daisy's published short stories are in any way autobiographical, she was a homely and unhappy little girl whose dominant attribute was a conscious disdain for personal hygiene. Her French relatives consistently reprimanded her for her dirty fingernails. Perversely, she delighted in refusing to wash or comb her long dark hair.

When she was twenty and a bit more presentable, she married the Prince de Broglie. In memoirs, he is usually described by a single anecdote: soon after his wedding day, he took up with his chauffeur. Nonetheless, this marriage produced three daughters. Once a particularly brave guest asked Daisy about her progeny. "The eldest, Emmeline, is like my husband, only a great deal more masculine," she said tartly. "The second, Isabelle, is like me without guts. The third, Jacqueline, was the result of a horrible man called Lischmann. Now, are you satisfied?"

The prince did Daisy the favor of dying during the First World War, not a fallen hero in combat, but of influenza. His passing allowed her to embark upon what James Pope-Hennessy called "a spectacular widowhood." Her great passion during this period was for married men, the more recently married the better. One of her more renowned trophies was Duff Cooper, whom she bedded while he and Diana Manners, the reigning beauty of the day, were still newlyweds. Once a friend wondered why she chose such a peculiar hobby. "Because it annoys their wives," Daisy replied matter-of-factly.

In 1919, she found a single man and married him. The Honorable Reginald Fellowes was, like Daisy, handsome, glamorous, and rich. And although her devotion to him until his death in 1953 was legend, so was her unfaithfulness. While she added yet another daughter to her brood, her maternal instinct was practically subliminal. One morning she was walking in the Bois de Boulogne with a friend when she spotted a quartet of pretty little girls. "What lovely

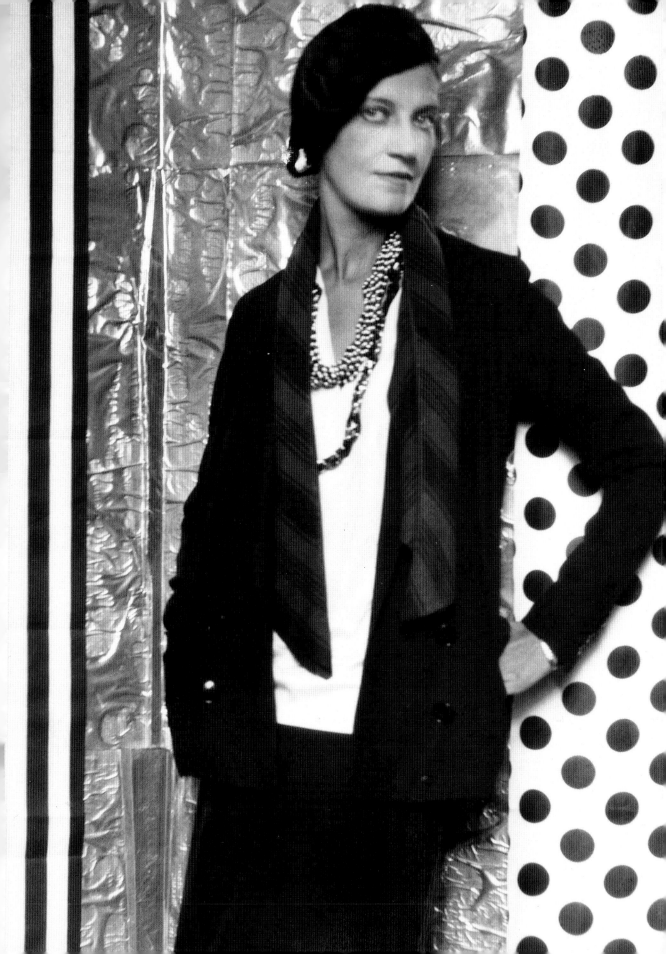

A SPIRAL SET WITH DIAMONDS
TO CLIP OVER THE EDGE OF THE
DECOLLETAGE. VAN CLEEF AND ARPELS.

AN EARRING OF CARVED
GREEN AGATE SET WITH
DIAMONDS. BOIVIN.

NECKLACE OF SAPPHIRE AND
EMERALD BEADS, CLASP
OF RUBIES. HERZ.

CLIP OF CRYSTAL, SET WITH
DIAMONDS. VAN CLEEF AND ARPELS.

LITTLE DETACHABLE BUTTONS
MATCH THE CLIP ABOVE.

MRS. FELLOWES' PIGEON'S WING OF PALE BLUE
INDIAN SAPPHIRES AND DIAMONDS. SHE WEARS
THIS BROOCH WITH A GRAYISH BLUE TWEED SUIT. BOIVIN.

dresses," she exclaimed. "We must ask whose they are." Daisy approached the nurse and said, "Whose lovely little children are those?" "Yours, Madame," the nurse replied.

Another woman might have been mortified. But Daisy cherished her own insouciance, and so there are as many stories about "the notorious Mrs. Fellowes" as there are of the style icon who, according to Jean Cocteau, "launched more fashions than any other woman in the world."

There was the time she gave a dinner party, with the guest list composed entirely of people who despised one another. She made sure to seat them so that a man's wife sat near his mistress, a divorcée next to her former husband, and a literary critic within whispering range of a writer whose book he had recently savaged.

Once, she discovered that a lover had infected her with gonorrhea. Her way of announcing this news was to telephone him and simply clap her hands repeatedly over the mouthpiece. Another lover, who fled England because he'd lost all his money and the creditors were after him, came to stay with her in Paris. There, he was greeted by two actors she'd hired to dress up as bailiffs.

Because she had a life of unlimited luxury, Daisy had more than ample opportunities to torture her friends. Her prize prison was the *Sister Anne*, a 150-ton yacht that lured a great many unsuspecting visitors to the Mediterranean each summer. Once on board, however, they discovered that the boat's magnificence did not extend to its cuisine. Daisy lived on caviar and vodka; her guests subsisted on tinned food. At some point on the cruise, Daisy would say, "I've got a treat for you. Hobbs has found a beautiful sirloin of beef onshore, and we're going to have it for

lunch." Right on cue, Hobbs produced the beef. Everyone admired it. Everyone except Daisy. "Oh, Hobbs, what a pity. It's gone bad!" she'd say, then grab the beef and fling it overboard.

Invariably, guests found reasons to go ashore and send themselves telegrams describing emergencies that required their immediate presence elsewhere. Daisy was never distressed by this news. As she once told the departing Cecil Beaton and David Herbert, "You needn't have made up all those lies, darlings, you two have stayed on this ship longer than anyone else."

Sometimes her tortures could be quite elaborate. At the Bestigui Ball in Venice one year, Daisy and her troop won first prize, but Daisy's triumph as the queen of the American Indians was less significant to her than the fact that one of her daughters had been ten minutes late for the procession. The following morning, Daisy instructed that unlucky young woman to deliver a birthday present to Princess Aspasia of Greece. The gift was the stuffed monkey that her daughter had carried at the ball. A meaningless present except to the princess, whose husband had died from a monkey bite.

These spectacular acts of sadism were at odds with her demeanor. Even at her most demonic moments, Daisy possessed the serenity of a Tibetan monk. The aspish James Pope-Hennessy was uncharacteristically kind in describing her: "When Daisy Fellowes entered a room, you noticed less her clothes and her jewels—all of which were exquisite and brought her international fame—than her poised and graceful movements and her calm. Here, you immediately felt, was someone who had herself under perfectly coordinated control."

Nowhere was this more apparent than in her self-presentation. Her frame was long and lean, her face was scrubbed to alabaster purity, her hair was cut short and slicked back. "She looked like she had been licked by a cat," a writer once observed. Her daughter Rosamond recalls her

eyes: "They were her best feature. Translucent blue, that could change to an extraordinary navy blue, especially when she was enjoying herself." But more than the color of her eyes, there was the direct stare that oozed wisdom and "an attentive amusement with life."

Her fashion sense was right in sync with her looks. Although she was long considered the best-dressed woman in the world, the honor was really awarded, in her case, for what Cecil Beaton called "her studied simplicity." For Daisy in the 1920s, that meant Chanel. But Daisy was not an acquisitive clotheshorse. If anything, she was noted for ordering the same dress in a dozen colors, or wearing the same dress, quite literally, day after day. "Any woman with taste could be well-dressed provided that, in lieu of ordering many clothes, she took enough time to be fitted over and over again," she once said, explaining her sense of fashion.

ᐬᐯ *Posing for* Harper's Bazaar, *a demure Daisy is seen through de Meyer's lens in 1925.*

But Daisy had a more daring side that she displayed as if it were as commonplace as her linen shifts. In the 1930s, she switched her allegiance to Schiaparelli, and became the designer's *mannequin du monde.* Other women also bought Schiap's famous lobster dress and hat shaped like a shoe with a shocking pink velvet heel inspired by Salvador Dalí, but when Daisy wore it, it made news. On her, this surrealistic design seemed as practical as a good mackintosh.

Daisy was part of a group of women in pre–World War II Paris known as Les Dames de Vogue. The set included Princess Jean-Louis "Baba" de Faucigny-Lucinge, the Viscountess Marie-Laure de Noailles, and Princess Natalie Paley. These wealthy and titled trendsetters dictated fashion, as Bettina Ballard observed, "by making fashionable what they chose for themselves." Of this egocentric coterie, Daisy was the leader, the supreme word in elegance and style. Her combination of contrived simplicity as well as her fondness for the extreme "simply blurred everybody out," noted Carmel Snow, the editor of *Harper's Bazaar.*

Hubert Givenchy, who worked for Schiaparelli in the late 1940s, recalls making Daisy an exceptionally simple leopard coat. It was collarless, wrapped around the body, and bunched "like the edge of a paper bag." Hours had been spent fitting it. "Some days later she breezed through the salon wearing the coat with a huge necklace of topaz flowers and flat gold shoes laced as plain as a bicyclist's," Givenchy remembers. "The topaz reflected the tawny leopard and the slash of gold shoes. But one was not conscious of topazes or leopard or gold shoes. Rather it was Daisy's love of the contradictory, her irreverent spirit that made one stare. She had gone beyond fashion to create a style of her own."

Whatever Daisy wore, others had to have. She invented the sequined evening coat that was cut like a man's dinner jacket, which she always

adorned with a green carnation. She was the first to wear a woolen dress in the evening. While other women were entertaining at home in tea gowns, Daisy greeted her guests wearing leopard-print silk pajamas.

At one point, a glove maker's saddle-stitched leather gloves were the rage among the Parisian ladies. When Daisy appeared in public wearing them, the fashion-conscious were delighted to learn that Mrs. Fellowes had, at last, given in to a trend. But after closer investigation, they realized that her gloves were only made to look like the leather version. By the end of the week, the glove maker was besieged with requests for "Daisy's cotton gloves."

For Daisy, this intense individuality was like a sport, and the object and fun of the game was to make other women appear foolish. Her choice of wearing a simple wool or linen frock on nights when she knew that other women would be dressed to the nines wasn't a fashion statement, it was social commentary. Once when Lady Kenmare, a noted hostess, gave a party in the south of France, everyone was plastered in diamonds, but Daisy's only adornment was a necklace made of corks. Her hatless appearance at the races, an event where the emphasis was on the elaborateness of a woman's hat, prompted many women to recoil in embarrassment—for themselves, not for Daisy.

As a result of her incessant pranks and her free-wheeling sexuality, Daisy had few female friends. Men were captivated by her; wives feared her. Even in uncontrived moments, her charm, wit, and looks had a defeating effect on other women. "Somehow even when only eating bread and cheese and drinking a rough tumbler

❧ *At Carlos de Bestigui's Venetian Ball in 1951, Daisy came as "America, 1750." Inspired by an eighteenth-century tapestry of the continents, she had Dior design a yellow gown with leopard-skin sleeves and train. Her headdress is made of lyre-bird plumes.*

🌱 D*aisy's bed was padded in white satin and curtained in fine handkerchief linen.*

of vin ordinaire, she would manage to do it with such finesse that other women felt they must look clumsy beside her," observed David Herbert.

Daisy would go to extraordinary lengths to maintain her status as a character of distinction. In a nightclub, she discovered a fashion rival wearing the same black tulle dress adorned with ostrich feathers. She located a pair of scissors, unceremoniously cut off the trimming, and used the feathers for a fan for the remainder of the evening.

Intoxicated by her style, Carmel Snow hired Daisy as the Paris editor of *Harper's Bazaar* in 1933. Her entrance into fashion journalism caused a sensation and did exactly what the editor intended—it put *Bazaar* on the map in Paris. Daisy's passion to shock and go against the grain made her "indirectly responsible for a

promotion that stabilized our financial position in those uneasy Depression years," Snow recalled in her autobiography. "Bearing a rose in one hand, she came to a fashion collection looking as no woman had ever dared appear in a city before. Her sunburned legs were bare, her red toenails peeped out from open sandals, and her dress was of white cotton piqué. Cotton in town? Cotton was used then for aprons, for housedresses, for children's play clothes." Snow capitalized on the attention Daisy had focused on the magazine, promoting the use of cotton to the haute couture and using Daisy to sponsor it; that, in turn, generated advertising for the magazine.

Daisy's fashion coverage for *Bazaar* allowed the masses to experience vicariously her ability to evade the commonplace. In her first column, she announced that "clothes are more important than ever, as nudism is definitely out. It went out too much and got lost in the great open spaces. Even stockings have turned against the nudists, and people (I am one of them) are wearing a dark shade that does not imitate anything human, however sunburnt. If this color did have to have a name that reminded one of oneself, it might be *bruise*—as it has that violet tinge that happens on the second or third day of a bruise."

About furs, she wrote: "Isn't it time you were letting the poor wee things out for an airing? When you do, you'll probably find they look a bit drab. Of course they do, they're just plain bored, that's all; and it's not to be wondered at if they have been doing a sister act round your neck since goodness knows when. It's time you let them off. Give them the run of your whole body. It'll take years off their age."

For the autumn collections of 1933, she had this to say about Mainbocher: "I am afraid that Mainbocher's uneven hemlines, short in front, dropping down at right angles in the back, were a mistake. There are maniacs in London who go about in buses and the tube cutting chunks out of other people's clothes. These skirts look

rather as if the maniacs had been at them."

And she shared her fashion philosophy with *Bazaar* readers: "Fashions have a volition of their own. They don't move with the times, they move ahead, occasionally glancing back, but they keep moving; this is what very few women realize. They cannot imagine that the perfect garment which they have just seen will one day appear absurd. Yet it is this absurdity which is the hallmark of a good fashion, for fashions must be absurd. A good fashion is a daring fashion, not a polite one."

*Bazaar* readers had the privilege of her breezy, personal style of writing, which would set the standard for eccentrics to follow, most notably Diana Vreeland. But Daisy quit after two years. She had grown bored with her work and perhaps resented it when editors had the audacity to make changes in her copy.

There was one area where Daisy remained extravagantly consistent—her jewels. Her collection of jewelry represents some of the most important work designed during the 1920s and 1930s. On her travels to India she acquired gemstones and, on her return to Paris, had them constructed into pieces with barbaric motifs—emerald handcuffs, exotic necklaces of Indian stones, and conch shells of diamonds. She was one of the first to order Jean Schlumberger's naturalistic diamond leaves, which became so popular in the thirties. Of course, Daisy created her own twist to the branch by adding a fresh flower.

Boivin, Herz, and Van Cleef & Arpels all designed for Daisy, but Cartier was her real passion. And it was from Cartier that she purchased the seventeen-carat pale pink diamond known as the *tête de bélier* (ram's head), which Potemkin supposedly gave to Catherine the Great.

Her jewels were Daisy's one concession to balance. Everything was ordered and worn in duplicate: "Why unbalance your hands and arms?" She was, however, never lacking in her sense of fantasy, and she worked closely with her favorite

The view from Daisy's sea-green glass dining room. The curtains were made of glass beads.

designers to create baubles that would adorn only her arms, hands, or lapels—a jeweled boutonniere that was a butterfly of emeralds and topazes, a pigeon's wing of pale blue Indian sapphires and diamonds, a gold and topaz brooch made to look like a bishop's crook. Daisy's originality was coveted by jewelers. Binoculars at the ready, they would eagerly await her appearance at the theater or opera so they could study her jewels and promptly go back to their workrooms to recreate them.

Unlike many women of her era whose clothes were backdrops for their jewels—Mona Williams and the Duchess of Windsor, to name just two—Daisy's clothing and jewels were complements to one another. When the designer Suzanne Talbot made her a pair of long black lace gloves, Daisy was inspired to rush off to Cartier to have

matching diamond bands made to hold the gloves up. Jewels for Daisy were simply a part of life—she even wore them with swimsuits. And her passion for restrained elegance often reached epic proportions, for she was known to have her emeralds and rubies ground down to look as if they were plastic beads from Woolworth's.

Although Daisy is considered to be one of the most luxurious-minded women of this century, she had an absurd love of the deeply ordinary. She preferred to wash her own stockings. During World War II, when she and Reggie Fellowes left France and fled to England, she turned the wartime rationing and scarcity into a playful treasure hunt by scouring London's cheapest department stores and then unearthing drop-dead chic trinkets at bargain basement prices. At Donnington Grove, her

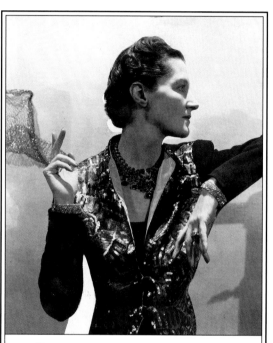

❧ *Daisy wears a Schiaparelli jacket for this 1934 Beaton sitting.*

English country house in the Berkshires, the historian and diarist James Lees-Milne noted, "For so sophisticated a woman, Mrs. Fellowes has simple country tastes. She keeps a cow which she likes to milk herself, when she is here. She asked someone the other day if the cow would mind her going to Paris for a long weekend without being milked during her absence."

And although she lectured on Joan of Arc, she had a particular fondness for the oeuvre of Zane Grey, the American Western novelist. She adored Laurel and Hardy films dubbed into dreadful French. Her favorite field trip when cruising on the *Sister Anne* was to pull into a remote coastal town and dine in the seediest restaurant on the wharf. For these occasions, she never altered her dress code. She'd arrive in one of her white linen shifts, sit on the dirty seats, and relish the rough red wine and peasant food. Then, as she got up to leave, she'd brush the dirt off her dress and say, "Once again, badly dressed."

Daisy's contradictory penchants for the elegant, the exotic, and the ordinary were nowhere more evident than in her houses. The Paris house in Neuilly that she had bought before the war was one of the most glamorous of the day. It was a small mansion, once the *petite folie* of the Duke d'Artois, who had been the playboy brother of Louis XVI. There she ingeniously created a 1930s hard, chic, modern palace while still preserving its classic essence. She chose the architect Louis Sue to streamline this house and turn it into a space suitable both for simple living and elaborate entertainment. Her reasons for selecting Sue, however, may have had less to do with talent than with personal attractiveness. Disillusioned by a famous fat architect whose plans were as large as his girth, she told him, "Your weight is your first error. If this house is to be as I have dreamed it, the architect must be young, handsome, tall, intuitive." Sue

❧ A *1933 sketch by Jean Cocteau for the frontispiece of Daisy's novel,* Les Filles du Diable.

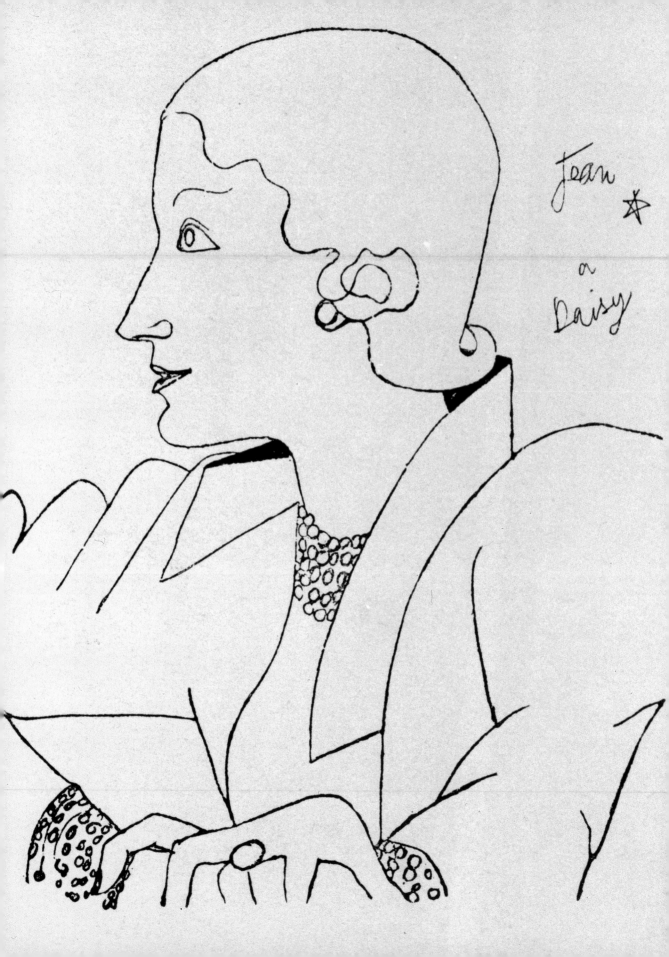

Jean ✪
a
Daisy

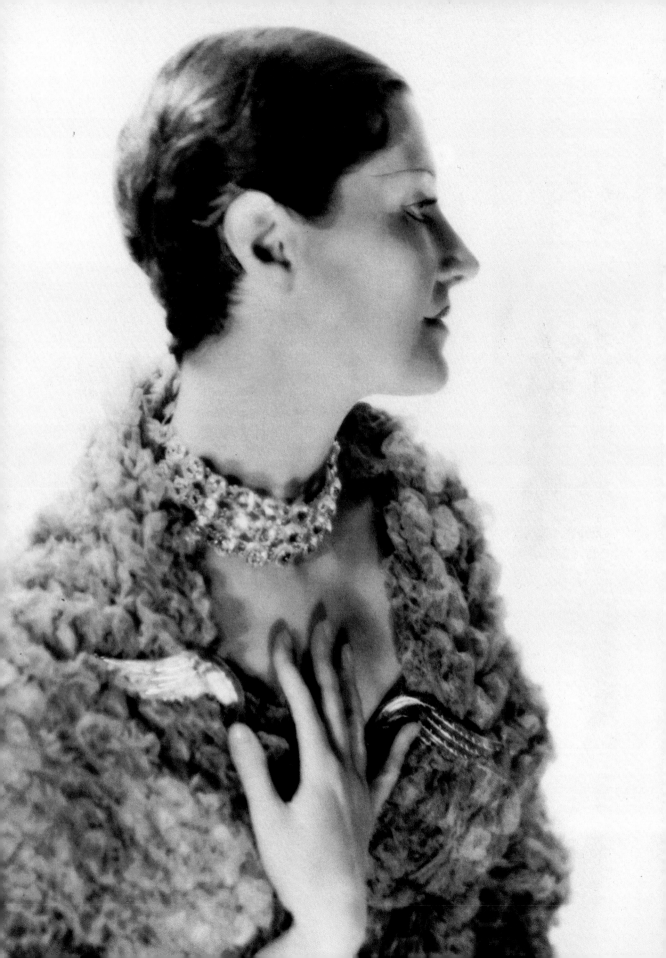

was youthful, good-looking, and had a dash of Daisy's spirit.

The house was as multifaceted as Daisy, with a grand salon that could be converted into a music hall, a cinema, a theater, or a winter garden. The dining room shimmered with modern glass. In fact, everything that could be made of glass was—tables, candelabras, and arched doorways set in frames of green glass made by Lalique and lighted from within. The central focus of the dining room was the enormous arched window that overlooked the garden. The reflection from the different surfaces, archways, and the garden made the room shine pale green and silver.

The garden itself had metal-tube sculptures that had been created for Daisy by her friend Jean Cocteau. These sculptures were molded into different forms, one of which was a woman designed to be a target, complete with a bull's-eye for trapshooting.

This house was the scene of one of the most memorable fancy dress balls of the 1930s—Le Bal Oriental. The fountain in the garden splashed perfumed water. Nearby were white palms carved of plaster and a golden ripe banana tree. Indian servants passed trays of rare and exotic fruits. For this soiree, Daisy was dressed as a Chinese princess in a stiff white satin gown with a mandarin collar created for her by Schiaparelli. Antoine, the famous hairdresser of the era, shellacked her hair black and garlanded it with blue-black lacquered leaves.

Even Daisy's more mundane entertaining was memorable. Carmel Snow recalls a lunch that was unforgettable for its sheer simplicity: "Lunch was served at a modern bar in the reception hall, where great doors led into the garden. The food was delicious, very simple and French —I remember boiled eggs in their shells appearing in a basket wrapped in a beautiful white linen napkin."

Among the houses that Daisy collected was Les Zoriades, in the south of France. It was here that her love of the exotic may have got the better of her; this house was considered by many a discerning eye to be hideous. "A rather ugly house," recalled the English designer and collector Rory Cameron,

*but one was never given a chance to become aware of its failings. Here she reigned supreme in her exoticism—simulated leopard-skin carpets put down long before the decorating world had become conscious of Africa's fauna, mirrored balls hung in clusters filling the stairwell. Great comfort, delicious food, and always the unexpected, the contraption for instance in which coffee was sometimes served, an object brought back from the Bosphorus: a kind of suspended glass beaker with an iron stopper at one end up against which one had to press one's cup in order to have it filled. "So amusing," Daisy would pipe. It was, in fact, hideously ugly, decorated with vine tendrils hammered out in black iron, but that it was seen in Mrs. Fellowes's possession somehow exonerated it.*

Right up to the end of her life, Daisy maintained a passionate interest in the decoration of her Georgian Gothic manor in England, the pied-à-terre in Venice where she lined her boathouse with Tiepolo drawings, and her final nest in Paris, a *hôtel particulier* on the rue de Lille. It was here, in 1962, that the Honorable Mrs. Reginald Fellowes, age seventy-two, entertained that most unwelcome visitor, death.

The passing of a woman of style is often followed by the transfer of property and the auctioneer's notice. This was not the fate of Daisy Fellowes's belongings. Although Amyn Khan, brother of the Aga Khan, bought the house on

*◈ Daisy was one of Beaton's favorite subjects. He was enchanted by her "unparalleled air of slickness."*

the rue de Lille, other properties remained in the family. As for jewelry, only one piece has ever been auctioned: a necklace of diamonds and other gemstones that Cartier designed for her after a trip to India in 1936. It sold, in 1991, for three million dollars, almost as much as the entire jewelry collection of Mona Williams had sold for in 1984.

And though it is her lifestyle that continues to fascinate, the most memorable part of Daisy is the character who so adored luxury. She often said that she wished she had been born a man —she would have loved to shape events. As a woman, her sphere was more limited. In her time, the most she felt she could do was affect other people.

People remember the endless stories that illustrate her sadistic side, yet she had some sterling qualities. Soon after her marriage to Reggie, his partner in his stockbroking firm ran off with all the firm's money. Daisy gave her husband a significant share of her inheritance to prevent bankruptcy and to make sure his clients didn't lose their investments. And she never belittled the title he held for the rest of his career: assistant manager of the Paris branch of Lloyd's Bank. Reggie suffered from a heart condition and by World War II was an invalid confined to wheelchair. Later, both of his legs were amputated. To her credit, Daisy was the epitome of the loyal wife, faithfully attending her husband until his death.

She was equally attentive to Gwen Fargo, a shy and introverted American woman who became one of her few female friends. Like Daisy, Gwen had a nose that spoiled her features. Daisy, recalling her own happy experience with plastic surgery, treated her to a nose job. Gwen emerged devastatingly pretty, and a wealth of previously hidden charm bubbled to the surface.

A few other women discovered a discrepancy between the legend and the woman. Reinaldo Herrera, the scion of an aristocratic Venezuelan family, remembers going to dinner at Daisy's in the south of France. "She asked if I would bring a woman to even out the numbers. I invited Peggy Scott-Duff, a nice attractive young girl. Peggy knew of Daisy's reputation for being a horror to other women, so she was a bit nervous about accepting my offer. That night, Daisy was wearing a white dress adorned with beautiful diamonds. While we were chatting, someone bumped Peggy's arm and her glass of Dubonnet spilled all over the front of Daisy's dress. Peggy froze in panic—she was absolutely terrified. Before she could make her apologies, Daisy breezily said, 'Oh, it's much *better* like this, white is such a *boring* color.' "

By then, old age had softened and sweetened Daisy's character. Since World War II, she had lost interest in clothes and considered herself a writer. Her five books may not have outlived her, but they were, in her time, read for their wit and whimsy. And Daisy was ahead of her time in one more area—as she had with her *Harper's Bazaar* salary, she gave her book royalties to an orphanage.

Her choice of artists for a final portrait is telling, for she chose Graham Sutherland, whose strongest suit was truth. In this portrait, which Sutherland was still working on when she died, Daisy is incontestably a woman of a certain age —and at complete peace. Lightly lined and wrinkled, wearing a watch and a simple necklace, Daisy reclines on a bamboo chaise. Her gaze is away from the painter. She is looking thoughtfully and calmly toward what might be her future.

Sutherland's is the ideal portrait of a woman who was both of her time and ahead of it. What he captures is not style but intelligence. In that light, Daisy Fellowes was not an ephemeral creature, she was a woman of substance.

*Wearing Molyneux at her office in London during the 1940s, when she was the president of the Society of London Fashion Designers.*

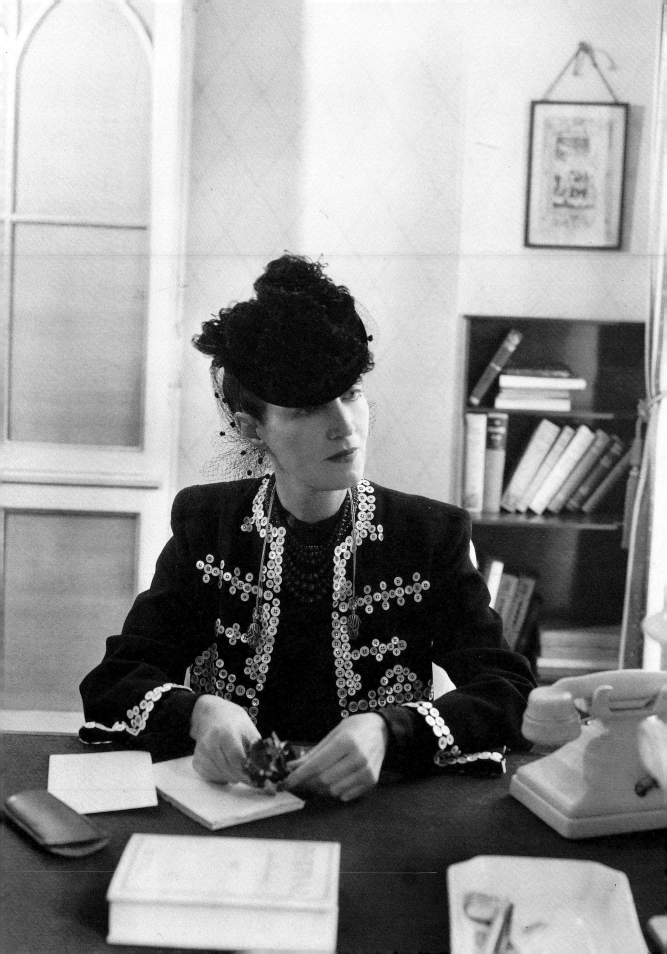

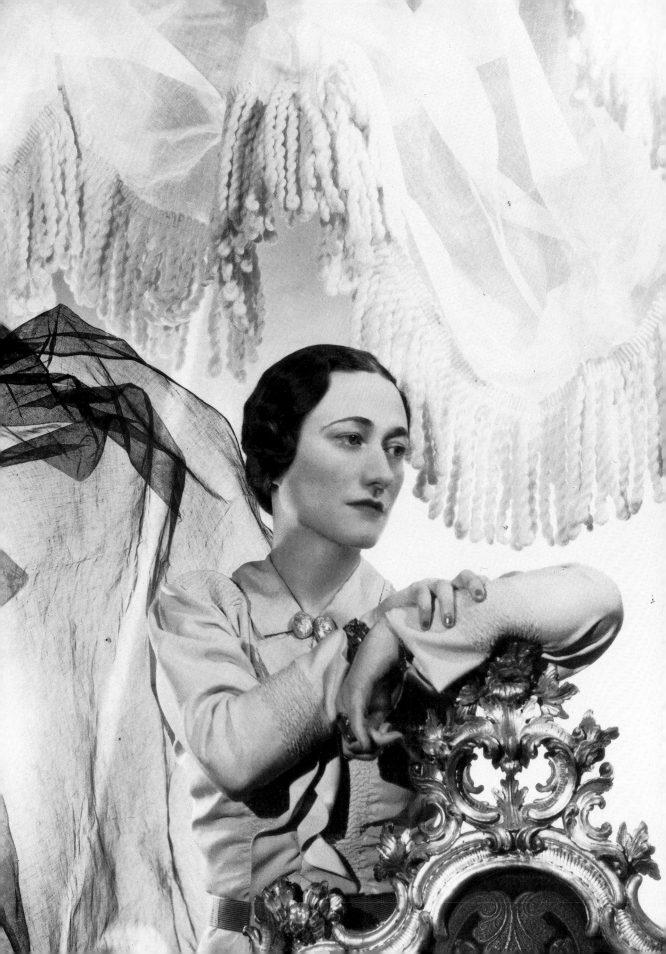

# Duchess of Windsor

## "Mine is a simple story. It is the story of an ordinary life that became extraordinary."

The Duchess of Windsor wrote this as the opening lines of her autobiography. The lady doth protest too much. Hers is a remarkably complex story, practically a labyrinth of psychological twists and societal turns. In its endless retellings, it has become immensely popular. Cinderella stories always are. But it is patently unbelievable, an operatic version of a life that, on close inspection, seems small and drab. The Duchess of Windsor was, in fact, the most famous housewife in history.

❧ *In 1935, Wallis posed for Cecil Beaton, who would become her official photographer.*

That Wallis Warfield would crave home and hearth might have been predicted, for she was born out of wedlock in 1896. Her parents, both from genteel Baltimore families, married a few months later, blunting the scandal. When Wallis was a year and a half old, her sickly and passive father died, and she and her mother found themselves living in a residential hotel in greatly reduced circumstances. For the next few years, her mother supported them by working as a dressmaker. It was her generous Aunt Bessie who later rescued them and paid for Wallis to attend an exclusive girls' school. But that return to comfortable circumstances was blighted by Wallis's difficult home life. Once again, her mother had married a weakling. This time her choice was a lazy alcoholic riddled with liver and kidney ailments.

It's completely unsurprising, therefore, that Wallis would seek in a husband a protector, only to discover that she had married a child. And it makes sense that in this marriage her overriding preoccupation would be to create such perfectly regulated domesticity that reality could never intrude. And, finally, it is fitting that the woman who is sometimes regarded as the very emblem of twentieth-century style should be nothing more than its ultimate student. The Duchess of Windsor was the Madonna of her time: attentive, calculating, relentless.

How did she do it? Certainly not through beauty. When she arrived in London as the wife of the stolid Ernest Simpson, she was, as Cecil Beaton noted after meeting her in 1930, "brawny and raw-boned in her sapphire blue velvet." Lady Thelma Furness, then mistress to the Prince of Wales, saw no threat in her friend. To her, Wallis had ugly hands, a round face, dowdy clothes, a loud shrill voice, and the aura

of a nanny. But Wallis was nothing if not attentive. She went to school on her betters, observing their dinner parties, their clothes, their repartee. First, she replaced her loud voice with a soft southern drawl. She then found the best cook in London, mastered the art of making men shine in conversation, and learned how to use her personality to minimize her physical flaws. "I liked her immensely," Beaton remarked when he next met her, in 1934. "I found her bright and witty, improved in looks, and chic."

Enter the Prince of Wales. Until Wallis came along, dinner with the heir to the English throne was a jejeune affair, low in conversational nutrition. Guests routinely deferred to him, only to discover that he had nothing to say. Wallis, however, knew how to throw a topic up in the air and then let the more informed guests take over. So while she would never have consciously represented herself as a great individualist, she was just that to him. What she offered as wit, he took as substance; in his love of all things American, he regarded her willingness to speak up, and even better, to disagree with him, as a touchstone of character.

In addition to her conversational skills, Wallis had other allures. Allegedly using sexual techniques that it is said she learned in Chinese bordellos, she satisfied the prince's idiosyncratic sexuality. And she drew on her friendships with German leaders to sanction his fascist sympathies. Her charm, however, was completely lost on the English public. In photographs taken at the height of their romance, her eyes were pinholes when she smiled, and her nose seemed to have been broadened in a barroom brawl. But no matter. Wallis had a constituency of one. And to

*Man Ray's portrait of Wallis appeared in British Vogue in 1935, when she was still Mrs. Ernest Simpson.* FOLLOWING PAGES, LEFT: *The duke and duchess dancing at the Waldorf Astoria.* RIGHT: *In later years at their country house in France.*

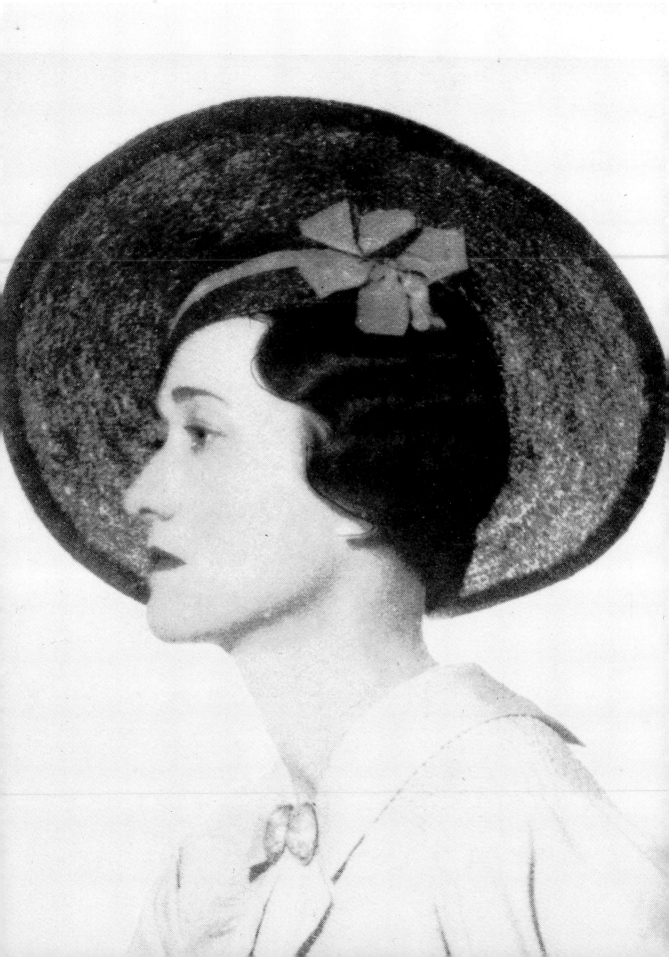

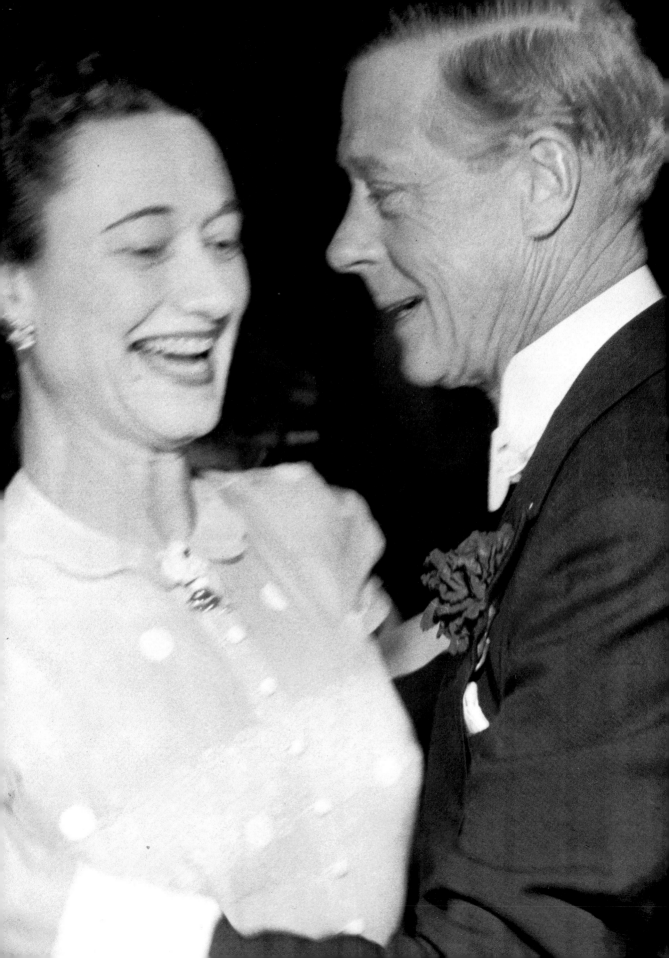

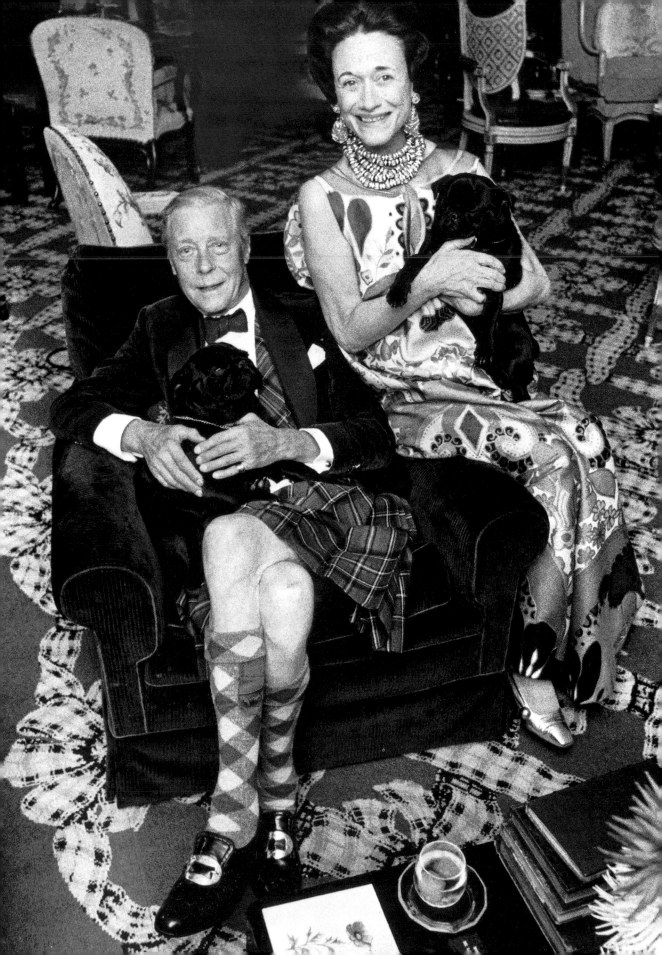

the prince, she was indispensable—like a nanny.

Her real career began in 1936 when the prince, having recently become the King of England, decided he would rather marry his jewel than wear a crown. Now, as the exiled Duke of Windsor, he became an oddity: a royal trained only for a ceremonial position he would never occupy. If ever a man could be said to be unemployed—or unemployable—he was. And so he found occupation solely as Wallis's husband, burdening her with an attentiveness that would test even the strongest marriage.

Shortly after the marriage, *Vogue*'s Bettina Ballard and the photographer Horst went to Paris to do a story on the world's most celebrated couple. At the Windsors' suite at the Hotel Meurice, Horst set up his lights and Ballard opened her notebook. No one appeared, so the journalist and the photographer decided to have a good snoop. They found not a single magazine and only one book, *Fur Trading in the Reveillon Family*. But they did come upon one leather dispatch box which spoke volumes. In gold letters, it announced, very simply, THE KING.

The duchess's approach to her marriage was always to make the duke feel that he was still the

king. "My husband gave up everything for me," she told Elsa Maxwell. "I'm not a beautiful woman. I'm nothing to look at, so the only thing I can do is dress better than anyone else. If everyone looks at me when I enter a room, my husband can feel proud of me. That's my chief responsibility."

She set about that task with steely determination. Fortunately, before her marriage to the duke, she had acquired an indispensable ally in Elsie de Wolfe. The decorator and hostess not only taught Wallis what kind of clothes to wear, but who designed them. She introduced Wallis to Schiaparelli and Mainbocher, the couturiers whose style would become synonymous with the future duchess's. And because Wallis's physical type was similar to Elsie's—petite and slim, with slender hips and a flat chest—she adopted Elsie's high-polished simplicity.

When Wallis became the Duchess of Windsor and settled in Paris, she turned to Elsie for advice on entertaining. Her funds were comparatively

❧ ABOVE LEFT: *Memories of a king: The royal dispatch box held by a footman in day livery designed by the duke.* ABOVE RIGHT: *The duke's dressing table.*

limited, but by adopting Elsie's clever techniques —the use of mirrors, an abundance of flowers, and a few significant pieces of furniture—she created an effect of great splendor. Although she was renowned for her delicious southern-influenced American food, she still turned to Elsie for advice. Soon enough Wallis was following Elsie's "You can't build a meal on a lake" credo, and the duchess's aversion to serving a soup course became as well-known as Elsie's hatred of it. And in time, Elsie's signature words-of-wisdom-embroidered throw pillows could also be found resting cozily in the duchess's drawing room. There was one lesson, however, that Wallis was temperamentally unable to absorb: unlike Elsie, who never denied her penchant for a touch of vulgarity, Wallis was slavishly devoted to rigidly perfect entertaining.

In his new life, the duke spent his days playing golf or engaged in such intellectual activities as organizing a filing system in the pantry for china and glass. The duchess was more of a careerist. To please her husband, she set out to become one of the best-dressed women in the world, and for ten years in a row, she was. This was accomplished not only by the purchase of more than a hundred dresses a year, but by an astute sense of makeup and hairdressing. If Antoine of Paris is to be believed, she had her hair done three times a day—once in the morning before donning a little hat, again

❧ *Wallis in a relaxed moment at Château Croé in Cap d'Antibes.*

in the afternoon before the races, and in the evening before going out.

All this work translated brilliantly for the camera. By 1936, Wallis had lost weight and now had a model's measurements: 34–24–34. She learned to smile less in the presence of photographers. She believed she had unattractive hands, so she hid them. She knew her best angle and showed it. The result was dazzling in its severity. "The duchess gives the impression of terrific neatness, not a hair out of place, not a line awry," Helen Worden wrote in the early 1940s. "Her slip never shows. She looks like a period room done by a furniture house, a room in which nobody can live comfortably. Figuratively speaking, there are no ashes on her rugs, no papers lying around, no blinds askew."

For all that, the duchess liked to say that she wasn't really interested in clothes or fashion. "I'm far more interested in housekeeping," she insisted. She missed, of course, the irony of that protestation—her idea of housekeeping was worlds away from the everyday chores of the women who read about her. In her home, dinner began exactly at nine. Napkins were changed twice during the meal. During the day, she walked around with a little book in which she made notes about imperfections in the running of her establishment. As one of her personal maids put it, "Her Highness is a most orderly and downright pedantic person."

But not, however, a substantial one. She was never a patroness of the arts, or a friend or benefactor of a hospital or orphanage. She did not read. She didn't enjoy music or great art. She adored flowers but not gardening. Her idea of exercise was dancing or strolling with her pugs. She did not even crochet. During the war, Elsie de Wolfe suggested that a good to way to win friends in her adopted country of France would be to volunteer her services. The handmade woolen items she distributed to the French troops, though, were actually made by the duke, who had long ago adopted crocheting and needlepoint as hobbies.

Wallis's concerns lay elsewhere: the phone, a daily massage, a manicure, the hairdresser, the endless wardrobe fittings, the challenge of organizing a dinner party and seating it correctly. Her hobbies pertained to all matters social—people, amusing conversation, parties, food and wine. But above all else, it seems her real devotion was to planning the duke's day, week, and month.

"She had no personal life of any kind," confirmed Johnny de Faucigny-Lucinge. "She was like Scheherazade, she constantly had to keep the duke busy. When he wasn't playing golf or lunching with a friend, there was nothing. Once I went to visit them in the south of France and I arrived a little early and was waiting in the main hallway for them to appear. I happened to steal a look at some papers lying randomly on a table.

❧ The day before the historic wedding at Château de Cande, 1937

I noticed a typed-out itinerary of his daily schedule that consisted of rather ordinary and mundane things. As the heir to the throne, he had been brought up to live by schedules. Wallis had one typed out every day to give him a sense of purpose."

There is a persistent underground rumor in certain social circles that the Duchess of Windsor was really a man. In a symbolic way, that rumor expresses the fundamental truth of her relationship with her husband, for in a sense she was the dominant figure and he was a mere consort, following her even to the dressmaker's. You can see it in the paparazzi photos—he's the one trailing behind her. How perfect that a woman who was undoubtedly dazzled by power and by authority would end up with a Milquetoast for a husband.

The only way the duke found to adequately express the feelings he had trouble acting on was to shower her with one-of-a-kind jewelry. So great was the duke's love, in fact, that he stated in his will his wish to have those jewels removed from their settings after Wallis's death, lest her pieces be collected and worn by lesser women. That was the only wish of his that the duchess seems to have countermanded. This was fortunate, for in death, she accomplished something: the terms of her will stated that her jewels were to be auctioned off for the benefit of the Pasteur Institute. That auction, held in 1987, produced

Beaton found her face difficult to draw.

"Clothes should be so simple and unobtrusive as to seem unimportant," she said.

Napkins were changed twice during dinner.

Her interests were housekeeping, dancing, walking with her pugs.

Elsie de Wolfe was a powerful influence on her sense of style.

The drawing room in Paris.

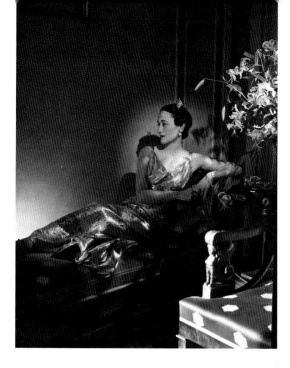

fifty million dollars for AIDS research, a more than respectable legacy for a lady of leisure.

Her life, though, provides a cautionary tale. She landed the man she wanted, and then had to devote the rest of her days to him. Hers was a velvet prison, an entire existence devoted solely to the art of living. She is a monument to the ephemeral, a woman without an interior life. Like her husband, she sought to fulfill an image. Like him, she was all style and no content.

Although the Duchess of Windsor may, as a person, be less than meets the eye, she nonetheless deserves inclusion in any book on twentieth-century style. Her passion for imagery over substance anticipated what style would become for certain highly publicized women in the latter half of this century: synthesis rather than originality, acquisition rather than creation. But give her this: she also never dropped the mask, never shared an indiscreet confidence, never dishonored the memory of the greatest media love story of the twentieth century. To the end, she was what she most wanted to be: a lady.

*Posing for a portrait by Horst in her suite at the Hotel Meurice. RIGHT: Noted French photographer Roger Schall took this picture as Horst prepared to shoot the memorable image above.*

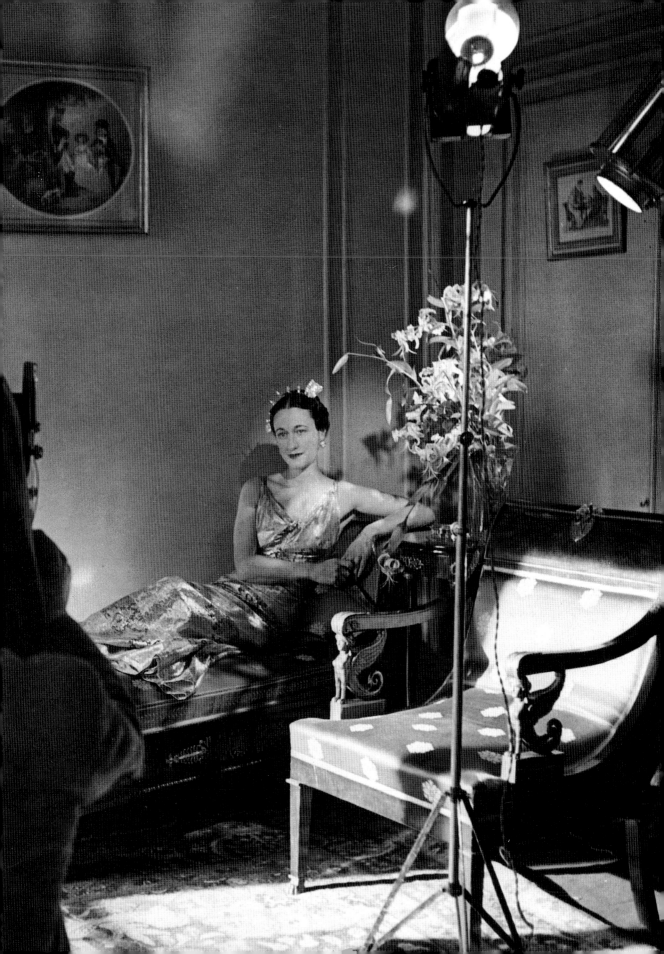

"SHE WOULD COME TO MY STUDIO FOR A FITTING

# Mona, Countess of Bismarck

AND STAND BEFORE ME TOPLESS," GIVENCHY RECALLS.

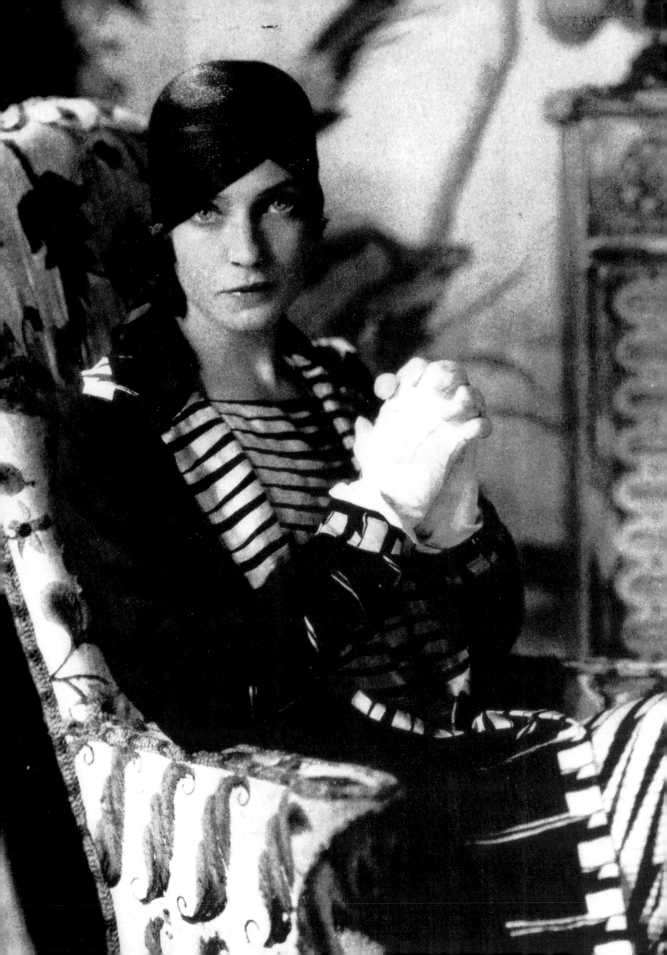

I was so embarrassed that I would try to throw a piece of *mousseline* over her, but it would fall off. Finally, I would leave the room and smoke a cigarette. Mona had the most beautiful body. Her lingerie was gorgeous. Eventually, I'd return and we'd finish the fitting. After she dressed, she'd look in the mirror, run her little tortoiseshell comb through her short, perfect hair. Then she'd take her famous pearls —she wore them like a scarf—and wrap her neck and wrists in the most stylish way. I'd take her down to her waiting car and when she left I'd always sigh in amazement. The charm of her face, her enchanting gestures . . . she was so beautiful. Everything she did had allure."

Mona Williams, who ended her life as the Countess Bismarck, was born with only her beauty and innate charm. As Mona Strader of Louisville, Kentucky, she was the daughter of a manager of a horse farm, although there were those who said her father was really a groom. In any event, her circumstances were modest, perhaps even sad. Her parents separated when she was five, and she remained with her father. Although her formal education was scant, the grandmother who raised her gave her a classic southern young woman's training in manners and housekeeping. She also gave Mona some prophetic advice: "You must learn to do everything because one day you may have to explain it to others."

That advice became useful in 1917, when Mona was just twenty. The bridegroom was wealthy, socially prominent, appreciative, and, not surprisingly, familiar: Harry Schlesinger, thirty-seven years old, and the owner of the horse farm where her father was employed. Mona, he thought, was "the prettiest thing I ever saw," so he simply swept her up and took her back to his

*❧ When Steichen photographed Mrs. Harrison Williams in 1928, she was, noted Vogue, already "very well known for her chic and great beauty."*

primary residence in Milwaukee. That city and that marriage held little allure for Mona. Two unhappy years and one son later, she was once again single, having traded her infant son to Schlesinger in exchange for a settlement of half a million dollars.

In 1920, armed with a wealth of social connections and the cash to run with them, Mona moved to New York. She was, a columnist wrote, immediately "caught up in a whirl of fashionable parties." A year later she made her second marriage, not to any of the gay blades she met in Manhattan, but to James Bush, with whom she'd had a brief affair while still married to Schlesinger.

Bush, a wealthy banker, was better known in some circles as "the handsomest man in America." His charms began and ended there, for he was also a rowdy drunk, whose favorite activity at parties was urinating in the fireplace. After three years of this, Mona fled to France and filed for divorce.

When Mona returned to America in 1926, she astutely recognized that society, even in the morally forgiving flapper age, had scant tolerance for multiple marriages. This time, she established herself more solidly in New York's social circles and began the quest for what she imagined would be her third and final husband. She became known for her alarming beauty, an expensive and exquisitely chosen wardrobe, and her ability to listen attentively to the monologues of her dinner partners.

To occupy and amuse herself, Mona, along with her friend Laura Curtis, opened a fashionable dress shop. This business was immensely profitable, at least for Mona. As it happened, Miss Curtis was engaged to Harrison Williams, who was both rich as Croesus and delightfully old. As she was going off to Paris on a buying trip for the shop, she asked her partner to look after her fiancé. And Mona did. Laura Curtis returned from Europe to discover that Mona

Gardening at Il Fortino.

Mrs HARRISON WILLIAMS reads to her Guests

A Beaton illustration
accompanied an article about
Palm Beach that he wrote
for Vogue in 1929.

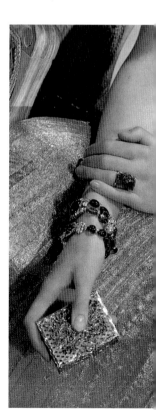

Painted in rags by Dali.

Her jewelled
cigarette case
once belonged
to Louis XIV.

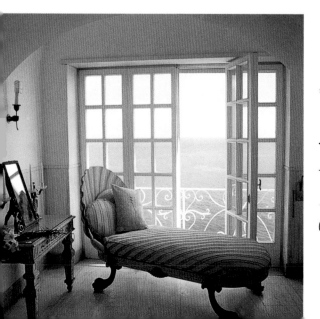

An embracing view
of the Bay of Naples
from one of the five
terraces at
Il Fortino, Mona's
Capri retreat.

"Fascinatingly beautiful, like a rock crystal goddess", Beaton wrote.

"What do I care If Missus Harrison Williams is the best-dressed woman in town?"
— Cole Porter, "Ridin' High"

Mrs Harrison Williams
BY
Cecil Beaton

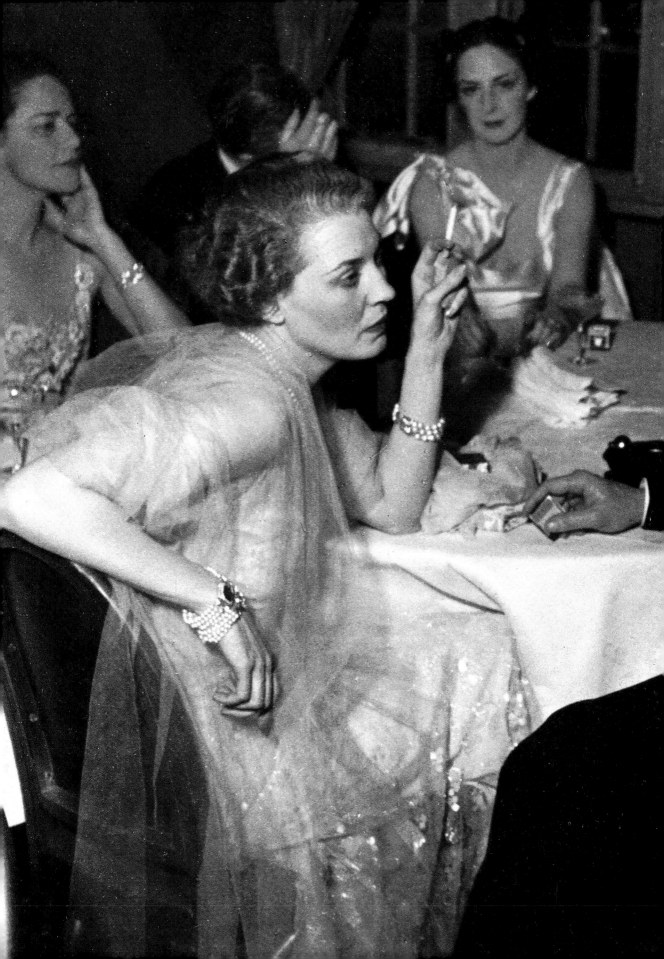

Strader Schlesinger Bush and Harrison Williams were about to be married.

Williams, twenty-three years older than his bride, was a catch and a half. Said to be the richest man in America, his origins were, like Mona's, downright humble; he started out as a streetcar conductor and gradually worked his way up to manager of a tricycle factory in Ohio before setting off to seek his fortune. In the 1920s, he was a prescient investor in the electrical power boom and the beneficiary of a dazzling series of successful stock manipulations. His fortune, in pre-Depression dollars, was estimated at $700 million.

The marriage of the "utilities king of America" to his fiancée's business partner was, the *New York Times* reported, "a complete surprise to Mr. Williams's friends and to New York social and financial circles." Harrison Williams was, after all, known for his cynical humor, disdain for social trappings, and his single-minded passion for Wall Street. It was widely assumed that his head had been turned by a cool-eyed operator who shared his passion for money. In the ensuing scandal, many took the side of the jilted Laura Curtis.

The around-the-world cruise that Harrison and Mona embarked on almost immediately after their marriage did nothing to quiet the talk. At that time, Williams was the owner of the *Warrior*, the largest and most expensive pleasure boat in the world, with ten staterooms, a crew of forty-five, and a purchase price of three million dollars. This trip was lavishly chronicled, and all America was encouraged to think of Mona as a fairy princess.

This image was confirmed in 1927, when Mrs. Harrison Williams opened the doors to her thirty-room brick Georgian house on Ninety-fourth Street and Fifth Avenue. The luxury and

☙ T*he Toast of Society. Mona, then Mrs. Harrison Williams, in deep conversation as socialites look on.*

☙ 111

extravagance were dazzling. The furniture was English, a novelty at that time. The rooms were lined with paintings by Reynolds and Goya and Boucher, and filled with masses of white flowers imported from her own greenhouses. The entire house staff seemed to have worked overtime to prepare for Mona; every surface was polished, buffed, or waxed to a brilliance that indulged her obsession with cleanliness and perfection.

Whatever the New York upper crust had once thought of her no longer mattered; everyone scrambled for invitations. The attraction wasn't only what Mona had bought, it was Mona herself. Her eyes were "pools of magic" —vast, aquamarine, and almond shaped. Her hair was prematurely silver, her figure flawless, her posture perfect, her skin reminiscent of a Vermeer maiden, her features "faultless as Garbo's."

Mona's goddesslike beauty was heightened by her manner. Wealth had only made her more gracious, and although she quickly replaced her Kentucky drawl with an English accent, she was wise enough to know she would never be as witty or as intellectually accomplished as her new friends. The quiet charm that won Williams was now turned on the highest levels of New York society, and her salon soon became the central meeting point for "the only crowd in New York evenly divided between clever men and fashionable women."

Unrivaled wealth, a regal style, and physical attractiveness made the Harrison Williamses the most glamorous couple of the twenties and thirties. Where they went, what they bought, or what Mona wore was a delicious subject for the press all across the country. Mona and her Midas were characterized as "the epitome of the American dream."

In 1930, for example, after Mona had gained acceptance into the inner sanctum of Palm Beach society and reached the first peak of her social career, the social columns of newspapers across the land noted that she made her first appearance there wearing a necklace and a bracelet encrusted with 129 square-cut sapphires, 144 square-cut emeralds, 762 small round diamonds, and 79 pearls. But Mona didn't overreact; she knew exactly how to play her part. When a writer stopped her at one of her lavish Palm Beach parties shortly thereafter and asked if she was satisfied with her life, she tactfully replied, "Is anyone ever satisfied?"

What Mona would never have confided—especially to a writer—was that money allowed her to move effortlessly from satisfaction to satisfaction. For the next three decades, she was a fixture in *Vogue*, *Harper's Bazaar*, and *Town and Country*. Her beauty, her clothes, and the decoration of her houses were endlessly written about, photographed, and sketched. Hers was perhaps the first private life to be shaped and pitched for public consumption.

Cecil Beaton, a frequent visitor to their Palm Beach estate, captured Mona and Harrison Williams in their living room in 1937.

So society—as well as a great many followers of society—was well aware that, in 1933, Molyneux and Lanvin and Vionnet and Lelong and Chanel got together and voted Mona the best-dressed woman in the world. She was the first to acquire this label, and she would prove herself equal to it for the rest of her days. Her credo was inconspicuous elegance, and she achieved this by choosing the subdued, clean, and sparing silhouettes of Charles James, Mainbocher, and Balenciaga. Ultimately it was Balenciaga whose style was synonymous with Mona's. In 1968, when it was announced that he had closed the doors of his atelier, Diana Vreeland was staying with Mona in Capri. "Mona didn't come out of her room for three days," Vreeland recalled. "She went into complete shock; it was the end of a certain part of her life."

"She never orders the 'successes' in a collection," Vogue noted, "but instead, the costume which is noticeable only on second glance." At a time when black was the fashionable color, Mona rarely wore it until at least the late afternoon. She favored white and made it her signature color. "In Palm Beach, clad in tailored white silk shirts, impeccably tailored white shorts, her slim waist encircled by a gold kid belt and with gold kid sandals on her bare feet, she was a dazzling figure," recalled Vogue's formidable editor, Edna Chase. This pared-down, almost minimalist approach to clothes paid particular dividends in the evening, when her tasteful monochromes provided a backdrop for her amazing collection of jewels.

Mona's popularity went way beyond fashion —she attained a glamour that was usually considered the exclusive province of movie stars. Everyone knew she hired Syrie Maugham to create one of the first all-white drawing rooms in America, she lined white material with pink fabric so a little warmth would glow through, she set fresh violets from her own greenhouse in front of each guest's place at her annual Christmas night party in New York and her Christmas tree one year was made entirely of ermine tails, she had Fabergé flowers carved from gems in pots of jade and lapis. Her friend Cole Porter mentioned her in a song. Salvador Dalí painted her barefoot in a tattered skirt so her legendary eyes—"the most beautiful in the world"—would dominate the picture. She started a vogue for aquamarine jewelry, and then during World War II, she patriotically had these famous gems reset in the shape of bombing planes.

Even Mona's trivia was duly reported. When she appeared in public wearing colorless nail polish, the news ran in Vogue. Leland Hayward, the theatrical impresario who saw and married his share of beauties, once spent forty-five minutes telling his wife Slim how Mona looked in her sable coat as she walked into the Colony for lunch. And when Mona slipped down to seventh place on the 1938 best-dressed list, the writer and humorist Phyllis McGinley felt compelled to compose a dirge for Town and Country on this astounding news:

The ancient order passeth to Limbo or to
    Hades
And Time goes matching onward with ruin in
    his fist.
For couturiers in conclave have named the
    Smartest Ladies,
And ah, but Mrs. Williams is sliding down
    the list.
The elegant Mrs. Williams, Mrs. Harrison
    Williams,
Stands seventh on the list.
Vogue, lament for your falling star.
Weep for your idol, Harper's Bazaar.
Where is the glory you both were sweet on?
Gone with the wind and Cecil Beaton!
Mrs. Williams, O Mrs. Williams,
How did you fall from grace?

Even at the height of the Depression, life for

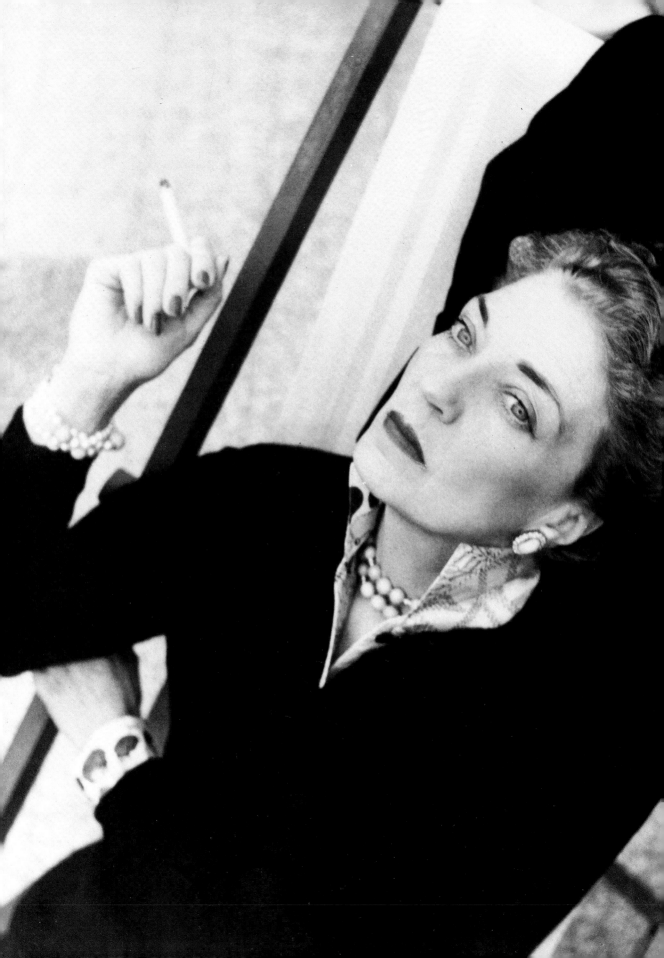

Mona continued to be about getting and spending. She was a fantasy figure for those mired in reality. In addition to their New York and Palm Beach residences, Mona and Harrison had a one-hundred-acre estate in Bayville, Long Island, that was impressive even by the standards of the Long Island gentry. While Harrison laid out his own golf course, Mona converted an indoor tennis court into an aviary. It was here that she discovered her love of and talent for gardening, and created her personal Eden. Her many greenhouses were filled with gardenias, camellias, and orchids. Tropical birds could be seen through the foliage of orange and lemon trees. She would travel to South Carolina in search of rare specimens of flowering plants that reminded her of her childhood.

By the end of the thirties, Mona had achieved all she could in America. Her clothes, her houses, her gardening, her style—in every category, she was at the pinnacle. And so, like the ambitious wife in Sinclair Lewis's *Dodsworth*, she turned her attention to Europe. An apartment at the Hotel Lambert in Paris—"our economy flat," Harrison joked—was just the beginning. Soon Mona found an abandoned Roman fortress on the island of Capri. This cliffside property, with its spectacular view of the Bay of Naples, had once been the summer residence of Caesar Augustus and later the emperor Tiberius. For Mona, the transformation of Il Fortino, as it was called, provided a challenge that would blissfully occupy her for the rest of her life.

By the end of the thirties, Harrison was also in search of fresh challenges, although not ones that had much to do with Mona. He had withdrawn from the luxurious public life he had

made possible for her. Although he was proud of his trophy, he'd seen it all. Because he and Mona had no children and shared no common interests, there was nothing beyond their possessions to connect them.

But Mona was too clever to let any rift come between them. Although she was not an emotional woman, she had real feeling for her husband. What she wrote after their honeymoon cruise remained true for decades: "Harrison, with his great understanding and immeasurable tenderness, has given me the path that will take me to the world around me. May only the good and beautiful things of life come to him!"

In 1937, one did—and Harrison had an affair with Coco Chanel. "My wife is a fashion model," he told Chanel. "Come with me." To her later regret, according to the designer's biographer, Claude Baillen, Chanel declined. Mona may not have known of that romance, but as they spent more time apart she was certainly aware that Harrison was free-lancing. On occasion, Mona also had other partners, not because she wanted the intimacy, but because she liked the reassurance. She needed to be told by her sophisticated and well-traveled lovers that she was the most beautiful woman in the world.

In the end, though, it wasn't adoration that she required, it was friendship. Beginning in the late thirties, that friendship was provided by Count Edward Bismarck, grandson of Germany's Iron Chancellor. Eddie, as he was called, was a homosexual and was never her lover—although there are a few who believe the marriage was consummated—but he was absolutely her soulmate. When they met in Venice, she was immediately taken by his immense refinement, cultivated taste, and vast knowledge of art and furniture. But just as important, Bismarck understood her as no man ever had. He saw that her beauty, which in part made her way of life possible, also made it difficult for her to have real friends. He realized that Mona's looks, coupled

↝ Mona at age fifty-nine. Cecil Beaton had been photographing Mona for four decades when she sat for him in 1956. "With the years, an exotic but classic bone structure has become more pronounced, giving her the strange beauty of an Egyptian cat," he once wrote.

with her wealth, had made her actually lonely.

The archetypal European aristocrat and the Kentucky farm girl turned American aristocrat became inseparable. Bismarck had some experience as a decorator, and it was only natural that Mona would enlist his help in the renovation of Il Fortino. Harrison, too, was thrilled; Bismarck was no rival, and would, in fact, protect her from less scrupulous men. And so Harrison hired the count to be his private secretary.

Working together, Mona and Eddie created a dazzling retreat. The most spectacular room was Mona's bedroom, overlooking the Bay of Naples and Mount Vesuvius. One wall was glass, and the bed was carved to resemble a seashell that was supported by feet in the shape of dolphins. As ever, the dominant color of the villa was white. This time, though, the reason was the flowers—white made the best background for the riot of colors blazing in the gardens outside.

These gardens were a grand folly. Water was scarce on Capri, and a special boat was required to ferry each day's supply from the mainland to Mona's paradise. No matter. Here Mona would import every variety of plant that ever appealed to her, regardless of its appropriateness to the island's arid climate. On Capri, Mona recreated her Kentucky youth by growing magnolias. There were jacarandas to remind her of Palm Beach and sweet-scented jasmines reminiscent of tropical resorts. And to celebrate her European education, she installed a classic rose garden and a perfect English lawn with daffodils and primroses.

In the final two decades of her life, her garden provided Mona's most enduring romance. At a dinner party in Paris in midwinter, she remarked to her companion that she was on her way to "see how my best friend is getting along." Only her intimates cracked the code, gleaning that her references were always to her garden. There, for four or five hours each day, she could dig into the rich earth. Wit and erudition were of no con-

sequence; clothes were unimportant here; all she kept in her closet were two dozen identical pairs of white trousers. With her gloved hands in the soil, she could, at last, feel authentic. Afterward, she would indulge her other passion, swimming in the sea that was the color of her eyes.

Harrison Williams died in 1953, and the day after his death Eddie became the new occupant of his bedroom. A year later, Mona became the Countess Bismarck. Eddie had been diagnosed with inoperable stomach cancer and had only a few months to live, or at least that's what he told Mona. As he said to his cousin Celia Sternberg, "I wanted a few more months of happiness and of Mona belonging entirely to me as my wife before I died. Of course, she agreed to marry me. She is like that." Fortunately for Eddie, fate didn't take its course for another sixteen years. It is speculated that Mona's reasons for marrying him were far more calculated. A title was the only thing that had eluded her, and here was her chance to acquire one. She was later said to be annoyed that Eddie robustly lingered on. Most ironically, although she was now a countess, she was promptly dropped from New York's Social Register.

After Eddie's death in 1970, Mona made her last romantic lapse of judgment and married Eddie's Neapolitan doctor, Umberto de Martino. To give him social credibility, Mona traveled to Portugal and bought him a title from Italy's exiled king. This marriage, like those that preceded it, was motivated by practicality. Mona believed that her "count," who was twenty years her junior, would watch out for her health and her gardens. This was Mona's stab at recapturing her youth, and apparently she was as giddy as a teenager. "He kissed Mona passionately in public, took her around to the local trattorias, cooked Neapolitan spaghetti for her. . . . It was her first

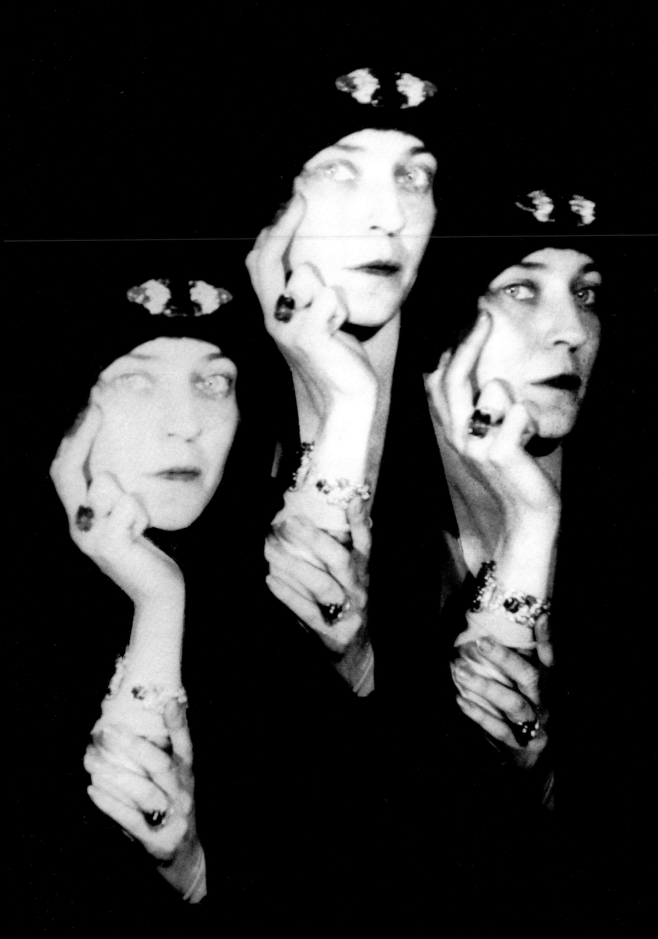

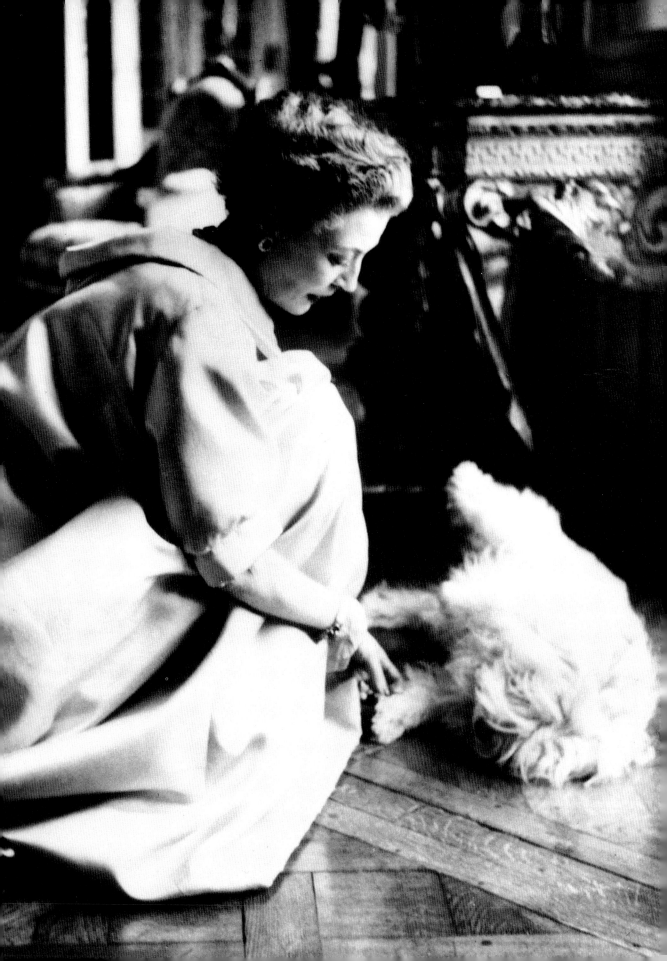

taste of bohemia and she loved it," wrote Arthur Gold and Robert Fizdale. For all that, the doctor was also something of a Svengali—he fired her servants, he gave her pep pills and sedatives, and, to make himself absolutely indispensable, took to spoon-feeding her.

As it turned out, Umberto was a bigamist. Even worse, Mona discovered, he was also funneling her money to his aristocratic English mistress. Not too long after Mona had unearthed his secrets, he was killed in a car accident. With her health failing, and her spirit broken by her last marriage, Mona retreated to her house in Paris and remained there, a virtual recluse, until her death in 1983. In her last years, her thoughts were of Harrison and Eddie, so she arranged to be buried with them. Their ashes are buried together on Harrison's Long Island estate, now a municipal park.

Mona left some money to friends and servants, but it was her wish that the bulk of her $22 million fortune would establish a foundation in her name. Its purpose was both noble and egocentric: to maintain Il Fortino as a "scholarly retreat, to be used in part as a museum." But Mona, who had arranged her life like an impeccable stage set, had forgotten one character from the first act. This was her son, who reappeared,

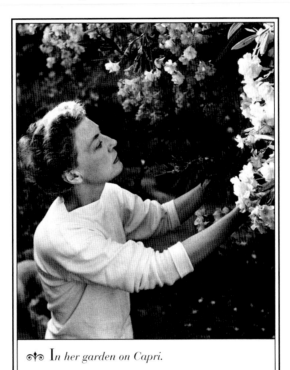

❧ *In her garden on Capri.*

❧ Left: *Beaton snapped a playful moment during this 1955 sitting with Mona wearing Balenciaga's Madonna blue faille negligée.*

broke the will, and walked off with half of the enormous estate. The houses were sold, the jewels were auctioned, a foundation was established in Paris with greatly reduced aims, and Mona's hopes of a larger-than-life legacy were reduced to dust.

On one level, Mona's life was a flawless hymn to style. According to her chroniclers, her only recorded fashion gaffe was her ill-advised decision to dye her trademark silver hair a light brown, for, as it was noted, she then looked just like everyone else. Those who knew her well saw more. If she ever read a book, she kept it a secret. For all her years abroad, she never learned to speak French or Italian. Except for Eddie and Harrison, she was a poor judge of character —before the outbreak of World War II, she saw nothing wrong with displaying a portrait of Mussolini at Il Fortino. And yet she was, as Eddie recalled, "a perfectly normal, nice, warmhearted human being—a bit capricious and spoilt because of the admiration she gets and Harrison's wealth, but in spite of that, she is simply the most lovable creature I ever met."

If Mona is remembered now, it is through the work of the great photographers of her time, although they never captured her essence. She had a soft, seductive, purring quality and skin that seemed transfused by inner light. "She was at her most beautiful in the late thirties but difficult to photograph as she froze into frightened

poses completely unlike her," noted *Vogue*'s Paris editor during the thirties, Bettina Ballard. Cecil Beaton, who adored her, called her a "rock-crystal goddess," rhapsodized about her at length in several volumes of his diaries, and prefaced his many photos of her with "an ode to abiding beauty," but never was able to capture the full extent of his feelings in a portrait.

There was one attempt at a literary portrait of Mona. In Truman Capote's *Answered Prayers*, Mona is the model for Kate McCloud. Although Kate's fictional biography is almost exactly like Mona's real one, the guessing game that followed the publication of *Answered Prayers* focused on the swans that dominated Capote's life—Babe Paley, Lee Radziwill, Pamela Harriman, and Gloria Guinness. Besides, by the early eighties, Mona Bismarck's name was no longer resonant.

It was Mona's love affair with Il Fortino that is perhaps the key to her character. Beyond all the trappings, Mona was a rather simple person who craved privacy so she could indulge herself in the most luxurious levels of simplicity. She spent nearly six decades attaining the best of everything, and once she completed that shopping spree she could be the person she was. She figured out that money bought privacy, the greatest luxury of all. In Capri, on her hilltop fortress, Mona literally cultivated her own garden.

*Mona created an array of green lawns, trees, and flowers not usually known to flourish in southern Italy.*

# Pauline de Rothschild

**B**ARON PHILIPPE DE ROTHSCHILD'S DESK WAS piled high with invitations. He accepted them all: "To be sure of not missing anything, I take the rough with the smooth." That is how, in 1950, the baron found himself seated next to a "tall, striking-looking" woman at a luncheon party. They engaged in little conversation—she was telling amusing stories and captivated the entire table—so it wasn't until the cheese course that they faced one another.

*In the 1940s, Pauline designed for Hattie Carnegie. Here she wears one of her own creations at home.*

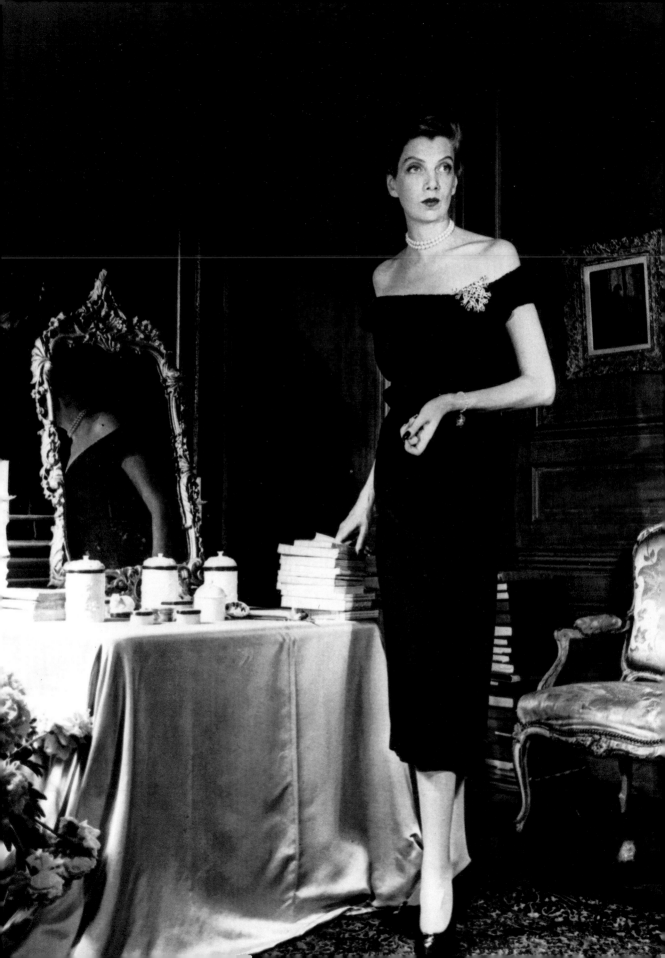

He told some jokes.

She asked his name.

He told her.

"Oh, the poet!"

With those three words, the future of Pauline Fairfax Potter was assured. For the baron, long considered an eccentric by his financier brothers for his involvement in the arts, promptly fell in love with her. Four years later, he married her. Together, they set about restoring the Mouton-Rothschild vineyards and establishing themselves as the most glamorous of all the Rothschilds. And this was the best part—with all the entertaining, the renovations, and the publicity, the impression she cultivated as expertly as her husband's enologists cultivated his vines was of an ultrasensitive aesthete who only lived for art and beauty.

It was only after she died that the baron blurted out the unthinkable truth: "Our marriage was complicated, difficult, costly."

Pauline Potter's marriage was also her own prophecy come true. Many years earlier, she told Billy Baldwin, the interior designer, who was a lifelong friend and fellow Baltimorean: "A young woman must be a debutante in Baltimore and a young married woman in New York City. An old woman must marry a European, preferably in Paris, and live the rest of her life there."

Pauline de Rothschild's journey from Baltimore debutante to chatelaine of Château Mouton was done on a shoestring. Both parents came from families long on lineage and short of cash. Pauline's father, Francis Potter, had a meager income from his family. But he was charming, so he was able to supplement his funds by keeping company with a rich widow. Indeed, it was because of this woman's generosity that he was able to marry eighteen-year-old Gwendolyn Cary, who hailed from a respected Baltimore family.

The deal was too good to last—the lady died without remembering Potter in her will. On their reduced income, the Potters decided to join the expatriate American colony in Paris, where they could live cheaply but well. And off they went, leaving a trail of unpaid bills behind them.

"The first thing one must arrange to do," Diana Vreeland once intoned, "is to be born in Paris." In 1908, Pauline Potter accomplished that, but the fairy-tale aspect of her childhood ended abruptly the following year when her father abandoned his family and divorced his wife. Pauline's next years were spent under appalling conditions. Gwendolyn was a drunkard and dope addict who carted her young daughter around from one seedy hotel to another. Unable to support herself, she lived on sporadic handouts from her Baltimore relatives and the occasional kindness of her casual lovers.

In 1920, Francis Potter turned up again in Paris and found his ex-wife and daughter half-starved, and Pauline ill with rheumatic fever. Though they had nothing to eat, the only table in the room was graced with an enormous bouquet of lilies and white lilacs. For Pauline, the presence of beauty in these unfortunate surroundings was a lifesaver. For the rest of her life, these two flowers would remain her favorites.

Fortunately for Pauline, Francis had once again found himself a wealthy woman. Upon seeing the impoverished circumstances in which his only child was living, he got custody of Pauline and took her to Biarritz to live with him and his new wife.

Yet again, a sour turn was in the wings. The stepmother had mental problems and died four years later. Raising a seventeen-year-old daughter would have definitely put a crimp in Francis Potter's freewheeling lifestyle, so he shipped Pauline off to Gwendolyn Potter's relatives in Baltimore. As a sendoff, he gave her just enough money to buy a decent wardrobe so she could make a proper debut.

Though Pauline's life in Baltimore was infinitely more wholesome than the one she'd known, it still had a ring of sadness. For as soon as she began to feel comfortable there, the relative she was living with promptly died and she had to move in with another. This happened to her again and again.

As for her mother, Pauline never saw her after she returned to Baltimore. Gwendolyn married a Parisian taxi driver and divided her time between Paris and Biarritz, where she had fallen in love with a violinist. One drunken night she went to a nightclub in search of him, found him on the dance floor, and threw her arms around him. When he rejected her embrace, Gwendolyn returned to her hotel and shot herself.

In his memoirs, Billy Baldwin recalled meeting Pauline shortly after her arrival in Baltimore.

ᐇ *George Platt Lynes's view of Pauline.*

*lip. There was just no chin. But what there was, though, was a pair of the most enormous eyes, which were accented by the lack of chin and the paleness of her skin. She stood there looking frightened to death, and the saddest thing I've ever seen, but from her throat came one of the loveliest sounds I've ever heard, one that I was able to enjoy all of her life . . . her voice. It was absolutely beautiful.*

For all of Pauline Potter's exposure to her mother's sordid existence, she had led a sheltered life. The only outfit she owned was her French school uniform, she was not accustomed to the company of young men, and she couldn't engage in small talk with the other Baltimore debutantes she was expected to befriend. Her friend Billy Baldwin observed that when she arrived, she had never even heard a record on a Victrola, much less danced with a boy.

*She was dressed in a simple black cotton dress, heavy black stockings, and wore brogues. Her hair was braided into two pigtails tied with black ribbons. Although she was sitting down, it was possible even then to know that she was very tall. Upon our arrival, she decided to unfold herself, which she did like a great gigantic yardstick; she ended up being nearly six feet tall and pounds underweight. She had the palest possible skin, and hair that I can only describe as being hair colored. I realized that her face stopped at her lower*

Pauline could easily have become a wallflower. But her sympathetic and kind nature made up for her lack of social knowledge. Pauline also had willpower to burn, and most of all, she had charm. "She could have been called a freak really, but one 'How do you do?' and everyone melted," noted Baldwin.

The unexpectedly popular Pauline Potter found herself waltzing through a whirlwind of deb parties. Although she held on to her uniqueness, she also developed a taste for the "best."

Once, when the seventeen-year-old Pauline was in need of a basic coat, she ignored the Baltimore stores, found a way to get to New York, and bought one there. Her acquisition was a chicly simple black buttonless coat that she highlighted with an attention-getting double silver fox that wrapped around her neck and traveled several inches below the hem.

With her grim childhood seared in her memory, Pauline came to adulthood with a startling maturity. After she turned eighteen and her relatives had given her a proper debut, she had a clear idea of the life she wanted. Unlike her girlfriends who had already made "good" marriages for themselves or who had accepted the fact that they were required to live at home until they married, Pauline envisioned an independent life.

She found a tiny house in the heart of Baltimore. To avoid becoming a scandal, she persuaded her aunt to live on the top floor. With the funds from a small trust left to her by her mother, she inexpensively fixed it up and turned it into a salon of sorts, offering the first glimmer of the future baroness's intimate style of entertaining. In those days, Pauline liked to invite a few friends for dinner, play some bridge afterward, and then go dancing. What seemed simple for her was, for Baltimore, out of the ordinary.

By creating an image that was far more stylish than that of her more monied friends, she managed to surround herself with wealth. Still, she lacked a serious beau. With reason—she was hardly a conventional beauty. Many who knew her then recalled her as being downright ugly. She had a receding chin and a giraffelike neck that put her head up at least a mile in the air, a slightly pigeon-toed walk, and a less than smooth complexion. All of that, combined with her exotic nature, made romance a little difficult. "With looks like mine one can't do anything except excuse oneself," she told Cecil Beaton many years later.

Beaton, who had seen beauties both natural and created, saw that "this was a rather tragic revelation of the truth. Yet she does not accept the truth. She rises above it, and by determining to play the game, by wearing the most audacious clothes, she succeeds in projecting a very personal and exotic brand of beauty."

When Beaton made his observation, Pauline was wearing St. Laurent's most innovative couture. In the late 1920s in Baltimore, the inexpensive clothes that she designed herself were considered outlandish rather than audacious. She wore bright red nail polish—then regarded as the ornamentation of loose women—and was known to dye her eyelashes, with one eye a shocking white and the other stark black. She dyed her mouse-brown hair a bright golden hue so that it looked almost gilded.

It became increasingly clear to Pauline that Baltimore was a provincial backwater. "Baltimore had an almost English atmosphere then," she said, years later. "People spoke and dreamed only of horses. Intelligence or any display of it was in truly bad taste." She had to move on, but had yet to find a decent escape route.

Perhaps the dream of an acceptable exit was what drew her to Fulton Leser, an attractive, cultured young man of good Baltimore pedigree then living in New York and restoring art at the Frick Collection. Leser had drawbacks—he was an alcoholic and homosexual—but Pauline chose to ignore them. No sooner had Billy Baldwin introduced them than she decided that this was the man she was going to marry.

Their 1930 wedding was a lavish affair. Typically, the bridal gown that Pauline designed for herself defied convention. The Baltimore society columns gave a great deal of coverage to the yellow satin frock that matched her hair, its gold tulle veil, and a train the length of the church

aisle. Her bouquet was one single calla lily. But Pauline did not stop there. Her eight bridesmaids wore café au lait taffeta from Bergdorf Goodman in New York. These gowns were accented by velvet hats and by muffs made of real purple violets. But more extraordinary was the price of each dress: $125. It was an exorbitant amount in the Depression and a completely unreasonable sum for one bridesmaid, whose clergyman father earned just $3,000 a year.

After all that preparation, the bride was more than half an hour late. She had requested that the church be lit only with candles; her friends explained that the cause of her tardiness was her refusal to walk up the aisle until every electric light in the church was extinguished. That, as it turned out, was not the real reason. The groom had arrived for the ceremony as drunk as a skunk, and the ushers had to sober him up enough so he could at least walk a straight line down the aisle. Pauline understood that disaster awaited this marriage. Minutes before she was to greet three hundred guests at the reception, one of her bridesmaids found her in a puddle of tears.

If Pauline's escape route was less than perfect, she nonetheless threw herself into New York life. With Billy Baldwin's help, she decorated her apartment with made-to-order taffeta from Paris, Rose Cummings chintz curtains, and wonderful furniture from Fulton's relatives. At that point, she began to give small dinners.

The Depression eventually reached Fulton, and he lost his job. Just like her parents before her, Pauline moved to Europe with her husband so they could live on her minuscule trust and the small allowance that he received from his family. Their haven, however, was not Paris, but the Spanish island of Majorca.

It was here that Pauline experienced her first taste of commerce, opening a shop that sold local craft items. And it was here that she finally decided she could no longer put up with Fulton's excessive drinking and his taste for rough trade.

With consummate practicality, she shipped him back to Baltimore while she stayed in Spain, leaving only when the rebels bombed Majorca in the civil war.

When she fled to France, she had absolutely nothing. Through the kindness of an elderly lady she'd met in Majorca, she was given an apartment in Paris and a few very good pieces of furniture. Even better, she caught the eye of Elsa Schiaparelli, who promptly hired her. Pauline divided her time between London and Paris working for the designer until the outbreak of World War II. Once again she fled, taking only the most prized possessions that she'd acquired in Paris—two small paintings by Vuillard and some white Mennecy china.

She arrived in New York without a job and short of funds, settling in a modest railroad apartment. As ever, it didn't take long for Pauline to establish herself. Her friend Louise Macy, a fashion editor at *Harper's Bazaar*, had decided to capitalize on her knowledge and go into the clothing business. Backed by Jock Whitney, her boyfriend at the time, Louise opened a smart salon, recruiting Pauline to design the clothes and enlisting Baron Nicolas de Gunzberg, then a New York socialite, to draw the crowds.

Bettina Ballard recalled the salon's inaugural collection.

*The opening was one of the most perfect fashion disasters I have ever witnessed. To all eyes, Pauline Potter laid the most complete egg that had ever been laid, to all eyes but one. Hattie Carnegie, who wouldn't have sold one single piece on that line, went behind the scenes and offered Pauline a job designing for her. Pauline had underestimated the American wholesale market and designed down to it. Hattie Carnegie was shrewd enough to know that she could edit Pauline's ideas to the benefit of Hattie Carnegie's rich made-to-order customers. That was what she did for many years,*

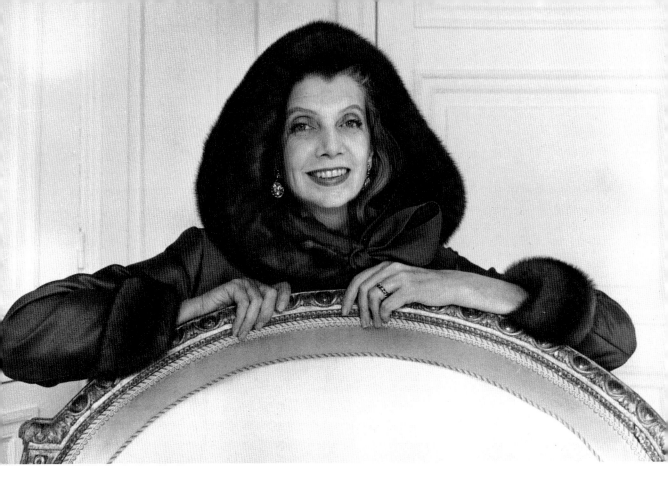

*turning Pauline Potter into one of the most subtle designers in New York.*

Pauline's talent was considered to be on a par with that of the great couturier Norman Norell. While working with Carnegie, she became widely known as one of the highest paid women in the United States. And it was during this time that Pauline began to form a style of entertaining and decorating that would earn her a reputation on two continents as a woman of great personal style.

Like the Duchess of Windsor, another of Baltimore's more famous exports, Pauline was known for her food, flowers, and entertaining. She turned her two-room apartment into a jewel box. Unlike the duchess, however, Pauline liked her luxury restrained. From the beginning, uncluttered but richly appointed surroundings were her trademark. In the modest drawing room of her small flat, for example, she decided that the insignificant moldings had to be done in real gold leaf in the proper eighteenth-century way. The room was all white and furnished with simple white silk curtains, a few good pieces of Louis XVI furniture, and flowers so fantastic that no one could figure out how or where she got them.

Here she gave her intimate but impeccable dinner parties and cultivated a wide array of friends from writer Glenway Wescott to ballet dancer and choreographer John Butler, fashion arbiter Diana Vreeland, to the wealthy and very social Kitty Miller or the old-moneyed John Barry Ryans. These dinners had one common thread: the guests were, without exception, beautifully dressed. Although she had, for years, passed herself off as a champagne bohemian, there was, as Billy Baldwin noted, "nothing bohemian about Pauline."

As success crowned her, Pauline moved to an

apartment that had larger—but not more—rooms. She decorated the drawing room with poufs, books piled artfully into columns, and twenty vases of peonies. Her next move was to a town house. Here again she made do with her few pieces of museum-quality furniture, her remarkable collection of French and English classics, and her tall camellia trees. Her philosophy was that if there was nothing fine enough to fill the space, leave it bare.

Though Pauline was immensely successful during these years, it's hard to fathom how she afforded museum-quality Louis XVI furniture, a great sunlit Bonnard painting, and other costly objects. Billy Baldwin observed that her charming and flirtatious manner made it possible for her to get anything out of anyone. It's also known that she had a habit of not paying for things. But although many of her friends saw that she was wildly avaricious, no one really minded. Her hunger was overshadowed by her charm, her kindness, and her exquisite manners.

Intellectual, sensitive, tranquil, ethereal, romantic—the adjectives that people used to describe Pauline explain how she was able to soften and even obscure her ambition. She was a great actress, and over time, she grew into the role of an aesthete. As Cecil Beaton noted, "Her affectations became completely natural."

Observers might well have seen through her artifice, but they couldn't help being impressed by her originality. Literature, drama, and painting were genuine passions for her. Though her formal education wasn't extensive, her curiosity and appetite for knowledge were boundless. If something piqued her interest, she would read and research it until she had found out everything she possibly could about the subject.

For Pauline, reading was not just the great love of her life, it was "a process of life itself, an unpunished vice. Real readers are like real drunks—a nip here, a nip there. And they don't get to their loved ones until days later." Pauline liked to make the quaint claim that she learned to read before she learned the alphabet. What she didn't say is more telling: as a lonely child in confusing circumstances, reading was her escape, her oasis, her salvation.

Rapt silence became her. Like many women who have achieved personal and social success, she had the gift of listening intently to what others were saying. John Huston, who met Pauline during her New York period, recalled that "she had the ability to bring out the intelligent best in people. She guided conversations with rare grace and delicacy, and she was quick to conceal another's awkwardness of expression. It was flattering to be listened to as Pauline listened. Before long you were surpassing yourself—thinking more lucidly, speaking more eloquently, using words you had forgotten you knew, and saying exactly what you wanted to say."

Evelyn Keyes, the actress who was Huston's wife then, saw a less sensitive side of Pauline.

*She gave little sit-down affairs for six people, as carefully chosen as her objets d'art. At one such evening, John encouraged us all to give our opinions of Picasso's paintings. "Ah," said one, "perhaps the aesthetic and philosophic understanding is lost in words." "The vitality is almost more than I can bear," said another. They were going around the table one by one; they would get to me soon. I could feel myself getting hot with embarrassment. I had seen some of those distorted (to me) things by Picasso with the eyes all crooked, the nose where the ear should be. "Maybe he's pulling our leg," I blurted. "I mean, aren't those funny-looking people jokes?" Silence fell with a thud. "Well, yes, I suppose that's one way to look at it," Miss Potter murmured. Her pleasure at my gaffe was ill-disguised. "Shall we have coffee?" she said.*

Perhaps it bothered Pauline that she had to

put up with the unsophisticated wife of the glamorous film director for whom she had long held a torch. Though Huston has written that there was never any romance between them—Pauline, he claimed, was simply the closest female friend he ever had—they could have certainly fooled Evelyn Keyes back in 1946. The newly married Keyes was perplexed when, just after their arrival in New York, Huston presented Pauline with an eighteenth-century bedspread that cost him a bundle. Keyes asked herself, was the gift an apology for showing up with a wife? Pauline's renowned graciousness was also lost on Keyes, who observed that her husband's chum did nothing to disguise her displeasure whenever Keyes was around: "She acted as if I was some foul odor that had wafted by."

Despite her unusual features, Pauline had several traditional virtues. She was long legged, deep breasted, and broadcast a sensuality that provided her with many lovers. Huston's memory of meeting her for the first time has a sexually charged ring to it. After a dinner party, he walked her home. "We'd only gone a block or two when it began to rain. She asked me if I minded getting wet, and I said I didn't. The rain came down harder and harder. Her hair, which she wore up in an old-fashioned bun, came undone and fell loose and dripping around her shoulders."

Huston had had his share of great beauties, and he completely understood Pauline's allure. "She gave the impression of being a great beauty. In fact, she *was* a great beauty. She had large, heavily hooded gray eyes, was slender and tall, walked with the Grecian bend, and wore clothes with an elegance I've seldom seen approached. Her voice was lovely, with tones like a clarinet."

For all that, a husband eluded Pauline. And though the men in her life—an ex–grand duke of Russia, an Irish diplomat, two married American diplomats, and John Huston—must have recognized her keen intelligence, superb taste, and good humor, none of them was willing to commit. But at their introductory lunch in 1950, Philippe de Rothschild saw right off that she was a jewel of a woman who should not, under any circumstances, be allowed to escape.

Rothschild was a poet, sportsman, and author, but for all his celebrated eccentricities, he was like many wealthy European men—his household needed a great deal of organizing. He recognized immediately that Pauline could run a house. And she could, in a curious way, bring a class and dignity to his life that, even with his exalted name, he currently lacked. He was, he knew, considered by many to be a touch vulgar, a little obnoxious. To be affiliated with Pauline was to bask in her extreme sensitivity to beauty and her love of literature. If their relationship jelled, marrying her was marrying up.

Rothschild understood all this and one thing more: although Pauline wanted marriage, she had a great need for solitude. He allowed her that luxury. After a four-year trans-Atlantic courtship, it was Pauline who proposed. She had no illusions—the baron was incapable of fidelity. "I've seen the way you behave with women," she told him. "In that respect, you are totally unreliable, but we could have an interesting life together."

They resolved that they would, in Paris, keep separate residences. Philippe had his house on the avenue d'Iéna, and Pauline fell in love with an apartment on the ground floor of a house on rue Méchain surrounded by a morgue, a nunnery, and a prison. In typical style, she set about renovating it. Although she now had unlimited funds, she maintained her aesthetic, creating a residence of almost Japanese minimalism. Her objects were of such beauty, such quality, and so artfully placed, it seemed as if she were not dec-

☙ P*eering into Pauline's bedroom in Paris—a jungle of eighteenth-century wallpaper.*

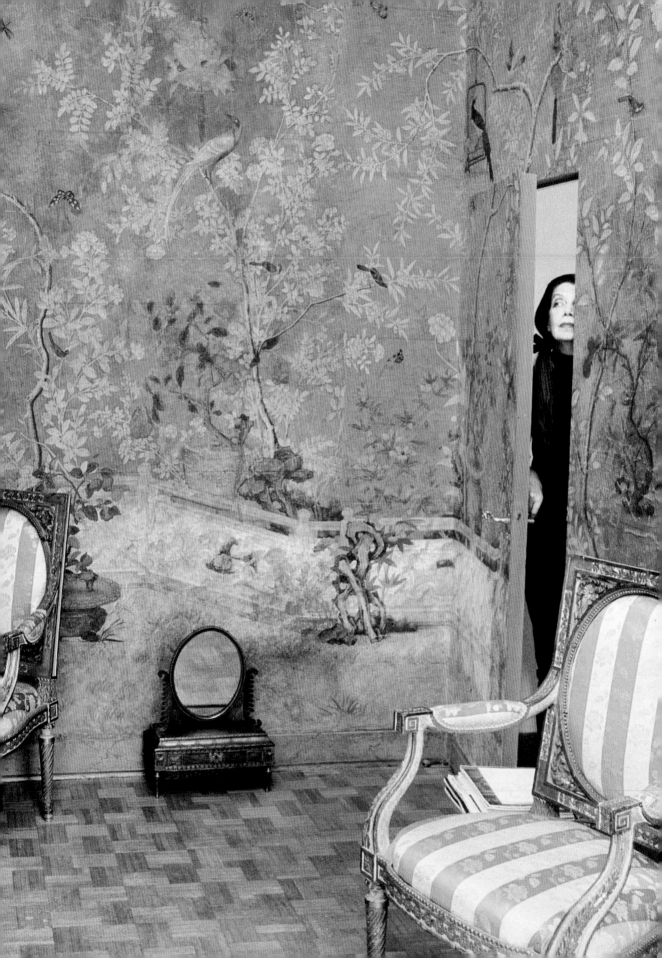

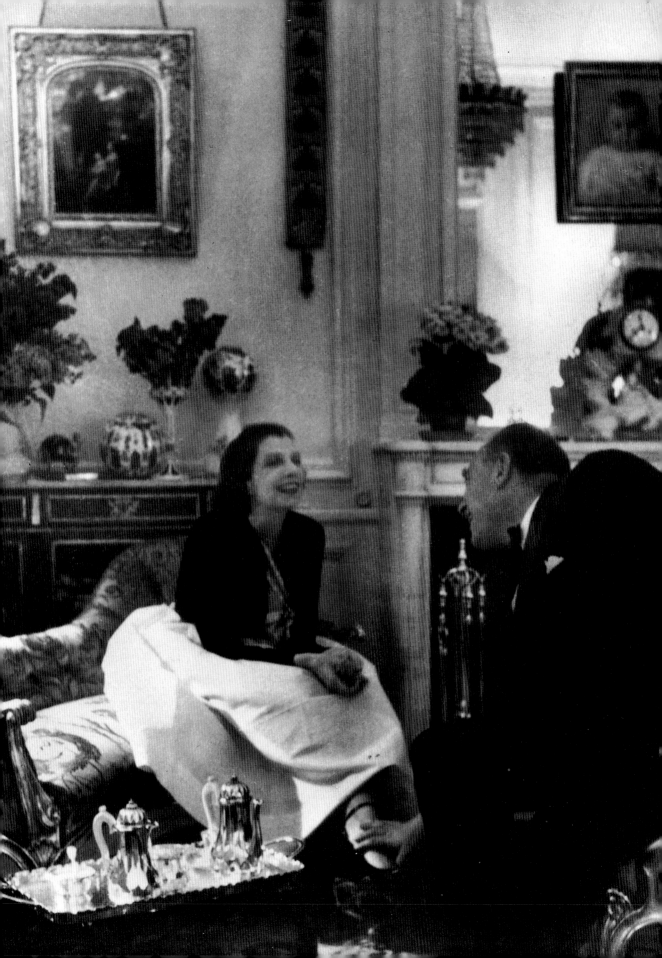

orating with but rather paying homage to them.

In this new life, Pauline could at last be an artist in the medium that suited her best: the art of living. As a baroness, she could be both Sybarite and intellectual. She could indulge her passion for decoration and entertaining, and, at the same time, become a writer, help her husband translate the Elizabethan poets into French, and go to Rome to learn how to draw.

Château Mouton Rothschild was a neglected vineyard that Philippe's father had given him on his twenty-first birthday. At that time, Philippe was a first-rate athlete and race-car driver, but gave all that up to live at Mouton. Instantly, he was committed to managing the property, renovating the buildings, and making his wine, like his relatives' Lafite Rothschild, worthy of the *premier cru* classification. World War II intervened. German troops and then the French resistance took over the château, Philippe was imprisoned, and his first wife died in a concentration camp. When he returned to Mouton in 1945, it was overgrown and ravaged.

The Vichy government had usurped Philippe's inheritance; to restore his estate, he had to use borrowed funds. In this new world, he realized, the vines would have to pay for themselves. As luck would have it, the wartime vintages were actually good. Now all he needed was a brilliant marketing plan that would help the vineyard turn a profit so he could get credit from the bank. And he had an idea: instead of conventional labels for the bottles, he would get prominent contemporary artists like Jean Cocteau, Max Ernst, Salvador Dalí, and Pablo Picasso to design them. Thus began another Rothschild success story.

Before Pauline's arrival, Château Mouton was a Gothic structure filled with the baron's collections of Victoriana. This small manor house filled with knickknacks was definitely not her idea of

❧ *Pauline and Philippe combined their talents and intellects to create a unique house and museum.*

a graceful residence. With her unerring eye, she saw the possibility of a perfect château in the large, beautifully proportioned but deteriorated stables. Pauline and Philippe renamed his former villa Petit Mouton and transformed it into a Second Empire fantasy. They connected it through a courtyard to the stables, which they gutted, renovated, and turned into Grand Mouton.

Here, seventeenth-century furniture and statues met twentieth-century abstract art. But the prize of the house was the library. This was no folly, no cozy retreat with books for decoration. Instead, the shelves were filled both with every classic imaginable as well as an extensive collection of books on art, travel, and gardening. And just below each shelf was a pull-out table complete with a chair, a lamp, and pad and pencil. For the less studious, there was a sofa covered in turquoise velvet and a chaise longue.

The balance of understatement and extraordinary richness that was Pauline's signature always intoxicated the Rothschilds' guests. "Nothing could be less dramatic than one's first sight of red-tiled Mouton—a series of plain lowish farmhouses as understated as one of Pauline's Balenciaga raincoats," the writer Susan Mary Alsop recalled.

*Inside is rather different. One is led upstairs into an immensely long room lighted by rounded windows directly overlooking the vineyards. This is no pleasure dome placed meaninglessly by rich people in a pleasant setting; vineyards are all-important and this is a working estate. Although sparsely furnished, there is too much in the room to take in at once. Pauline has a horror of overcrowding, but Giacometti is a happy neighbor to a sprawl of books on English gardens, just as in her bedroom the finest of Chinese wallpapers suits an austerity as severe as Carpaccio's rendering of St. Ursula's little room in the series in the Accademia in Venice.*

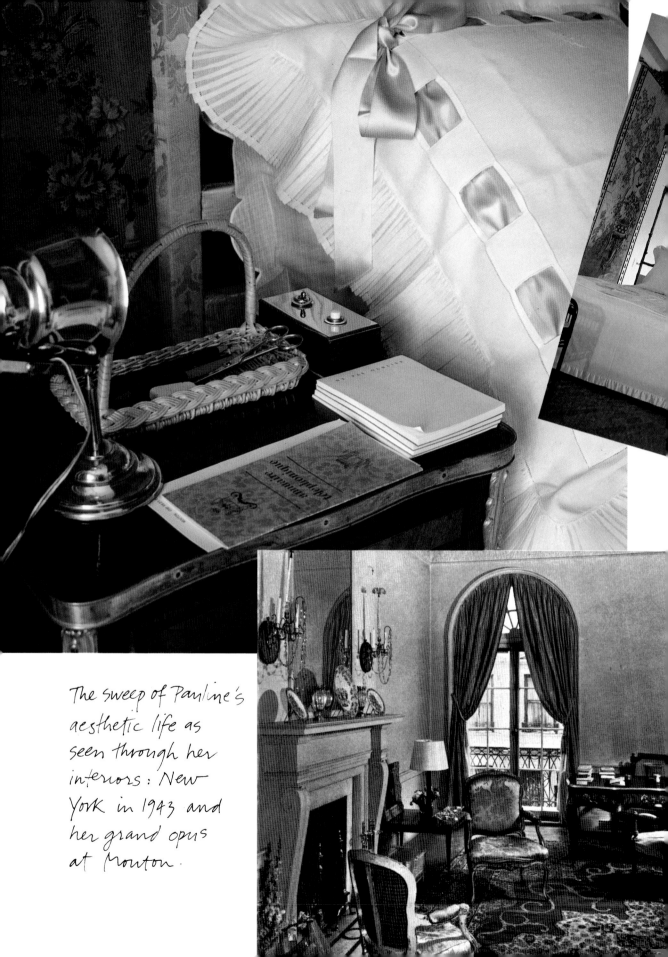

The sweep of Pauline's aesthetic life as seen through her interiors: New York in 1943 and her grand opus at Mouton.

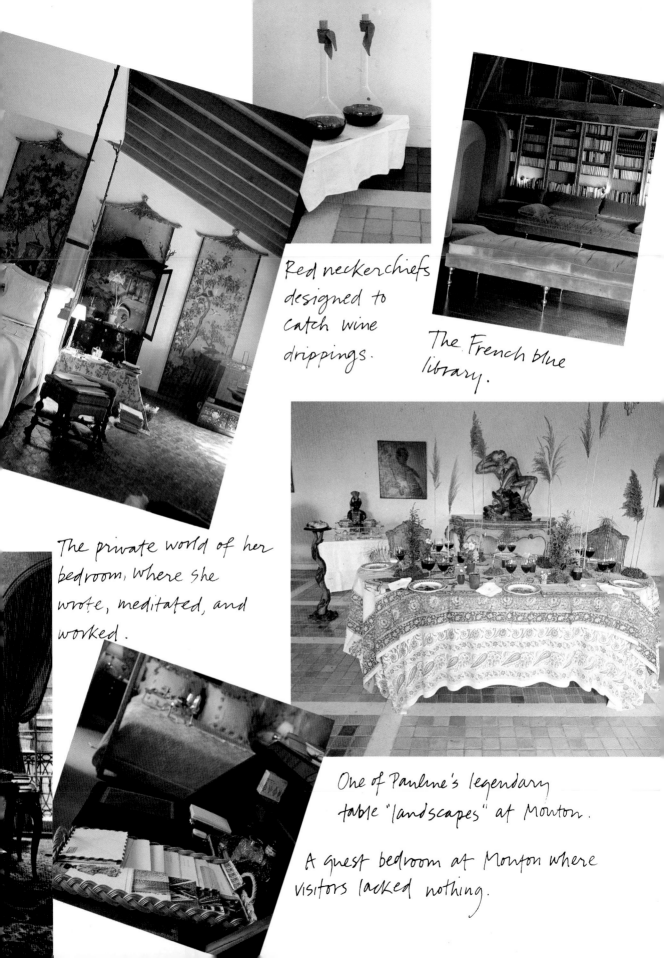

Red neckerchiefs designed to catch wine drippings.

The French blue library.

The private world of her bedroom, where she wrote, meditated, and worked.

One of Pauline's legendary table "landscapes" at Mouton.

A guest bedroom at Mouton where visitors lacked nothing.

In one area, Pauline went right over the top, and that was in her care of her guests. Weekend visits to Mouton became legendary events. "If you fall asleep with your arm hanging over the bed," mused one visitor, "you wake up with a manicure." The servants seemed invisible, but they were most definitely stationed close by, and on full alert. A shirt left on a bed would be washed and pressed while the guest was bathing in lilac-scented water. Each room was stocked with the latest books, French and English newspapers, and, for American guests, the *Herald Tribune*. Notepads, well-sharpened pencils, and a pair of gilt scissors were thoughtfully placed by the bed. "So benignly insidious is the positive and productive influence of this house," wrote Valentine Lawford, "that even the laziest guests are apt to find themselves making notes as they read, cutting out and keeping the odd newspaper item, or jotting down their private thoughts."

Her weekend guests represented, in a way, Pauline's most prized collection. They ranged from English men of letters like Stephen Spender and Cyril Connolly to French novelist and cultural icon André Malraux, the journalist Janet Flanner, Parisian tap-dancing prince Jacques Chazot, and Alexandre, the French master of hairdressing.

In 1973, Mouton was honored in the most significant way possible—Philippe's wine was elevated to the level of the *premier cru*, the culmination of decades of struggle. By then, Pauline had also been elevated. Starting in 1963 with a piece in *Vogue* by Valentine Lawford, she had become a favorite subject of the fashion press, and of her good friend Diana Vreeland in particular, who once characterized Pauline by saying, "She could dominate a room from a footstool." In 1962, Vreeland had become editor of *Vogue*, and along with her affection for youth and novelty, she also championed exclusivity and privilege. Over the years, Vreeland had met every title worth knowing and visited every house worth

seeing: now she wanted to give her readers the grand tour.

And there was Pauline, a source of inexhaustible copy.

How many ways are there to set a table? According to Pauline, an infinite number. Every morning the baroness selected her china, silver, tablecloths, and napkins from books that contained swatches and photographs of over one hundred and seventy patterns. All that was just the raw material for the table decorations that Pauline airily called "table landscapes." Sometimes she'd created woodland fantasies comprised of grasses, mosses, and ferns done to look like miniature forests. In other seasons, she might design a cherry orchard with branches of wild cherry and fruit in tiny Japanese pots. Or she might use ornamental kale like blossoms in bud vases.

What was it like to be a weekend guest at Mouton? Vreeland gave her readers detailed descriptions of the handmade bed linens, the exquisitely stocked bathrooms, and the plates of watercress sandwiches thoughtfully set on the well-stocked bar in each guest bedroom. For all this luxury, there was a foundation in practicality. The Rothschilds had good reason to make sure their guests would be happy on their own, as Pauline and Philippe rarely appeared until lunchtime, preferring to spend the mornings reading and writing in bed.

Once Vreeland had thoroughly covered the château, she moved on to the Museum of Wine in Art. Pauline and Philippe had established this center as a tribute to the history of wine making as seen through its artifacts. The museum was a treasure trove of sixteenth- and seventeenth-century vermeil cups, rare porcelain and crystal, Renaissance tapestries, a range of paintings by Dürer to Picasso, and drinking implements dating back to the fourth century before Christ. Inevitably, there was a catalog that was researched and written by Pauline.

For all the *Vogue* stories, Horst was the photographer—almost a photographer in residence —and Valentine Lawford the official chronicler. Twenty years later, they remembered how Vreeland and the baroness loved cooking up these story ideas, as well as the supreme pleasure Pauline derived from the articles. "Pauline adored being photographed, she adored showing what she'd accomplished," Lawford told me. Horst recalls the effort she put into the photo sessions: "When we were doing the wine museum story, I wanted to photograph Pauline in front of a Beauvais tapestry that had a treasure basket heaped with gold objects. I thought it would be nice to echo that motif by placing some of the museum's gold artifacts in a basket and have her stand next to it. She didn't think the baskets were good enough, so she went to Paris in search of better ones."

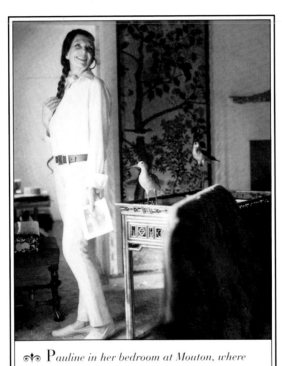

*Pauline in her bedroom at Mouton, where daily life itself seemed to be a work of art.*

And that wasn't her only reason to go to Paris. For this photo shoot, Pauline wore clothes that St. Laurent designed specifically for the occasion, including a regal, full-length satin coat with ermine-lined sleeves. When Diana Vreeland saw the pictures, even she had to admit that "Pauline had gone a bit overboard."

*Vogue* readers also encountered Pauline dressed like a Renaissance page in tights and a sealskin jerkin, in satin harem pants, in velvet breeches with a full-length coat that Watteau would have loved to paint, and in narrow raw silk trousers worn under heavily embroidered tunics. By 1969, Vreeland's editorial benedictions had made the baroness an institution, and editors didn't need to add a surname when they spoke of "le style Pauline."

The château was not the only place where Pauline expressed herself. Pauline disliked warm weather and sunsets—she thought the day should never end—so summers were spent in rented castles and manor houses in cool, gray climates like Sweden, Denmark, and Scotland. Even on holiday, she was not content to let a house remain as the owners had left it. She would renovate the place, and, more often than not, unearth a medieval wall painting or architectural adornment that had been hidden for centuries.

As the years passed, she wanted to enlarge her stage in order to accommodate her continuous flow of ideas— she felt that life was wasted without creative work. On a winter holiday in the Soviet Union in 1965, she kept a diary of her trip. The result was published as *The Irrational Journey*, a book of sharp and sensitive personal observations on Russian art, poets, museums, Leningrad, Byzantine monasteries, Moscow, and palaces. Janet Flanner wrote that it was a "contribution of rare, fine writing. . . . I remain dazed at her talent. We writers work all our lives for style and special faculties of expression; she has them as an amateur and out they flow as if part of her fortunate

wealth, though this time uninherited through marriage and instead earned with her head bowed over her pen."

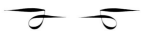

In 1970, Pauline's health began to fail. The rheumatic fever she had in childhood had left her with a weak heart. A series of operations only weakened her more. But as Cecil Beaton noted, "Since her illness, she seems to have made her life even more full of interests while remaining aloof from so much. She seems to have less interest in self-adornment, and just as at one period in her life, when she had the same wonderful chicken dish for dinner every night of a New York winter, now day after day she wears only a succession of dark jackets with tight, Indian man's trousers in beige of leather or voile. She has no need for or interest in ringing the changes."

During those last years, she told Philippe she'd had enough of Mouton and wanted to go away and write, but she must hurry as time was running out. Her refuge was a flat in Albany, London's magnificent eighteenth-century chambers. By now, she was an icon, and a young English literary court soon gathered around her.

In 1976, she was diagnosed with cancer, caused, it was thought, by the drugs she took for her heart condition. The doctors switched her medication and operated on her. As a break from the medical treatment she was receiving in Boston, Philippe took her to Santa Barbara, California. They walked on the beach, and her conversation, as always, was filled with dreams of the future. One afternoon, she told Philippe, "I feel we have been through a difficult time, but now we're reconciled and drawing closer together."

Philippe went for a swim. Pauline returned to the hotel—and dropped dead in the lobby. She had never opened the bottle of the new heart medication her doctor had prescribed.

She was laid to rest at Mouton. Her pallbearers were six vineyard workers dressed in their French blue work clothes; all the tractors on the estate followed the casket.

Two decades before her death, just before her first Christmas at Mouton, Pauline volunteered to decorate the banquet hall by herself. The decoration, she told Philippe, would be lilies and white lilacs.

"At Christmas?" he asked.

"That's just it," she replied. "Winter will seem like spring."

Philippe remembered Pauline's story of youthful poverty, and the grim hotel room in Paris with no food, only lilies and white lilacs for sustenance. He not only approved her eccentric decorating request, but beamed as the staff brought Pauline armfuls of white lilacs on her birthday, which was December 31. At midnight on those New Year's Eves, he has written, with the sweet smell of flowers in the air, "we embraced, toasted each other, and thanked the gods for the blessed gift of wine. Then Pauline would organize a procession with candles and music, and the party would begin again."

The parties weren't the same after Pauline's death—her absence was too palpable. Something more spiritual was in order, and so on every December 31 until the baron died, the staff at Mouton formed a procession and carried branches of white lilacs to her grave.

*❧ In 1963 at age fifty-five, Pauline was youthfully dressed in St. Laurent's suede jerkin, jersey tights, and the tallest of suede boots.*

# Diana Vreeland

**T**HERE COULD BE A VOLUME OF HER bons mots: *The Sayings of Chairwoman Vreeland.* The comparison to Mao is not casual—they were both revolutionaries who became dictators. Both commanded devoted armies. Both adopted sensible uniforms. For both, red was the color of choice. And after their death, both have been remembered mostly for their excesses.

Perception is everything, and the world knows only the most over-the-top aspects of Diana Vreeland's personality. There are the dicta: "Shocking pink is the navy blue of India" and "The bikini is the most important invention since the atom bomb." There are the witticisms that leap from her magazine pieces, offering advice like, to cite just two examples, "Why don't you rinse your blond child's hair in dead champagne?" and "Why don't you turn your old ermine coat into a bathrobe?" Lines like "Twist the hair up, twist it out, let it float into space, way, way out, all the way to Outer Mongolia" gave rise to the cartoonlike fashion editor ("Think pink!") in *Funny Face*, as well as characters in *Lady in the Dark* and *The Bell Jar.*

ᗉᔰ *Although she was known for her style long before she became a fashion editor, she was, in 1935, still identified in* Bazaar *as "Mrs. T. Reed Vreeland."*

Her later pronouncements—as well as her entire 1984 autobiography, *DV*—read, to the uninitiated general public, like a dotty aunt settling in to spin some morphine-fueled shaggy dog tales.

Her pictures have served her no better. Devotees of gossip columns may recall her nights on the party circuit. She seems to appear in every photograph ever taken at Studio 54, having a grand old time trading quips above the disco drone with Mick Jagger, Jack Nicholson, Andy Warhol, and the omnipresent Halston.

Even her reign as special consultant at the Metropolitan Museum of Art's Costume Institute, which should have enhanced her reputation, only brought fresh controversy and misunderstanding in her final years. As the creator of exhibits that claimed to be portraits of style in various periods and cultures, she presented shows that, according to some cultural historians, were more like sustained bouts of projection and fantasy than serious scholarship.

The result of all this hyped-up talk, incessant entertaining, and dragon lady self-presentation is that Diana Vreeland's larger-than-life persona has come to overshadow her considerable achievements. It's easy to forget her importance in shaping modern fashion when her detractors treat her as the empress of ephemera, a well-born social butterfly who dabbled in fashion, a

"Elegance

"People who eat white

"Never fear being

"The greatest vulgarity is any

"Without emotion,

"What sells

is refusal."

bread have no dreams."

vulgar, just boring."

imitation of youth and beauty."

there is no beauty."

is hope."

DIANA VREELAND

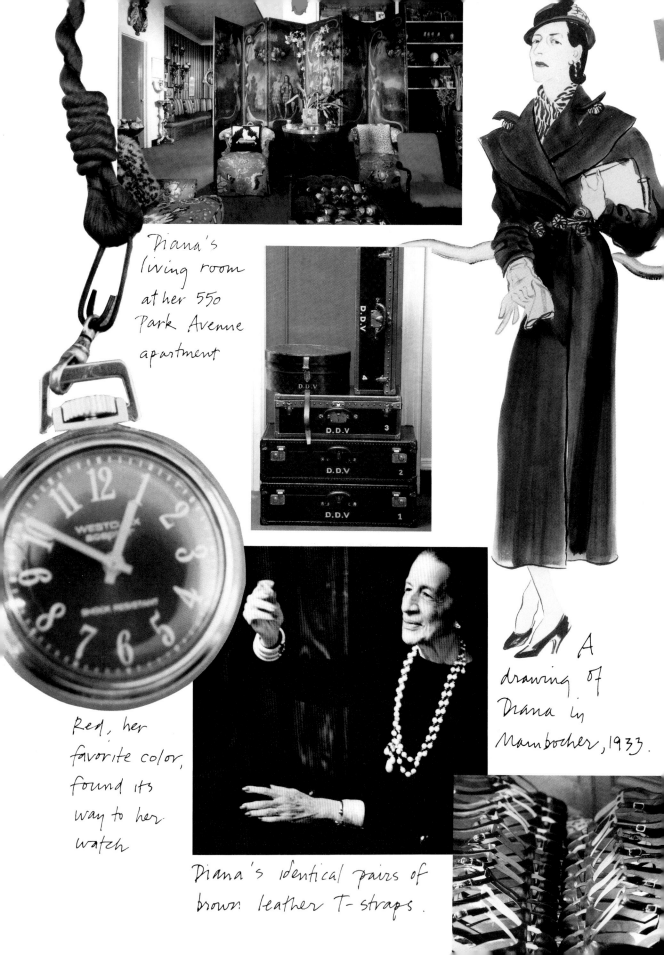

Diana's living room at her 550 Park Avenue apartment

Red, her favorite color, found its way to her watch

Diana's identical pairs of brown leather T-straps.

A drawing of Diana in Mainbocher, 1933.

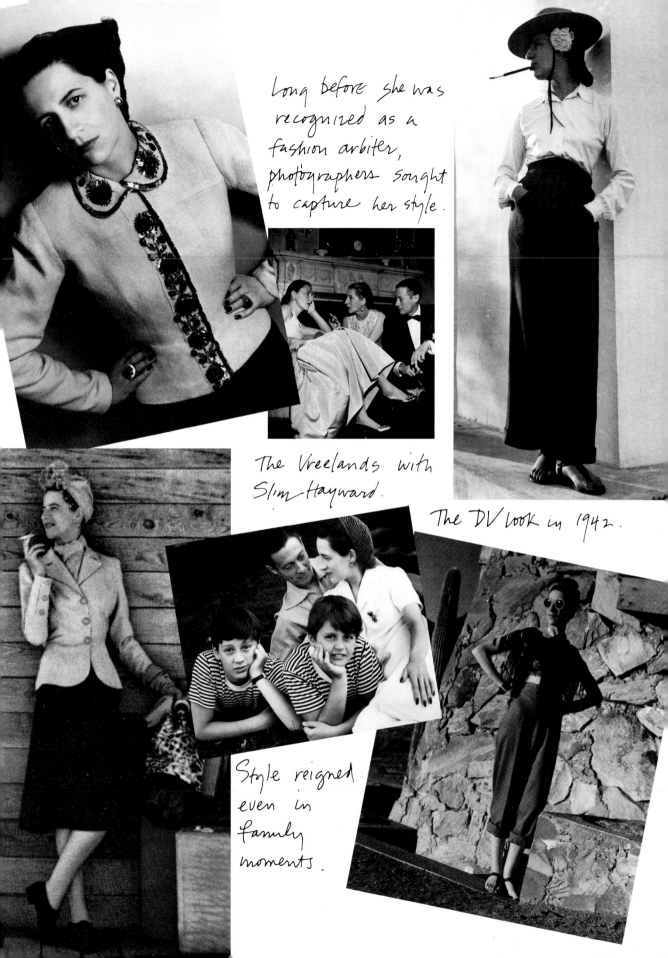

Long before she was recognized as a fashion arbiter, photographers sought to capture her style.

The Vreelands with Slim Hayward.

The DV look in 1942.

Style reigned even in family moments.

flamboyant partygoer who cared more about the rarefied world in which she lived than the bottom line; in short, a woman whose life has no meaning for us now.

The fact is, every bit of nonsense that passed Diana Vreeland's lips was deliberately said. She knew the effect her bon mots had on her audience, and she tailored her remarks so they would have the greatest possible value. Although she acted as if the editorship of *Vogue*, the world's most important fashion magazine, was a lark, she thought obsessively about her job and worked at it eighteen hours a day. In the final analysis, this apparent relic was really one of the first women of the twentieth century who had more style than money and used that style to earn a living. Small wonder she's been misunderstood—there is no clear antecedent for her.

Diana Vreeland was born into a world that groomed her to be like the women who adorned the pages of the two magazines she would eventually shape. Her mother, Emily Key Hoffman Dalziel, was a beautiful, spoiled, helpless American socialite who, Diana would say, lived "only for excitement." She described her father, Frederick Dalziel, as a good-looking, "impeccably dressed" Scottish banker who "never made any money and never thought about money." Sometime between 1903 and 1906, allegedly in Paris, they produced Diana.

Diana grew up on the avenue Foch with her younger sister, Alexandra, a handful of servants, and two nannies. One of her earliest memories was of her mother coming in from racing in a gold-embroidered satin coat trimmed with white fox. Even as a child, Diana said, she thought that was an "appalling" look.

In season, the Dalziels dragged their children to Deauville, Biarritz, and Cannes—all the fashionable watering holes. "My parents spent their days having a good time," Diana recalled. "They never contributed a bloody thing, and they and all our friends lived the life of Riley."

Diana's education was erratic. A young woman's only requirement, at least from her mother's point of view, was to be beautiful and charming. Alas, young Diana was neither. She had astigmatism that left her slightly blind, her features were homely, and just to make the package even less inviting, she was shy. Such unattractiveness was too much for her mother; early on, Diana recognized that she was regarded at home as an "ugly little monster."

Emily Dalziel may well have considered Diana an unfortunate specimen, but she and her husband were not just another pleasure-seeking couple drifting through the racy Belle Epoque. In a very forward-thinking way, they included their children in their travels. Diana saw a parade of talent troop through her parents' drawing room: Nijinsky, Diaghilev, Chaliapin, Irene and Vernon Castle. She saw Bernhardt and Duse perform. In 1911, her nanny took her and her sister to London for the coronation of King George V. "Ah, that was where my family was great," Vreeland wrote in her memoirs. "We never missed anything, and that is why I have grown up with a total sense of vision."

In repayment, Diana went through life ignoring the less-than-perfect side of her family, in particular, her mother's scandalous love affairs. When she looked back, therefore, she chose to recall some of this century's greatest talents and pivotal moments in history. And, inevitably, one memory that rose above the others was the beginning of World War I, for the Dalziels' European period ended then. Overnight, it seemed, they moved to New York and Diana found herself at the Brearley School for Girls.

Confused by Brearley's requirement that she speak English and refrain from lapsing into French, she quickly developed a stutter. Just

three months into the term, the headmistress told her mother, "Mrs. Dalziel, she's not us." Rather than fail at another academic-minded school, Diana was sent to study at the Fokine Ballet School with Michel Fokine, the only imperial master ever to leave Russia. But because of a polio epidemic, the Dalziel children were soon whisked off to Diana's third American environment, the remote Wild Western town of Cody, Wyoming. There, Diana met the legendary Buffalo Bill Cody, who was "just an Edwardian gentleman who happened to be in Wyoming."

Diana's life finally came together when she returned to New York: "I went to dancing school, and I didn't give a damn about anything else. All I've ever cared about since is movement, rhythm, being in touch—and discipline. What Fokine taught. And it's stood me in good stead all my life—it's forever. When I discovered dancing, I learned to dream."

Did any of this really happen?

That's a question often asked by those who knew Diana or wrote about her. With reason. Along with her season in Wyoming and the training at the Fokine School, Diana was also prone to remember childhood journeys to Cairo and Vladivostok. Even her birthplace cannot be reliably assumed to be Paris, given her shaky command of what she insisted was her native tongue.

"Never worry about facts," Diana said, ducking all biographical inquiries. "Project an image to the public."

"I'd better leave memories of childhood to Diana," her sister once told a reporter. "Sisters remember things differently."

By the 1920s, Diana's shyness and insecurity were forgotten in the excitement of the Jazz Age. So was her low regard for her looks. Around this time, Diana realized that "you don't have to be born beautiful to be wildly attractive," a revelation that led her to break a great many fashion rules. She lacquered her nails red like a "Chinese princess," indulged her passion for beautiful clothes, and spent hours giving her entire upper torso a lily-white hue with calcimine before her escort arrived to tango through the night with her. The girl who had once stuttered now found herself blackballed from the Colony, New York's stuffiest women's club, for being "too fast." For someone who was mortified when her mother showed up at the Brearley School wearing a bright green suit, gold Tyrolean fedora, and heavily caked makeup, Diana certainly seemed to be competing with the woman she so disliked.

In 1923, she met Reed Vreeland, the man who would be "the platform on which she danced" for the next forty years. Reed, a Yale graduate intent on becoming a banker, was tall and beautifully dressed, with drop-dead patrician good looks. He was as stylish as the father

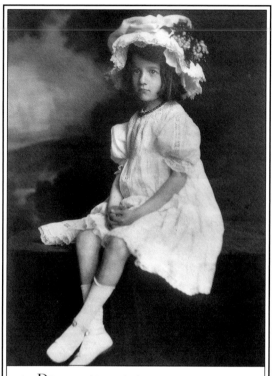

᭡᭡ D*iana making a fashion statement at age six.*

Diana adored, and, not surprisingly, she knew immediately she was destined to marry him.

The ceremony was held a year later at St. Thomas's Episcopal Church on Fifth Avenue, society's preferred place of worship. But there was something wrong. The church was half-empty. Her mother offered various face-saving excuses: The invitations had never been sent. They had been thrown out by mistake. A better explanation for the no-shows might have been that, just ten days before the wedding, her mother was publicly named as the corespondent in a divorce suit. No matter, her father told her, rise above it: "Worse things happen at sea." So Diana was a good sport about the "mistake." As she explained, "I just wanted to marry Reed Vreeland."

Long after her many career successes, she still counted that marriage among her greatest achievements. "Reed had fantastic glamour for me. And he always retained it. Isn't it curious that even after more than forty years of marriage, I was always slightly shy of him?" she recalled. "I can remember his coming home in the evening—the way the door would close and the sound of his step. . . . I can remember always pulling myself up, thinking, I must be at my very best. There was never a time when I didn't have that reaction—ever."

It makes sense: marriage made Diana finally

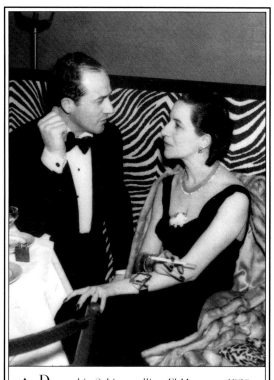

✤ *Dressed in Schiaparelli at El Morocco, 1938.*

feel comfortable with her own irregular appearance. For all the times Reed Vreeland would fail his wife, he nonetheless gave her something powerful and enduring: the confidence that his strong but dependent wife needed to become the woman the world would come to envy.

The Vreelands moved to Albany, New York, where Reed was to learn the banking business. For someone like Diana, Albany must have stretched the definition of *provincial*. But she was blessed with the ability to find something or someone to turn drudgery into adventure. In this case, Albany's premier grande dame, Lulu Van Rensselaer, appreciated Diana's originality and could see that she was definitely the most interesting person to hit town since the Dutch arrived three hundred years earlier.

"Don't think I was always the person you see now. Don't think I was the same person before I started working," she wrote. "I was born lazy. During this phase when I lived in Albany, I'd walk around in a mackintosh and a basque beret with *very* extreme, very exaggerated makeup—I've always had a strong Kabuki streak. I was criticized. I loved our life there. I didn't care what any other place was like. I'd still be there if Reed hadn't wanted to move to England."

The Vreelands pulled up stakes in America just before the crash of 1929. After setting up house in Hanover Terrace and giving birth to her

second son, Diana got right into the luxurious life that was so easily obtained in London. With her friend Edwina D'Erlanger, a great American beauty married to the scion of an English banking family, she opened a lingerie shop that sold exquisite undergarments, handmade bed linens, and racy black underwear to Mona Williams, Wallis Simpson, and other big names of the 1930s. For the sheer fun of it, she trained with a troupe of chorus girls and painted the front door of her sedate house red. More seriously, she spent her days reading and going to museums to fill the gaps in her spotty education. "My life became *completely* European," Diana recalled. "I had no interest in anything except educating myself."

For the next seven years, Diana's life "would be a dream of beauty," conducted in an atmosphere that was not too dissimilar from one her parents had known. Like them, she became caught up in the glamour of a provocative era. Only going to places "where the air was fragrant and life was easy," she and Reed traveled to Tunisia, Bavaria, Hungary, and Italy, and were received by the most illustrious hosts and hostesses of the fashionable world.

In Paris, Diana was part of the milieu that so effortlessly combined society and artists. She became friends with Coco Chanel, Christian Bérard, Jean Cocteau, Daisy Fellowes, and Prince Jean "Johnny" de Faucigny-Lucinge. In true contradictory style, Diana and her English maid would arrive in Paris in her chauffeur-driven Bugatti and stay at a ghastly, inexpensive hotel on the boulevard Haussmann because "I chose to spend my money elsewhere."

She spent it on beautiful clothes and ornamentation. In Paris, Diana reveled in passing long hours being fitted for clothes, gloves, shoes, and hats. "The life of fashion," she would say of those years as a socialite, "was very strenuous." Johnny de Faucigny-Lucinge, one of Paris's great social leaders, recalled Diana in that period: "She was what the French call *jolie laide*, which means ugly/beautiful. In fact, she was very ugly— but no one could ever say she was because of what she created for herself." Her looks didn't matter; the couturiers understood completely that she was an original. Convinced that she was an ideal *mannequin du monde*, they offered her clothes at next-to-nothing prices in exchange for her chic visibility.

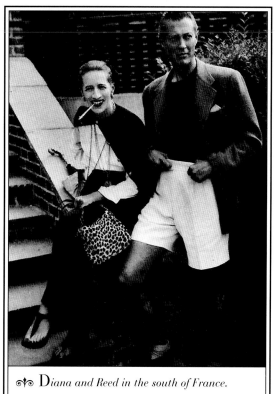

ⲟⲩⲟ D*iana and Reed in the south of France.*

Reed's salary was not large, but in those days any well-connected American who was witty and attractive could make the circuit of the great houses of Europe. "When I think of the luxury so available to a poor young bride like me in those days!" Vreeland once told a reporter. "Everything was so easily accessible. You could stop in and have Augustus John do your portrait, then sweep off to lunch."

All this came to a crushing end in 1936, when Reed was transferred back to New York. Diana hadn't been home for six months when it became clear that his salary wouldn't support her standard of living, much less feed, clothe, and educate two sons. As luck would have it, Diana was in the right place at the right time, or rather, she was wearing the right outfit at the right time.

One night, while dancing on the roof of the St. Regis Hotel in a white lace Chanel dress with a bolero and a rose in her hair, Diana was spotted by Carmel Snow, editor of *Harper's Bazaar*. The next morning, Snow called to say how much she admired that dress. She went on to offer Diana a job covering fashion for *Bazaar*.

*Job*—that was definitely a new word in Diana's vocabulary. She explained to Snow that she'd never even seen an office, rarely rose before noon, and was incapable of getting dressed until lunch. Snow, a genius at sniffing out virgin talent, was undeterred.

"You seem to know a lot about clothes," Snow said.

"That I do," Diana admitted. "I've dedicated hours of *very* detailed time to my clothes."

Snow assured Diana that all she wanted was to pay her for what she was already doing. That made sense even to the quirky Mrs. Vreeland, and so, at age thirty-plus, she went to work. It took three decades for her to confess her motivation: "Money, why does anyone work for anything else?" Or as she once put it, in a conversation of unusual candor, "My dear, I was penniless."

Carmel Snow hoped Diana "would make news for *Harper's Bazaar*. Diana reflected for us the new world of the international set." But that world and journalism didn't easily mesh for Diana. After a few months, she wanted to resign. "I can't stand these days, I just can't stand them! I'm so tired all the time," she told the managing editor. "I can't go from eight o'clock breakfast to eight-thirty dinner with nothing to eat." Her colleague tactfully suggested a break for lunch. Diana was enthralled by the idea: "That rather changed my life."

What really made the difference at *Bazaar* for Diana was the realization that her background was her future. The romantic splendor of her childhood, the privileged life she'd left, the people she knew—the reference points of her life were completely unknown to most American women. During the Depression, that was an asset. In the person of Diana Vreeland, *Bazaar* could present fashion and social coverage that would be a tonic for fantasy-starved American women.

Diana first applied her rarified knowledge and loopy point of view in a column entitled "Why Don't You?" Here, she cheered readers up with such absurd and snobbish suggestions as "Why don't you wear bare knees and long white knitted socks as Unity Mitford does when she takes tea with Hitler at the Carlton in Munich?" and "Why don't you have a private staircase from your bedroom to the library with a needlework carpet with notes of music worked on each step —the whole spelling your favorite tune?"

These fatuous offerings are the Vreelandisms most frequently cited. Few recall that Diana also presented chic but practical ideas for brightening the reader's world like: "Shop at Woolworth's for little Scotch plaid sock arrangements called Hi-Jacs, made to slip on your cold drink glasses to keep the table from spotting" or "Have two pairs of day shoes exactly alike, except that one pair has thin rubber soles for damp days. Any cobbler can put these on." Often the columns contained advice she had personally taken, such as "Cover a big cork bulletin board in bright pink felt, banded with bamboo, and pin with colored thumbtacks all your various enthusiasms as your life varies from week to week."

*Diana's feminine quality shines through in this striking Huene portrait.*

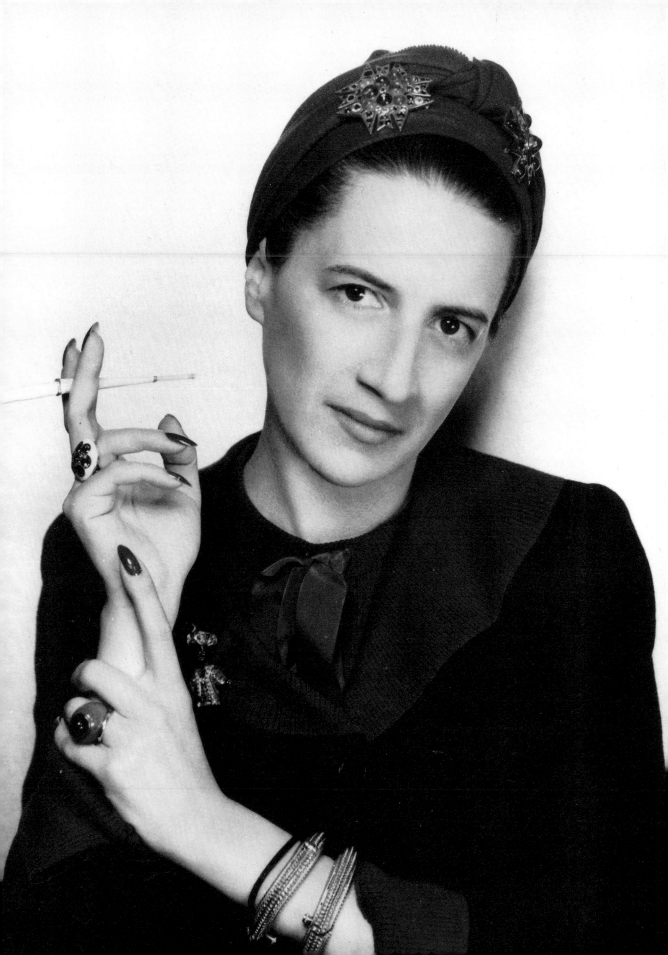

These columns were widely read. And widely satirized. S. J. Perelman even parodied them in *The New Yorker.* But the satire was affectionate, even respectful. The idea that a fashion magazine reporter was using her imagination rather than merely reporting on clothes was novel. Almost overnight, Diana cemented a reputation for taste and daring. In 1938, two years after she joined *Bazaar*, she was appointed fashion editor.

Diana spent the next twenty-four years revolutionizing the role of a fashion editor. Rather than report on what Seventh Avenue or Paris had to offer, her aim was to create, and motivate. And that she did. She discovered Lauren Bacall, popularized the turtleneck sweater and the thong sandal, and, at the height of World War II, convinced thousands of *Bazaar* readers to trade in their shoe coupons for ballet slippers because they weren't rationed. At the same time, she loved to have manufacturers whip up special items for the pages of *Harper's Bazaar*—must-have clothes that the reader could never acquire. (So solid was her intuition, so special was her taste that it seems only natural that she would be the one to tell Jackie Kennedy to wear the famous pillbox hat and sable muff to her husband's inauguration in 1961.)

Diana wore only French clothes but disliked the frenzy of covering the Paris collections. "How can you understand fashion smothered like this?" she asked Bettina Ballard of *Vogue.* "The terror of it, the indignity!" Leaving that coverage to the formidable Carmel Snow, Diana spent much time scouring the wholesale district and mingling with the mostly European owners in the fur, cloak, and suit world.

Diana was committed to American designers who had a look of their own; she thought they captured the youth and energy of the country. She was the first to discover the strengths of Seventh Avenue. And as the first to praise such designers as Claire McCardell, B. H. Wragge, and Norman Norell, she proved that fashion innovation did not begin and end in Paris.

Still, it was by personalizing *Bazaar*—creating an identity for the magazine that bound it to her own—that Vreeland had the biggest impact. For her, fashion was about much more than mere frocks. It was an expression of innate style, and it could be found in every aspect of a woman's life. Walking, talking, eating, thinking, traveling—if it interested Diana, it was grist for her pages.

Meanwhile, Diana herself was becoming the most talked about personality in American fashion. It could hardly have been otherwise. She lacquered her hair a deep navy blue and pulled it back in a crocheted chenille snood adorned with a bow at the top. Instead of camouflaging her large ears, she highlighted them by using rouge on her earlobes as well as her cheeks. She painted her lips and nails a clear red, slipped her feet into custom-made shoes, rested her cigarette in a holder that she wielded like a pen. These dramatic personal accessories were set against the stark simplicity of her clothing, which, in her days at *Bazaar*, was by Mainbocher. The message of this look was clear: above all else pay attention to neatness, tidiness, and maintenance.

Her daily routine was also the stuff of gossip and legend. Her morning could not begin without her ritual breakfast of tea and porridge: "My dear, how does one face life without a base in one's stomach?" Instead of coffee, she injected herself with vitamin $B_{12}$ for energy. She never appeared in her office before noon, preferring to work from her bathroom at home. Once she reached the office, she talked nonstop, with her listeners sharing her better one-liners. "Mrs. Vreeland is unquestionably the Madame de Sévigné of fashion's court," wrote Cecil Beaton. "Witty, brilliant, intensely human, gifted like Madame de Sévigné, with a superb flair for anecdotes that she communicates verbally rather than in epistles."

Long before 1954, when she was chronicled

in Beaton's *Glass of Fashion*, those in the know knew about the twenty-nine identical pairs of T-strap shoes which were religiously shined with rhinoceros horn and had soles that were polished with bootblack after each wearing. They knew that, because of the blue rinse she put on her hair, she slept on black satin pillowcases. They also knew that her apartment—later done by Billy Baldwin in "garden in hell" red Persian flower fabric—was a personal museum of her life, filled with books, photographs, and sketches of herself by Augustus John, Christian Berard, Cecil Beaton.

Amassed on every surface of this tiny two-bedroom flat at 550 Park Avenue were treasured horn-and-silver snuff boxes, an assortment of shells, and souvenirs from her travels. Diana was, quite possibly, the popularizer of the "cluttered look" that would eventually become the trademark of many interior designers. "An over-crowded Turkish seraglio on a rather elegant boat," noted Bettina Ballard in 1960.

It was here, in the evenings, that Diana shone most brilliantly. An invitation to the Vreelands meant a cozy dinner for eight to ten, with delicious food carefully planned by Reed, who recorded the menus and guest lists in a tiny leather-bound notebook. Diana held court "on a big Indian-print-covered sofa like a sultan's favorite, before and after dinner, with everyone gathered on small chairs at her feet," Ballard recalled. "She lives in an atmosphere of informal luxury confined in crowded quarters, in an aura of intimacy and mystery in which all conversation sounds important—one of the most attractive atmospheres I know."

Diana was two women at once. She entertained in a way that was rapidly becoming extinct and worked like a modern successful New York career woman. "She had a code of discipline," says André Leon Talley, the fashion writer and a close friend in her later years. "She really did take out the Madame Grès gown three days before a party so it could air. The style, the perfection was a great pleasure for her because it uplifted her spirit."

"Those two stars of modern fashion, Chanel and Diana Vreeland, were comparable," recalls Alexander Liberman, the editorial director of Condé Nast. In terms of influence, the women shared a lot. As businesswomen, however, there's no similarity. Unlike Chanel, none of Diana's style and influence translated into cash.

From 1938 until 1962, Diana's salary at *Harper's Bazaar* was less than twenty thousand dollars a year, a pittance for a woman who was the family's chief breadwinner. "Reed was always about to make a million dollars," Billy Baldwin noted. "He had the richest friends, men who made fortunes. Reed just never got around to it." In economic terms, life was a constant struggle for Diana. Her sons were attending prep school on scholarship at the same time she was scrambling to sustain the domestic luxury she required.

Why didn't she ask for raises or try to make more money? "It never occurred to me," she explained later. Perhaps she remembered that so many of the wealthy people she knew were aimless and miserable. "Money can do horrible things to ignorant people," she once observed. "They want more, the greed starts to show, and then they only want to be with other rich people to find out how to get richer."

Whatever the reason, Diana rejected every opportunity to go into businesses bearing her name. "When they want to overpay you," she liked to say, "there's usually a reason." She once told a journalist that at one point she had accumulated so much debt she had to account for every dollar she spent for the next three years, a rare admission for a woman who didn't believe in sharing her problems even with friends.

In 1962, *Vogue* asked her to be editor-in-chief, the biggest job in fashion journalism. The position came with everything she ever wanted —a large salary, a vast expense account, and

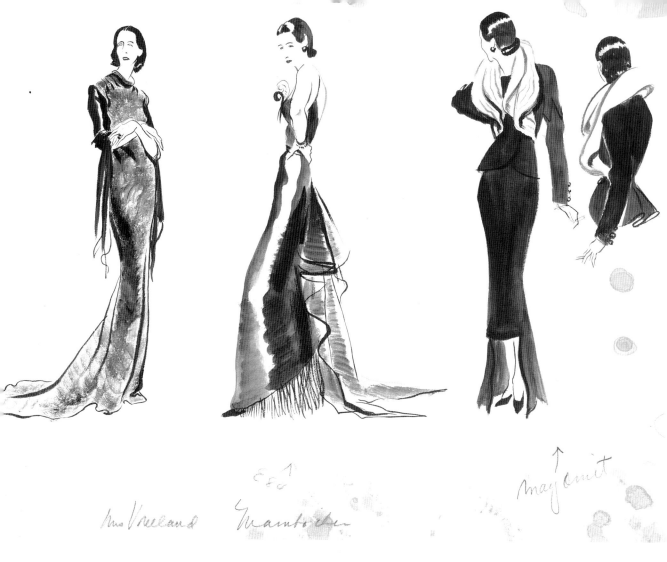

the freedom to do what she wanted with the magazine. The fashion world trembled, remembering Carmel Snow's warning: "Never let Diana Vreeland be editor-in-chief of anything, she will run a magazine right into the ground."

Those who knew Diana believed her not at all when she announced that she didn't intend to change *Vogue* in any way. Initially, Diana confounded her doubters. Sparing the magazine, she made all her changes on herself. She discarded the snood. She cropped her hair to the chin and smoothed it straight back behind the ears. She replaced her subdued Mainbochers with brilliant

᠙᠙ ABOVE LEFT: *Rene Bouet-Willaumez drew Vreeland in Mainbocher for* Vogue *in 1933.* ABOVE RIGHT: *Diana among her elegant clutter during the 1940s.*

colors alternating with cashmere sweaters that perfectly matched her skirts. And she painted her office bright red.

And then she set out to reinvent *Vogue.*

Diana's great perception was that the early 1960s were an echo of the 1920s. Like the twenties, youth ruled supreme, and there were new trends in music, clothes, and attitudes. Fashion no longer filtered down from couturiers or society women, but emanated from the street and from every strata of society. Teenagers, counterculture groups, and media idols were now news. As Vreeland read the tea leaves, it was now time for *Vogue* to shed some of its society airs and capture the excitement of what she aptly named the "youthquake."

The way to get at the new culture, Diana

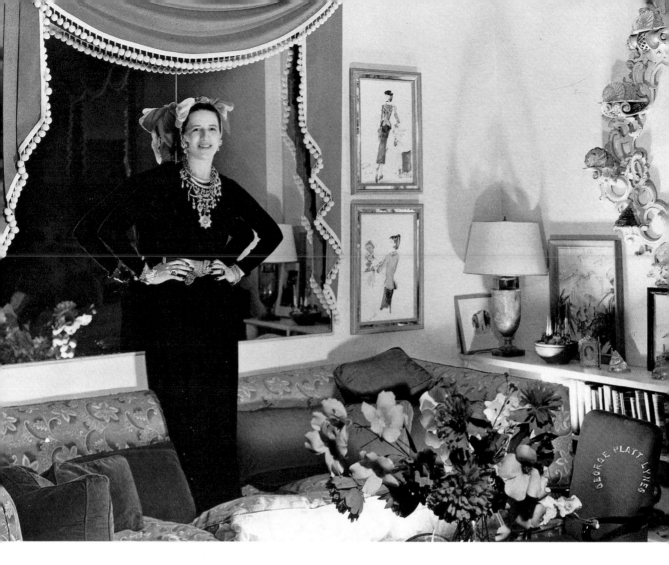

decided, was through stories that focused on personalities. So while she honored *Vogue*'s long-standing tradition of photographing debutantes, she took the most unusual-looking society girls —Penelope Tree, Marissa Berenson, and Loulou de la Falaise—and turned them into trendsetters. Next came the irregular beauties. The discovery of Verushka, Twiggy, and Lauren Hutton allowed her to do away with aloof, coldly beautiful models and invent a new creature: the celebrity model.

*Vogue*'s editorial content wasn't spared the Vreeland treatment. Arguing that "fit people like themselves better," Diana pioneered articles that discussed exercise, skin care, hair treatments, and plastic surgery. The personality profiles she commissioned were detailed, in-depth pieces on the stylish upper-class world and its denizens as they really lived. She invented the "lifestyle" piece. Using socially acceptable photographers like Horst, she invaded the private houses and gardens of Pauline de Rothschild, Marella Agnelli, octogenarian Consuelo Vanderbilt, Doris Duke, and even young and wealthy couples like the Carter Burdens.

Valentine Lawford, who wrote many of those articles, recalled Vreeland's belief that subjects "should have the taste and talent and the originality to create a rare ambience in their daily lives and surroundings." She christened them "the beautiful people" not because they were rich but simply because they were beautiful to look at. Tellingly, hers was a passionate exploration of attractive surfaces.

In the decades since Diana Vreeland left *Vogue*, her editorship has been romanticized beyond recognition. What the world remembers is her infusion of youth and vitality. A close inspection of her work, however, reveals that she balanced her ground-breaking pieces with elaborate projections of her own delicious world.

As early as 1967, astute commentators on fashion and society trends like Marilyn Bender picked up on this dichotomy. "Diana Vreeland is the conduit between the Beautiful People and the petite bourgeoisie of the United States," wrote Bender. "She does not rub elbows with the masses. By birth and marriage she belongs to an oldish society. She travels in chauffeured limousines, and except for the difference that she works extremely hard and with exceptional professional skill, she communes with the Beautiful People and lives like a Beautiful Person amid Porthault linens and scented candles."

Diana Vreeland's devotees have as much trouble accepting the notion that she was no revolutionary as they do believing that her vocational drive came from her need for money. Whatever the ultimate truth, commentators like Bender got the key fact right: Diana worked extremely hard. According to Alexander Liberman, her work ethic was as important to her success at *Vogue* as her ideas: "She was not wild; she was a disciplined savage." The woman who still didn't arrive at the office before noon was in fact

*Diana's feet encased in satin pumps.*

giving orders to her army of secretaries at 8:00 A.M. from her bathroom headquarters. Because of her fierce perfectionism, she could quite often be found well after midnight in photographers' studios overseeing endless reshoots until they captured the image she wanted.

Her motto was "I'm looking for the suggestion of something I've never seen before." But her quest for the ideal turned out to hold the seeds of her undoing. Exotica was high on her list of priorities she wanted to feature, and thanks to her contacts around the world, she had editors and photographers running all over Turkey, North Africa, and Mexico. And, soon enough, *Vogue* was featuring pictures of Verushka in Libya wrapped in Dynel braids, models in Pucci tights in the Israeli desert, a dozen pages or so about orientalism. When she was really enthusiastic about a story, it sometimes garnered as much as twenty pages. But truth was always subservient to beauty for her; although she was the first to publish models' names in the magazine, she was unsentimental about cutting up and mixing body parts of different models in order to create composite photos that showcased an ideal, if imaginary, woman.

By the midsixties, Diana's philosophy of creating fashion had transformed *Vogue* into a magazine that featured outrageous girls wearing clothes that couldn't be found in the stores, much less worn on the streets. This did not endear her to the street she had once embraced—Seventh

Avenue. A colleague recalls being in her office one day with Nicky de Gunzberg, a socialite and *Vogue* editor, when she asked, "Oh, Nicky, what is the name of that designer who hates me so?" Nicky's reply was one word: "Legion."

The death of Reed Vreeland in 1966 was a serious blow and a foreshadowing of things to come. Without her lodestar, she chose to surround herself with younger, less traditional companions who were content to sit at the feet of "Mrs. Vreeland" and savor every word that so effortlessly tumbled from her mouth. She was seen, photographed, and interviewed to death; in the process, the woman and the public image merged to create the legendary "DV."

Legends don't always sell. While her personal fame increased, *Vogue*'s advertising revenues plummeted. Worse, by 1970 the rage in fashion was antifashion. Seventh Avenue had to be placated. As Andy Warhol declared, "*Vogue* decided it wanted to go middle class." And so, in 1971, after having transformed the magazine into a chronicle of the extraordinary sixties, Diana Vreeland was fired.

"Elegance is important, courage and dignity essential," read a prominently displayed quote on Diana Vreeland's bulletin board. Whatever she felt about her dismissal, she kept it to herself. Friends recall that her only complaint was that the newspapers listed her age as "seventyish." Perhaps it was because all her emotions about the firing paled beside the more important issue: she hadn't enough money to support herself in her style. The sixty-plus woman who was by now an oracle—"The High Priestess of Fashion"—couldn't afford to retire and rest on her laurels.

In 1971, the Metropolitan Museum of Art's Costume Institute had been closed for five years while its quarters were being redesigned. "When you're not visible for four years, you're dead in New York," said Stella Blum, then the curator of the Costume Institute. As the reopening approached, the missing ingredient was visibility. Why not bring Diana Vreeland onboard? Many of her wealthy friends called the members of the Met board and pushed the idea. Her age made everyone assume she wouldn't be around for more than a few years, but there was still a resistance to hiring her as special consultant to the Costume Institute.

"She knows fashion and who wore it, but she doesn't know history" was a common sentiment among museum officials. But they didn't know about Diana Vreeland's full-throttle approach to her work, her insatiable curiosity, her originality, and her sense of fantasy. "She walked into that cellar that didn't have three visitors a day," exclaimed Truman Capote a few years after she took command of the Costume Institute, "and look what she has done."

Starting in 1973, Diana produced exhibits that not only drew fashion aficionados but enthusiasts of glamour. Her repertoire was vast: Balenciaga, Hollywood costumes, fashions of the Hapsburg era, costumes of China and Russia, Diaghilev's designs for the Ballets Russes, dance clothes throughout history, equestrian clothes, and great American women of style. Whatever the theme, the presentation was dramatic in the extreme. Visitors to galleries were seduced by period music and air scented with the perfume that best conjured up the era. Fantasy, romance, drama—by infusing these elements into her shows, Diana Vreeland redefined the idea of a costume exhibit.

Were these shows historically correct? Cultural writers criticized Diana's disregard of historical facts in exhibits like "The Eighteenth Century Woman," "La Belle Epoque," and "Man and the Horse." These shows, the critics believed, were merely an idolization of aristocratic luxury blended with episodes taken from her imagined historical world. Their inventor waved the question away. "Reality is a world as you feel it to be, as you wish it to, as you wish

it into being," Diana recalled in her memoirs.

Once again, Diana proved that she understood the climate of the country. In the 1970s and 1980s, when fashion was becoming a parade of revived ideas from earlier decades, she knew that the public wanted nostalgia. And each winter she served up a trip down memory lane into lost worlds of luxury. In the fifteen years that she reigned at the Costume Institute, her shows drew over a million visitors a year, making her the Met's most effective ambassador. In the process, she captured the public's imagination and became the last great romantic, a symbol of the grandeur of the past.

There are sprinters and marathoners in life. Diana Vreeland, who never intended to run any race at all, became, in her last years, the all-time queen of distance runners. In an era when few celebrities talked of quality and the things that endure, this woman in her eighties became the world's undisputed arbiter of fashion, taste, and style. She garnered every possible award in the field of fashion and was even made a chevalier of the French National Order of Merit.

"I loathe narcissism, but I approve of vanity," she said, and, in 1986, with her health in decline, she recognized that it would be narcissistic of her to attend the star-studded opening of her latest costume exhibition. Honoring her own dictum, she withdrew from public life. For the next three years, her bedroom was her salon. There, her closest friends read aloud from Capote, Proust, and Flaubert, while others telephoned with the latest dish about Madonna. Although it was quite clear that she would never allow herself to appear in public again, not for a second did she reduce her standards. "Right up until the end, the handbags and shoes she no longer wore were still waxed and polished," remembers a friend.

Diana Vreeland made the front page of the *New York Times* one final time in August 1989, when a headline announced her death. Next to a smiling picture, the text leaned on words like *oracle* and *myth maker* to usher her into the ranks of the immortals. The impression, not surprisingly, was that we'd never see her like again.

Diana Vreeland would have applauded that conclusion. "The energy of imagination, deliberation, and invention, which fall into a natural rhythm totally one's own, maintained by innate discipline and a keen sense of pleasure—these are the ingredients of style," she wrote. "And all who have it share one thing: originality."

Originality is more difficult to find now. It's too close to whimsy, self-invention, exaggeration—expressions of a fantasy-infused approach to life that our fact-obsessed media can't understand and won't tolerate. A woman who presented herself as Diana did would be raw meat for an investigative talent. Her fall would be as precipitous as her rise. Would-be originals know this, so they hedge their bets, play it safe, and, alas, end up stunting their originality.

Not Diana Vreeland. When asked in 1982 how she'd like to appear in a future Costume Institute exhibition of twentieth-century women of style, she jumped right in. "I'd like to be very *luxuriously* dressed," she replied. "I'd like to have on the *most* luxurious black cashmere sweater, the *most* luxurious black satin pants, *very* beautiful stockings, *very* beautiful shoes—*marvelous* shoes—and whatever would be suitable around the neck."

What would she be doing in this exhibit? She seemed not to understand the question. Her interviewer explained that women in these tableaux sometimes were involved in an activity. "Oh, no," said Diana Vreeland, ever faithful to the dual code of conspicuous style and elegant restraint. "It would just be *me*."

*So nothing would distract from her exuberance, Diana chose the simplest attire for Priscilla Rattazzi's 1982 portrait. As Cecil Beaton noted decades earlier, "To be with her is like quaffing handfuls of mountain spring water: so invigorating and fresh."*

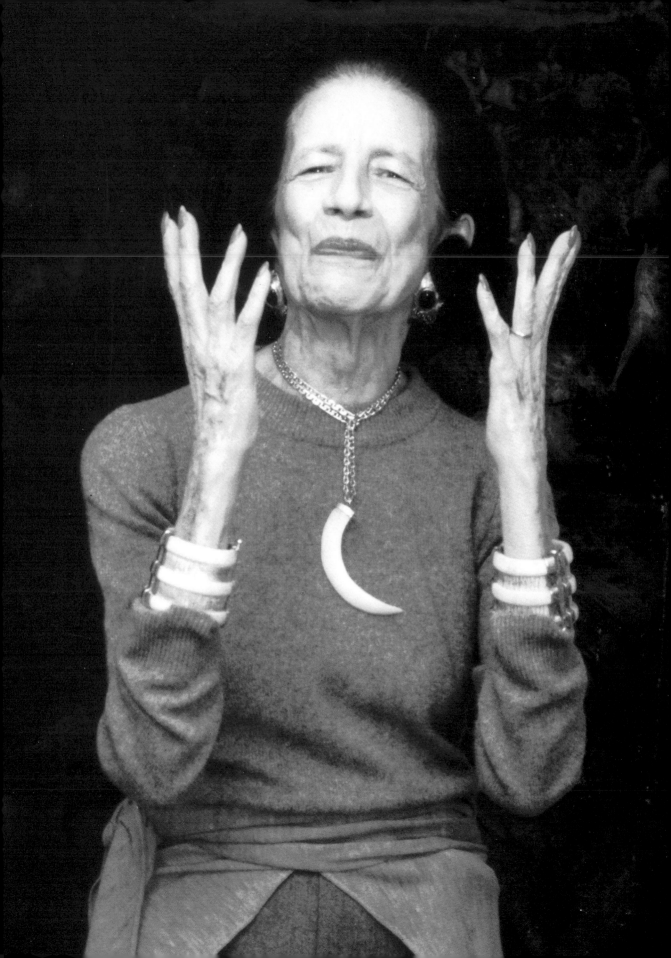

BABE PALEY     GLORIA GUINNESS

# The
# Swans

## SLIM KEITH

## C.Z. GUEST

It may be that the enduring swan glides upon waters of liquefied lucre;
but that cannot account for the creature herself—her talent, like all
talent, is composed of unpurchasable substances. For a swan is
invariably the result of adherence to some aesthetic system
of thought, a code transposed into a self-portrait; what we see is
the imaginary portrait precisely projected.

—TRUMAN CAPOTE

Truman Capote lovingly referred to these women as his "swans." *Women's Wear Daily* proclaimed them "goddesses." On two continents, they were regarded as high priestesses of the social arts, avatars with secret knowledge of beauty, fashion, decorating, and entertaining.

In recent years, these four women—only one, C. Z. Guest, survives—have enjoyed a renewed currency as style icons. Their clothes have been copied by designers, and a great many people now know what is meant by a Babe Paley luncheon shift or the Slim Keith trouser look or a C. Z. Guest twin set. Calvin Klein, Ralph Lauren, Isaac Mizrahi, Michael Kors—uptown and downtown, there's a heightened sensitivity to the shadow these women have cast. It's not hard to understand why. These women, legend has it, not only made great marriages, they maintained a standard of social excellence in a way that emphasized dignity and discipline and downplayed money and power.

The legend has it almost right but omits the immense personal cost that some of these women paid for their clothes, houses, and publicity. Although they seemed to be ladies of leisure, they actually worked immensely hard to please men who were, for the most part, never satisfied. Style, supposedly their reward, was really something less for them—their solace. To celebrate their lives without giving equal time to their tragedy is to miss the point entirely.

# BABE PALEY

Barbara Cushing Mortimer Paley, the most exalted of these women, spent her life making sure that everything was perfect. This obsession with creating an ideal world for the benefit of others extended, in her case, beyond death. For Babe had, in her ever-thoughtful way, planned her funeral and the luncheon that followed it. In fact, she planned them twice—one menu in case she died in summer, another for winter. Naturally, the lunch was exquisite. "The only one missing," friends said afterward, "was Babe."

Babe's "finishing school" began at birth. She was the daughter of an eminent but not wealthy Boston brain surgeon and a socially ambitious mother whose main goal was to steer her three beautiful daughters toward powerful and socially prominent men. Babe, the most beautiful of the famous Cushing sisters, held the most promise, even after a serious car crash that resulted in reconstructive facial surgery when she was eighteen. She had dark flashing eyes, a sculpted bone structure, luminious pearl-white skin, a ballerina's long neck, and a model's willowy figure. Complementing her looks were a lively interest in people and a gracious, thoughtful nature. She was, in short, first-rate marriage material.

Her first husband was Stanley Mortimer, a Waspy, old-money New York blue blood. In 1940, he was very much the correct match—although not correct enough for Babe's mother, who had hopes for a match with a powerful, rich man who came with a title. At the time of her marriage, Babe worked as a fashion editor at *Vogue*, where she put her innate fashion sense to good use and frequently posed for *Vogue* layouts.

"The shape of her face is as attenuated as an El Greco," recalled the noted *Vogue* photographer Erwin Blumenfeld. "She has the most luminous skin imaginable, and only Velázquez could paint her coloring on canvas. Her mouth is

*In addition to working as an editor at* Vogue *in the 1940s, Babe often posed for fashion layouts.*

like that of the fascinating Madame Arnoux in Flaubert's novel *Education Sentimentale*. She has the gentleness, poise, and the dignity of one of those grandes dames whom Balzac described in his *Comédie Humaine*. As for clothes, instead of merely wearing them, she carries them."

By 1946, Babe was, for the second year in a row, on the best-dressed list. She was also divorced from Mortimer, the mother of two children, and living on limited funds. She continued to work at *Vogue* and dress well on a shoestring, always remembering to choose quality over quantity. The fashion press adored her and showered praise on the designers she favored. Soon enough, she had joined the pantheon of women who get their clothes free in exchange for the press attention they generate.

Babe now set out to make a second brilliant marriage. This time, she avoided names like Phipps and Vanderbilt. Her experience with family trust funds had not been a happy one, in the end providing only a modest divorce settlement and barely adequate child support. William Paley was different. A pioneer in radio and television broadcasting and the founder of CBS, he was, by his midforties, a modern American success story. He was phenomenally rich. And he was estranged from an attractive and cultured café society socialite who had educated him in art so well that he was already a major collector. Paley was almost everything Babe had been bred

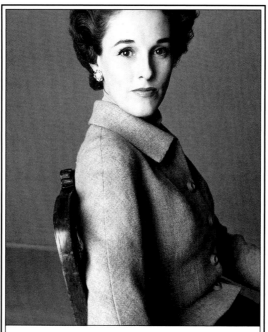

❦ *Her beauty, grooming, and style created an image of perfection.*

to marry. The only hitch was that he was Jewish, new moneyed, and largely self-made.

In Babe's world, those were all liabilities. But Babe and Bill were the perfect match for one another; each was looking for the very thing the other had. For Babe, the attraction was wealth, power, and worldliness. Paley, for his part, wanted entrée into the highest echelon of the Wasp society. She was the ultimate *shiksa* goddess, who just happened to be the sister-in-law of Vincent Astor and the man he most revered, Jock Whitney. This was no mere woman; this was a possession and a showpiece.

After their marriage in 1947, the Paleys set their sights on a common goal: the creation of a glamorous, picture-perfect world. During the week, they lived at the St. Regis in a suite decorated by Billy Baldwin (it was only after her children—two from her first marriage and two with Paley—were grown that they moved to a twenty-room duplex on Fifth Avenue). But the focus of their entertaining was Kiluna Farm, a sprawling estate on Long Island.

Neither Paley's wealth nor Babe's social standing could completely erase his "Jewish problem." Although the marriage was noted in the *New York Social Register*, they were not included in later editions. He was also rejected by several exclusive men's clubs. And despite Babe's connections, they never gained entry into society enclaves like Bar Harbor, Maine.

None of this was lost on Babe. She artfully cultivated a private club of her own, in which she and Paley were the only committee members. By excluding those who had excluded them, the Paleys established an independent power base.

Unless you were a close friend, they were unreachable on the telephone; a letter was required. They rarely attended benefit balls or cocktail parties, preferring to dine with friends or, if the occasion warranted, hold a private party in the ballroom of the St. Regis. They vacationed with rich and social Europeans: Loel and Gloria Guinness, Baron and Baroness Guy de Rothschild, and the Agnellis. At home, their circle blended a stellar combination of show business, high society, and powerful business types. All this, by the 1950s, made them the most talked about and sought after couple in New York.

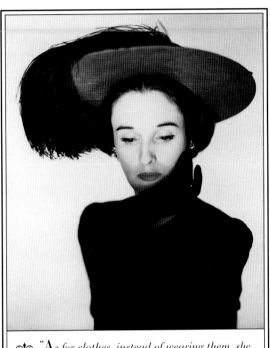

❧ "As for clothes, instead of wearing them, she carries them," it was observed.

Once you were admitted into the Paley club, it was impossible not to be seduced. The precision and luxury with which Babe ran her establishment were on a scale found only in the grandest houses in Europe. Servants were at the ready to pack and unpack, to draw baths, and to wash or iron for the guests. The bedrooms were stocked with every comfort and convenience. And the food, the food. "It was so original, even a lamb chop was unlike anything you had ever tasted," observed a frequent guest.

For over thirty years, the fashion press recorded Mrs. William Paley's every move. In the process, she set a standard of elegance for style-conscious women across America. Although she appeared on the best-dressed list fourteen times before being inducted into the Fashion Hall of Fame in 1958, she didn't achieve broad recognition until the 1960s. In that decade, she was an inspiration for store mannequins, fashion illustrators, and photographers.

So when Babe, who was then in her fifties, decided to let her gray hair show, masses of women followed suit. When she wore a pantsuit to lunch at Quo Vadis, it became acceptable. Once, photographers snapped her picture in front of La Grenouille with her scarf casually tied to the side of her handbag —she had removed it en route because it was too warm. Within a few months, it was a fashion "look." In 1990, twelve years after her death, designers from Paris to New York reinterpreted the refined and spare A-line shifts from the sixties for their Spring 1991 collections.

But no matter how slavishly Babe was imitated, no one could really duplicate her style. "She is the only woman I have seen who can wear a Chanel and make Chanel's Chanel a Paley style," observed John Fairchild in *The Fashionable Savages*. "I remember when she walked into La Caravelle in a beige Chanel with the usual Chanel braiding. It didn't look like a Chanel, because around her neck she had tied a long, long scarf (which went to her waist),

making the Chanel less hard, more feminine."

Unlike other fashion icons, she was never identified with one designer. Instead, she mixed off-the-rack Givenchy with Norman Norell, Chez Ninon, or an Ohrbach's knockoff. To those who knew her, her clothes never dominated her. "I never saw her not grab anyone's attention," recalled Bill Blass. "The hair, the makeup, the crispness. You were never conscious of what she was wearing; you noticed Babe and nothing else."

"Babe Paley had only one fault: she was perfect; otherwise, she was perfect," Capote remarked. But for the woman who washed and ironed her custom-made heavy white piqué blouses herself because she "wouldn't ask anyone else to do it," Babe's quest for perfection wasn't just about self-satisfaction. She was working over-time to please a demanding taskmaster of a husband. For all her elegance, for all the style that permeated her life, she was never good enough for the man who had ostensibly married her for just those qualities.

"What rich man is nice to his wife?" observes a wealthy and wise society matron. Typically, Paley made sure—for his own ego—that Babe was swathed in sable and covered in significant jewels, for her appearance was the ultimate symbol of his success. But was he successful enough for men like Jock Whitney and Loel Guinness? He never felt he was, and so he constantly pressed Babe to fresh heights of flawlessness, never realizing or caring what it cost her.

Her unceasing focus on her husband's limitless social ambition took its toll on all her children. It took a higher toll on her. For the husband of one of the world's most beautiful women was a notorious philanderer who lost sexual interest in his wife after a few years of marriage. The media attention that Babe garnered thus became of paramount importance to her battered self-esteem.

Even the media placed a certain stress on her, forcing her to maintain the unreal image of a goddess. By the late sixties, in a last-ditch effort to save herself, Babe attempted to separate herself from Paley. She had always been told that she could draw, paint, and sculpt beautifully. Now she took classes. And she reached out to Truman Capote, her closest confidant, unburdening herself of the pain of her marriage — unwisely, for he would betray her in *La Côte Basque*.

Capote and Babe's other "walkers" entertained her with their wit and gossip, and attended her in a way her husband never had. Most were accomplished in the arts, helping her fill the gaps in her spare educational background. They recommended books and instructed her in history, art, and music. Because these relationships were platonic, Paley was never jealous—although he had rejected Babe sexually, he had an irrational Mediterranean sense of propriety if he sensed a heterosexual man on the premises.

But the respites from Paley weren't enough. In the end, his demands and his infidelities wore her spirit down, not a good thing for a woman

❧ W*earing Paquin for a* Vogue *fashion shoot.*

smoking two packs of cigarettes a day. If stress is indeed a cause of cancer, then Babe's marriage can certainly be said to have contributed to her illness. What followed the doctor's verdict was the stuff of opera: after she was diagnosed with lung cancer in 1974, Paley was at last confronted with a force stronger than his wealth and power. While he devoted the next four years to saving Babe—and belatedly declared his love for her—she hurled decades of pent-up anger at him.

Although she was bitter and in great physical pain, Babe confronted her death, like everything else in her life, with elegance and dignity. She not only planned her funeral lunch down to her favorite white wine—Pouilly-Fumé Ladoucette—she carefully and thoughtfully allocated her jewels and bibelots to relatives and friends, noted each selection on a file card, and, in many instances, even wrapped the gifts in chic, colorful paper and placed them on a shelf in her closet for distribution after her death.

"A beacon of perfection in an era of casual convenience," read the eulogy that Paley and her friends Slim Keith and Irene Selznick wrote together. Babe would have graciously accepted the praise, but she would have been much more content with her obituary in the *New York Times*. This tribute, while not ignoring her role as a fashion symbol, placed emphasis on the part that was the true essence of her beauty and style: ". . . a gracious woman with a ready and warm smile. Her friends readily noted her sense of humor, enthusiasm, and thoughtfulness." This final anecdote, told by a friend, is perhaps the most telling. "I remember when she was going to China and she was told that the luggage carriers there were older women, she decided to take only one suitcase with her, because she said that she would be embarrassed to have her luggage carried by an older person and she wanted to be able to handle it by herself."

❀ *Hers was a cool, calm, detached style.*

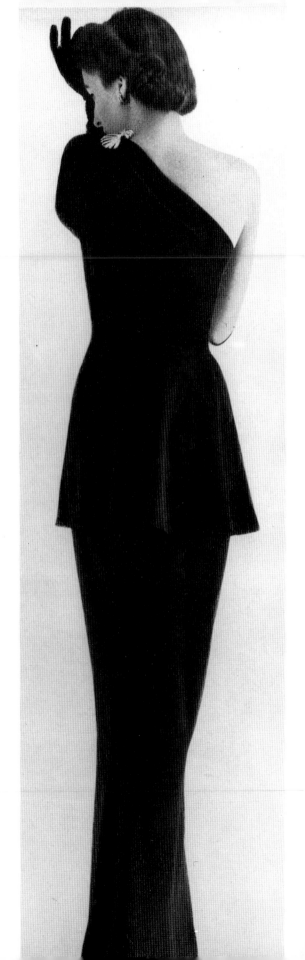

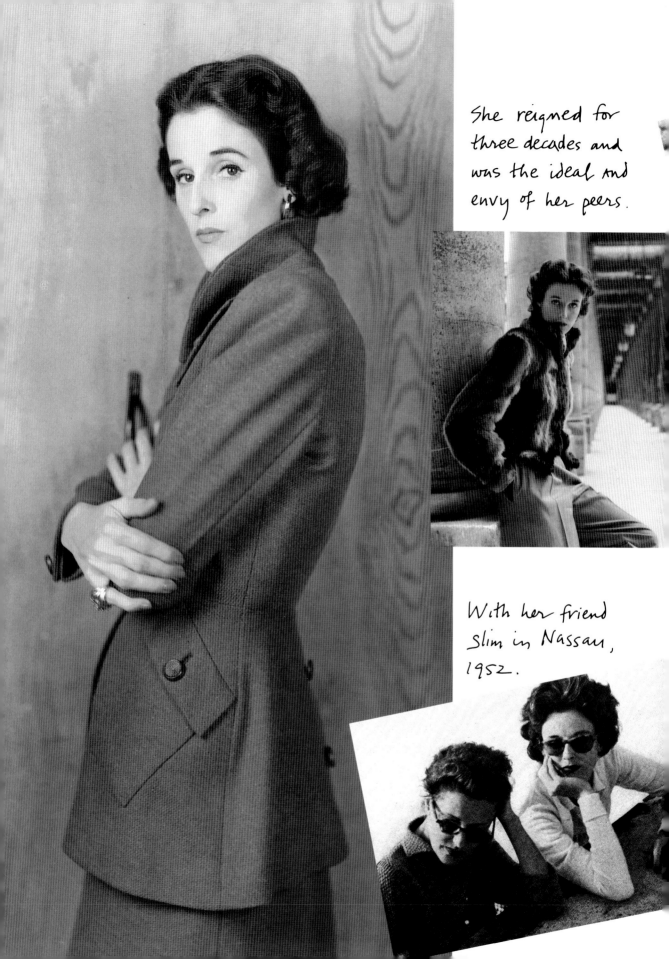

She reigned for three decades and was the ideal and envy of her peers.

With her friend Slim in Nassau, 1952.

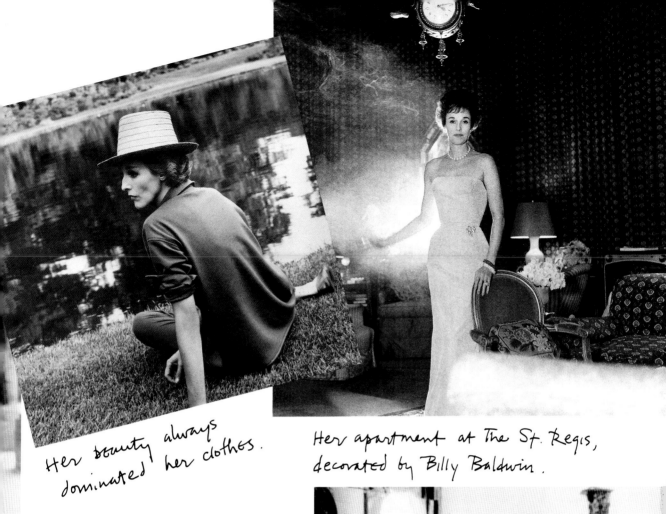

Her beauty always dominated her clothes.

Her apartment at The St. Regis, decorated by Billy Baldwin.

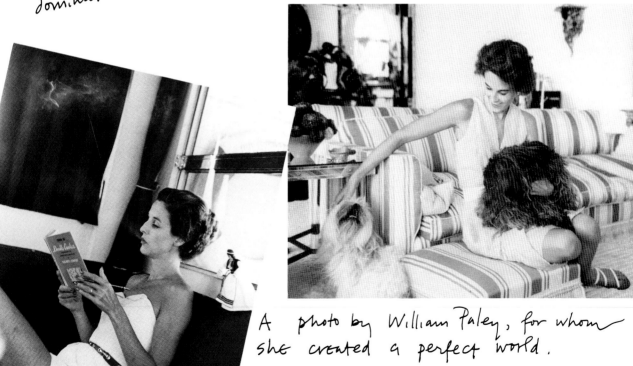

A photo by William Paley, for whom she created a perfect world.

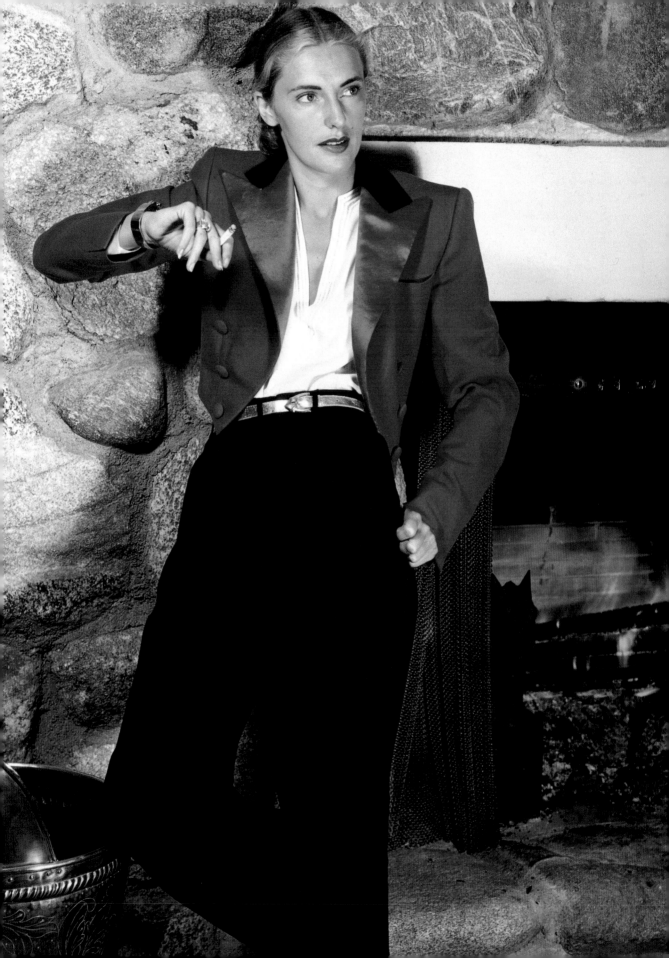

# SLIM KEITH

I never thought as a young woman that I was beautiful, which, in retrospect, I probably was, or at least damn good-looking. I never thought my hair was right or my dress or anything was *right*. But I plunged ahead somehow, and it always was right."

Unlike Babe Paley, Nancy Lady Keith—who was better known as Slim—wasn't renowned. And yet it is her style and not theirs that has had the most enduring impact on American culture. For it was Slim who saw Lauren Bacall's photograph in *Harper's Bazaar* and told Howard Hawks, her husband and one of Hollywood's top film directors, that this was the unknown he wanted to play opposite Humphrey Bogart in *To Have and Have Not*. Lauren Bacall was, Slim thought, "my taste in beauty: scrubbed clean, healthy, shining, and golden." She might have been talking about herself; that was her own look.

Bacall landed the female lead, and, in 1943, the world saw her thoroughbred look become a style that would be her signature. What the world

ᚙ She was the first to be identified as the epitome of the "California girl."

didn't know was that the director's wife was so much of an inspiration for Bacall's character that, in the film, Bogart even gives her the nickname Slim. Everything from the wardrobe to such insolent and sultry lines as "You know how to whistle, don't you? Just put your lips together and blow" belonged, in real life, to Slim.

She was born Nancy Gross in Salinas, California. Her father was cold and domineering; her mother was passive but loving. It was a combination that led to oppression and melodrama. Somehow, their daughter emerged a self-assured, lively, and witty young girl who also happened to be tall, skinny, as well as exceedingly pretty. Unlike some of her contemporaries, Nancy wasn't groomed to marry a prince or a millionaire. Nor was she intent on escaping her past by climbing the social ladder. The fact is, Nancy Gross had no ambition.

Her talent, if you can call it that, was being in the right place at the right time—and then following her instincts. Her first lucky encounter was with William Powell, the 1930s screen idol, when she was seventeen. When they met at a hotel in the Mojave Desert, he gave her a nickname that would cling to her long after it no

ᚙ At home in 1945, wearing an outfit that she designed herself.

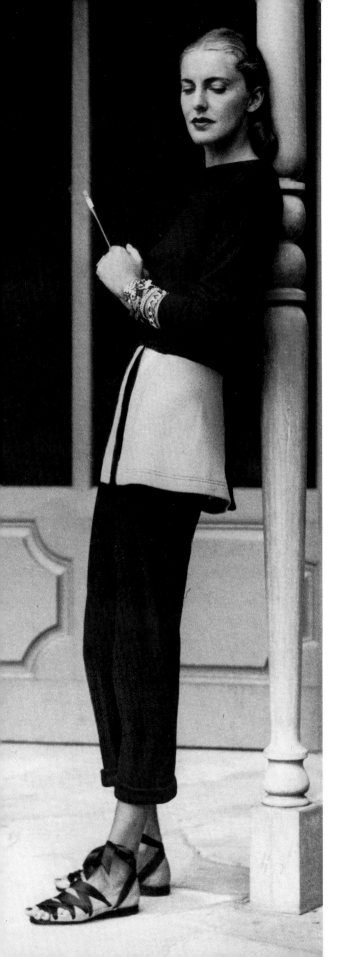

longer applied. Slim, convent-educated and fairly sheltered, was intrigued by the glamour of the movies. And with Powell as her guide, she had an instant entrée into haute Hollywood. She was instantly accepted—she'd made it clear that she didn't have the acting bug, she simply wanted to be where the action was.

She became one of William Randolph Hearst's favorite guests at San Simeon and could count among her friends such dashing leading men as David Niven and Cary Grant. By the time she met Howard Hawks, who was twenty-two years her senior, she still hadn't been lured by the silver screen, a lack of opportunism that, once again, sparked a powerful man to become interested in her.

Slim did have an ambition: to be with Howard. "He was exactly the package I wanted," she wrote in her autobiography. "The career, the house, the four cars, the yacht—this was the life for me." As Mrs. Howard Hawks, the twenty-four-year-old Slim was, like Gloria and Babe, a trophy wife, a hostess acclaimed for her entertaining and the originality of her decorating.

In a city where the status houses were a blend of "Moorish palaces and Spanish haciendas, garishly out of place," Slim's dream house was a stylish creation concocted from her clever imagination. On a huge piece of acreage, she commissioned a New England–style dwelling that was based on the set plans for her husband's film *Bringing Up Baby.* She turned it into a working farm, complete with her own fruit-and-vegetable garden, pigs, and chickens. Here, she found herself playing a new role: nest maker.

The natural by-product of a life with a major talent is an endless round of parties and premieres. This was Slim's world, but what she loved best of all was to run her house, ride her horse, garden, go to the skeet range, fish with Hawks and his buddies William Faulkner and

*Her lean beauty epitomized her nickname.*

Clark Gable, and shoot pheasant with Ernest Hemingway. Unlike some of her stylish counterparts, she was just as comfortable fussin' and cussin' with heterosexual men as she was shopping or lunching with a girlfriend.

This combination of sexy and outdoorsy, chic and athletic, was what attracted Carmel Snow, editor of *Harper's Bazaar*, in the midforties. In 1945, Slim was featured four times—not as a model but as herself—in an ongoing celebration of the all-American, long, lean, and tawny "California girl." A year later, she was named one of the best-dressed women in the world.

Slim claimed that if she had any talent at all, it was for individuality. What made her look unique was that there was no pretense to it. Everything about her seemed accessible and attainable. This populist approach to style was light-years away from the code of Hollywood's elite, with its movie-star getups that featured snoods, pompadours, and frills. Slim insisted on being photographed in her everyday clothes: suede jackets, men's jeans, and thin blue denim workshirts that were sold in Sears. On her feet were soft leather mocassinlike loafers and thick angora socks—modeled on her husband's —that she crocheted herself. This was what she called her "house uniform."

Five decades later, that style is still up-to-date, in part because it's been continually reinterpreted by such classic American designers as Ralph Lauren and Calvin Klein. The difference is that what, for Slim, was dressing down is today identifiable with wealth and pedigree. Even her hair, worn pulled back into a ponytail, is now considered a classic Wasp look.

Slim was not above self-invention. She begins her memoir with a warning that her memory is "a rickety contraption at best." Surely, she could have cast herself in the role of fawning helpmate and made the kind of brilliant marriage that was the speciality of so many of her friends. But she wasn't, at bottom, made of the same stuff as Babe or Gloria. However much she may have once been tempted by men of power and wealth, she couldn't squash her emotions. Until her last marriage, Slim never confused love and a deal; she was slow to make the Faustian pact that turned her friends' seemingly dazzling marriages into tragedies.

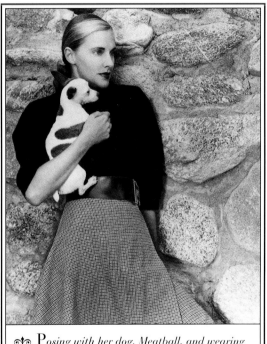

ɚ P*osing with her dog,* Meatball, *and wearing* Claire McCardell.

Her marriage to Hawks ended after eight years. Her marriage to Leland Hayward, the film and theatrical impresario, ended after ten. Her third marriage, to Lord Kenneth Keith, a captain of British industry, lasted no longer. "Ten years, that was usually my run," she once said.

In her final years, Slim lived in New York, at the center of a spirited and robust salon. She said she regretted nothing, except perhaps her lack of discipline. Paradoxically, if she had been born with just a bit more steel in her character, she might have turned out to be less content.

# GLORIA GUINNESS

abe Paley may have labored to make sure that she maintained her position as the world's most elegant woman, but her kind nature would never allow her to stoop to deviousness to get or keep that title. Not so her close friend Gloria Guinness. Gloria's need to dominate was stronger than any mere friendship. For her, the idea that a beautiful female friend could be an ally was a quaint canard. And, without any qualm of conscience, she took advantage of every opportunity to diminish Babe's astonishing presence.

Gloria's most successful schemes occurred on her own turf, usually when the Paleys came aboard the Guinness yacht for their annual summer visit. To ensure that she wasn't outdone in clothes and jewels, she always gave Babe careful instructions on what to pack—or rather, what not to pack. One year, she advised Babe to bring simple attire and no jewelry. After all, she pointed out, the purpose of the trip was low-key relaxation. Babe dutifully followed this practical advice. But no sooner had the Paleys arrived

&⁊❧ *Gloria wearing Balenciaga's Venetian red taffeta dinner dress for* Vogue, *1945.*

than Gloria announced they were invited to a formal dinner off the yacht. Hours later, Gloria emerged from her cabin dressed to the nines and wearing her jewels. The following year, Babe decided not to take any chances; she arrived with her baubles. "Really, darling, why all the jewelry?" Gloria coolly remarked when she first caught sight of Babe's awesome array. "We're just on a boat!" And this time, Gloria made certain that the trip excluded fancy dinners.

It's easy to understand why Babe and Gloria were in competition. Each one ruled the world of style on her respective continent from the 1950s until her death (Gloria, who died in 1980, outlived Babe by two years). Physically, they were similar; like Babe, Gloria had a slender, lithe figure, with dark hair and eyes that were offset by camellia-pale skin, a long swan neck, and Nefertiti-like profile. Each had a sleek, uncluttered approach to fashion and maintained an impeccable appearance. And each presided over many houses with a facility for organization that could run a major corporation. There was a marital bond as well; like Babe, Gloria was married to a tycoon who exerted complete control over her.

&⁊❧ LEFT: *Posing for* Vogue *in 1949 wearing a "late day" dress made for her by Schiaparelli.*

But in as many ways as they were alike, they were opposites in character and background. Gloria was a feisty, earthy Mexican from humble origins who had worked hard to become the wife of Loel Guinness, the English banking magnate. By her heritage, Babe may have been the more exalted of the two, but Gloria was definitely more intriguing. Unlike Babe, who created an air of mystery to maintain her flawless image, Gloria was mysterious for other reasons—"perhaps because she had a lot to hide," speculates an aristocratic French woman who knew her.

It's certainly true that Gloria Rubio von Furstenberg Fahkry Guinness reinvented her origins so many times that no one knew what to believe. At one turn, her mother was a seamstress; at another, she was the devoted wife of Gloria's left-wing journalist father, who, because of his politics, was forced to flee from Mexico. According to that story, the Rubios came to New York and were supported by J. P. Morgan, an "old family friend," while young Gloria was sent to school in Europe.

On one level, Gloria covered up her background; on another, she seemed not to care what anyone thought. Once when she was dining with an English duke, he asked, in a voice loud enough for all the guests to hear, "Is it true your mother was a laundress?" "Yes," she said, and without missing a beat, she continued eating and talking to her dinner partner.

Regarding her life after she left Mexico, she was equally covert. It's been said she started out as a manicurist, that she was a shill in a nightclub in Berlin, that she was the proprietor of a hat shop in Madrid and the mistress of a newspaper magnate. The most widely reported theory is that she was a spy during World War II. When Loel Guinness married her in 1949, it is rumored, she didn't have a passport—and he's later said to have paid one million dollars to obtain the dossier on her wartime activities. Only one thing is sure: she was married twice before she snagged Loel Guinness. The first time was to Franz von Furstenberg, a German count with whom she had two children. The second time was to the son of an Egyptian diplomat, whom she lived with in Cairo.

If her past stirred up controversy, so did her personality. To some, she was a mean-spirited wench and a troublemaker. To others, she was just another woman who delighted in exploiting men. "Gloria was happiest when she was an adventuress. She really liked that," the Duchess of Windsor once sniffed. Gloria might not have agreed with that summation; she once remarked to a friend that she had actually been happiest when she lived in Cairo and darned socks for her penniless Egyptian.

Those who adored Gloria have remarked on her rampant enthusiasm for life, her great sense of humor, her endless curiosity, her seemingly limitless intelligence, and her deep appreciation of the privileged life she had acquired. "Gloria was very conscious of wanting to be an original," recalls her friend Freddie Melhado. "She didn't want to just be the wife of a rich man, she wanted to be somebody. It was appealing and beguiling that she knew her struggles and admitted them."

One thing all who knew her agree on is that she was unfailingly confident. "When she was poor, she told everyone fur coats were tacky," Reinaldo Herrera says. And when she was rich, unlike other women in her set, she wasn't modest about her extraordinary style. "Chic? It is absolutely innate, I was born with it. Chic cannot be taught," she announced to *W* magazine.

Most of all, she was comfortable with her down-to-earth Latin nature. "I could never sleep in the same bed with Loel," she told Noël Coward over lunch at Piencourt, the Guinness château in Normandy. "He farts too much." Her favorite lunch spot when she was in Palm Beach was Howard Johnson's. And she enjoyed a good boxing match. Paradoxically, this was the same

woman who, when stung by a wasp in her rose garden at her house in Lausanne, immediately ordered the gardeners to pull out every last bush; and who once told a journalist, "I've never worn costume jewelry in my life. It's really very self-defeating. Why should a man buy a woman real jewelry when she wears false pieces?"

Even before Gloria was wealthy, she outshone more privileged women. When she first arrived in Paris before World War II, she lived in a walk-up apartment. "La Guinness was the chicest of all in a black cardigan and black skirt," John Fairchild noted. As she climbed up the social ladder and took a position next to other great ladies who had money for beautiful clothes, she never discarded her minimalist look.

Wealth only allowed her to carry her art of underdressing to a new level. Her favorite designer was Balenciaga, the master of spare, clean lines. He returned the compliment, claiming that she was the most elegant woman he dressed. "I do not follow fashion. I believe in consistency," she told an interviewer. "Every time I have tried to change my look, I have been unhappy."

She had an unerring eye for what was right for her. Like Millicent Rogers, she rarely took a designer's idea without insisting on some changes; she knew that the way she wore the clothes took precedence over what she had on. Her quest for originality bordered on the selfish. "She always wanted more style by herself," Givenchy remembers with amusement. "She always wanted it more personal. 'Hubert, why don't you do something special for me?' she would ask."

Although she told Balenciaga where to place the buttons and backed Antonio Castillo when he left Lanvin to open his own *maison couture*, she could have coined the phrase "throwaway elegance." "She could make an ordinary white Hanes T-shirt look chic," Oscar de la Renta told me. And she seemed to relish that talent. She

❧ *Gloria at her Acapulco retreat.*

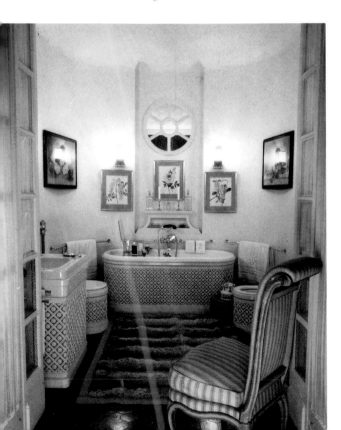

was able to accessorize one of her couture dresses with a scarf she'd found in the Prisunic—France's version of K-mart—and have it look terrific. When *Time* magazine did a profile about her entitled "The Rich, Having a Marvelous Time," the correspondent asked what her favorite at-home costume was during the day. "Comfortable robes that I pick up for twelve ninety-five apiece in Manhattan," she replied. Her trademark Palm Beach sun hat was a jaunty straw model from the local five-and-ten.

Unlike Babe, who gave just one interview to the fashion press, Gloria was more than happy to share her fashion *pensées*. During the sixties, she spent seven years as a contributor to *Harper's Bazaar*. Her first article, in 1963, defined elegance: "Elegance is in the brain just as well as in the body and in the soul. Jesus Christ is the only example we have of any one human having possessed all three at the same time." In her other essays she was equally fatuous. "Those who create chic are the passive dictators of our modern life," she wrote. About love, she was merely banal: "the most beautiful word in the English language. It is also the most common. It is almost as common a word as money and it is nearly as necessary."

For the wife of one of the world's wealthiest men, writing might seem like an indulgence or a way of getting attention. Not so. "She drove a bargain that would have pleased any professional author," Marilyn Bender wrote in *The Beautiful People.* Her reason was the same as most writers'—she needed the money.

Babe had a trust fund set up by her husband that gave her $160,000 a year to spend on herself—exclusive of jewelry, which Paley bought for her—but Gloria was under the financial control of her parsimonious husband. She had no money of her own, and he doled his out to her

as if she were a child. Even the jewels she wore weren't hers but the property of the Guinness Corporation. Loel would personally take the jewelry out of the safe for Gloria to wear. And then he would personally return it the next day. "Gloria had to fight for everything," recalls a friend, writer Nancy Holmes. "I remember the drawing room in her house in Lausanne was covered in the cheapest chintz you could buy. But she had everything so exquisitely made that it looked wonderful—she was very proud of things like that."

For all his tightness, Guinness appreciated his wife's taste and talent for organization. "After he married Gloria, he found himself sailing from yacht to yacht with the jet set, which wasn't really his game," an observer recalls. " 'How do you put up with it?' someone once asked him. He replied, 'I have houses in Acapulco, Normandy, Lausanne, and Paris. I have a yacht and a plane, and because of Gloria I never have to worry about any of it.' "

Loel Guinness was an infinitely more confident man than Bill Paley. He didn't demand more than perfection from his already perfect wife. But he did, like Paley, view his wife as a fabulous armpiece, the woman in charge of decorating his life. Although Guinness wasn't the notorious womanizer that Paley was, he wasn't above having a mistress. When Gloria found out, she was distressed, but not for the obvious reasons. What wounded her was that her husband and his mistress mostly took long walks and talked, the very thing she longed for Guinness to do with her.

Like her friend Babe, Gloria loved writers, painters, movie directors, and world leaders. To them, she presented herself as the quintessential warm, high-spirited Latin who loved to dance and entertain. "Wherever she is you feel comfortable, relaxed, and glad to be there," a friend has said. "A luxurious background isn't really necessary to her at all—she makes her own atmosphere. If she were entertaining three or four people in a whitewashed cell, she'd find some new way of arranging things that would be attractive. And whatever there was to eat and drink, there'd be a lot of it—a feeling of *abondance*."

But behind this facade was a woman who, according to friends, battled depression. If her beginnings were a mystery to her friends, so was her death. The papers reported that she was found on the floor of her bathroom, dead of a heart attack at sixty-five. Many believe that. But there are others who claim that the woman who became so celebrated for her beauty and style that *Women's Wear Daily* dubbed her "the Ultimate" was, in the end, disillusioned by the life she had always desired, and had killed herself.

Her last interview with *W* in the summer of 1980 is revealing. She told Patrick McCarthy that privacy was the most important thing in her life and that she had no desire to go out anymore: "Where could I go anymore? When I was young, there were restaurants, wonderful nightclubs, and beautiful parties. But now everyone wants to go to a disco. You can't meet people, you can't even flirt properly. And then some beautiful sixteen-year-old with long blond hair comes along and all you feel like doing is hiding in the corner."

It is instructive that, after Gloria and Babe were dead, their masters were dining together and the conversation turned to the inevitable. "Isn't it interesting," Paley mused, "that we were both married to women of enormous vitality—and we've outlived them?"

*I didn't make up all this legend stuff, somebody else did. I think everyone envisions me sitting at Alexandre's all day, picking out beautiful clothes from passing courtiers. My God, could you imagine the boredom."*

# C. Z. GUEST

I remember seeing C.Z. once in Paris, in the fifties," Bill Blass recalls. "She came into the bar of the Ritz wearing a knee-length tweed skirt, a twin set, and mocassins—and in a time when everyone else was tarted up in Dior's new look, she stopped traffic."

"Many women make their grand entrance at Lincoln Center looking like exotic orchids in diamonds and paint," John Fairchild wrote in 1965, "while Mrs. Guest walks briskly down the aisle in a pale cream cardigan suit."

And so it goes, decade after decade: homage paid to a woman who claims she has never aspired to be in any pantheon of style. "I had no idea I'd been photographed so much," she told me when confronted with a sheaf of pictures taken by some of the century's greater photographers. "I didn't think about it much. I was just busy leading my life."

Leading her own life was something that came naturally for the former Lucy Cochrane. Born a Boston Brahmin, she was a rebellious debutante who, at twenty-four, landed a job as a showgirl in the Broadway revival of the Ziegfeld Follies. Darryl F. Zanuck, who had a professional eye for young talent, met her at a party, arranged a screen test, and bestowed a seven-year contract on her. Characteristically, she left Hollywood after nine months. She next surfaced in Mexico, where Diego Rivera painted her—nude—and then displayed the work in the bar of the Hotel Reforma.

Winston Guest, a scion of the Phipps family, had seen a photograph of this astonishing young

❧ *Mrs. Winston Guest at her Sutton Place apartment, wearing one of her signature Mainbocher gowns in 1959.*

Snapped by
Cecil Beaton in
Spain.

Photographed at Villa
Artemis, 1969.

For four decades
C.Z. Guest has been
the prototype of the
classic American
thoroughbred look.

Wearing brocade Chinese
pajamas of her own design.

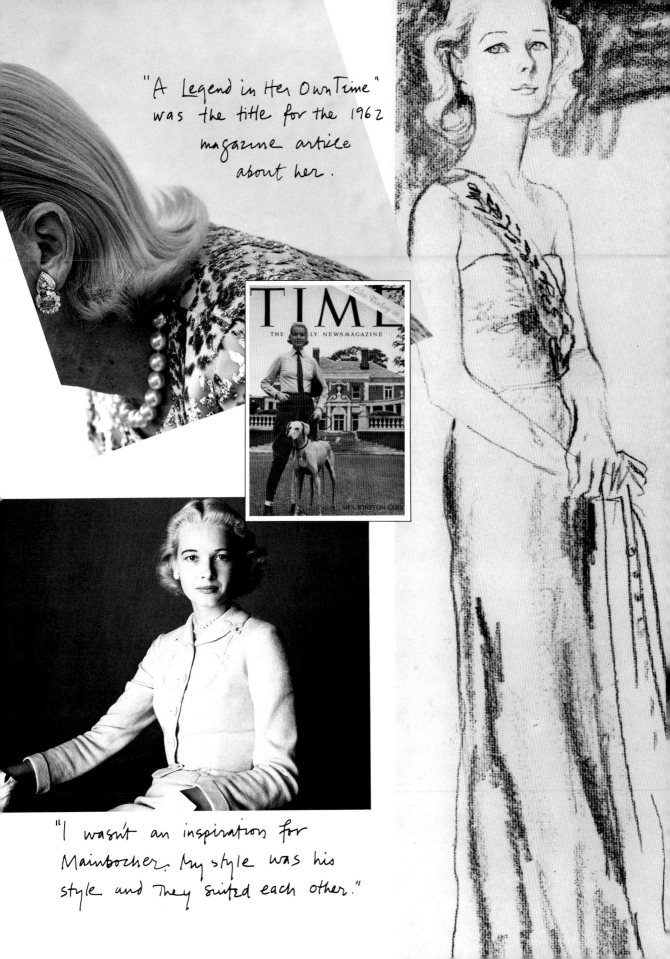

"A Legend in Her Own Time" was the title for the 1962 magazine article about her.

TIME
THE WEEKLY NEWSMAGAZINE

MRS. WINSTON GUES

"I wasn't an inspiration for Mainbocher. My style was his style and They suited each other."

woman. She was tall, slender, ash blond, with a greyhound's elegance and a twinkle he hadn't seen often in women of her class. He wrangled an introduction. In 1947, at Ernest Hemingway's plantation in Cuba, they were married.

For some society women who have had a taste of bohemia, the safety and rigidity of a dynastic marriage is the beginning of the end. "Most of my friends died from liquor and pills," C.Z. confirms. "Brenda Frazier, Diana Barrymore—they were all pals, but they drank and were unhappy. Luckily, I had a focus. I married, I had a family, I never divorced. I always thought when you married it was for life. You had to stick with it and be brave and cope with the problems."

In confronting her problems, C. Z. Guest had more than a belief system, she had a code of conduct. As a child, she had been trained by champion riders and went on to compete in horse shows across America and own her own stable. "I had a different attitude than many of my friends. I always wanted to win," she says. "I had goals. I never hung out. As an athlete, having discipline and goals really helps you."

C.Z. is now regarded as America's most elegant sportswoman, but she was not without an interest in more sophisticated fashion. She was the first to represent what was a true Mainbocher look. "I like fitted clothes that show off the body," she says. "My style was his style." Her loyalty was enduring; she wore his clothes for fourteen years, until he closed his house.

Winston Guest, a ten-goal polo player and stalwart of the Jockey Club, was a believer that birth, marriage, and death notices were all the personal publicity that a civilized life required. He hated to see his wife's picture in magazines; her solution was simply not to tell him. When he heard that C.Z. would be featured on a 1962 cover of *Time* magazine (under the dreadful headline "A Legend in Her Own Time"), he tried to block it. "If I didn't sit for a photo, Henry Luce said he'd do a composite of my face," she recalls. "So we had Horst do it. Main closed his shop and went to Paris for two months when they were doing the article because he didn't want anyone coming in and smuggling out info about his clients. The grandes dames were furious. They couldn't get their clothes."

Her private, horsey life stopped abruptly when Winston died in 1981. She needed a substitute focus. In her passion for gardening, she not only found it, she created a vibrant third act for her life and, in essence, reinvented herself. Writing gardening columns and three books, going on lecture tours, producing a line of gardening products—C. Z. Guest has, in her early seventies, touched every entrepreneurial base.

"Before I started working, I really didn't have anything to say unless someone asked me about a horse, an orchid plant, a jewel, or a Mainbocher dress," she says. "I had a very private life and a very tight circle. It was painful to go out of that environment. I had never spoken to *anyone* unless I wanted to. I could never have gone on TV, as I now have. But now, thanks to my career, I can talk to anybody."

Having seen life from the vantage point of rarefied clubs and, more recently, the home-shopping programs on cable television, C.Z. is in a unique position to assess the current striving for status. Frankly, it bewilders her.

"All the girls today want to be famous, but they haven't earned their spurs," she says. "They want to inherit at a very young age what it's taken me thirty or forty years to achieve. When I was young, I didn't want to be Helen Hull or Elsie Woodward. I wanted to be on my horse every morning, or competing at the Devon Horse Show. I never had a plan, I never had a press agent. Now I have people asking me about 'my style.' I don't quite know what to tell them. I mean, style is what you are inside."

∞ *When C.Z. posed for Louise Dahl-Wolfe in 1952, she was pregnant.*

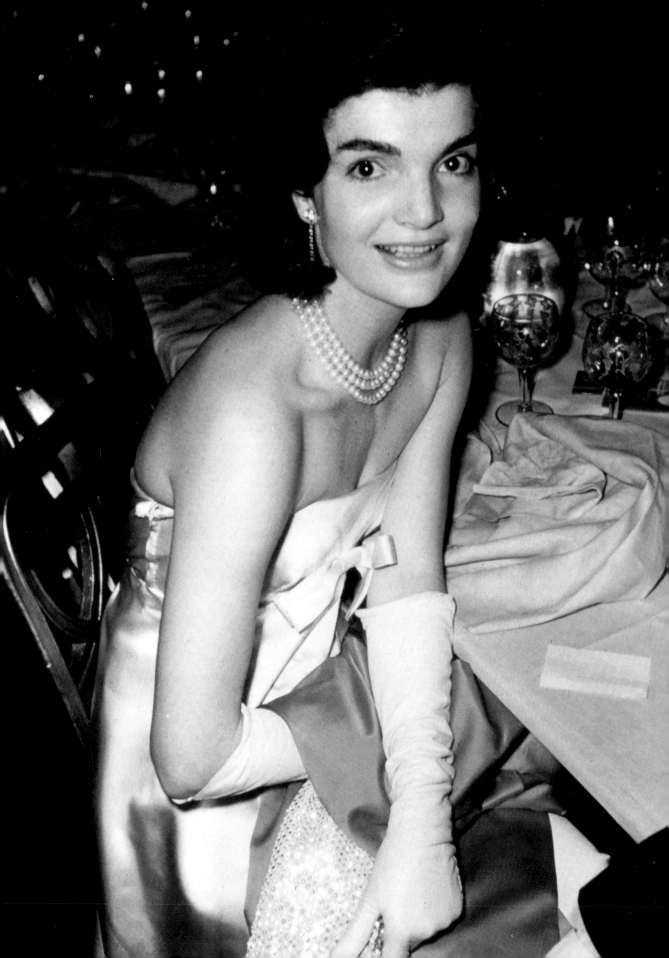

# Jacqueline Kennedy Onassis

F ASHIONABLE KENNEDYS BIG PARIS CUS-
tomers: Jacqueline, wife of the senator, and his mother, Mrs. Joseph P.,
are running for election on the Paris Couture fashion ticket. Together, the
two Kennedys spend an estimated $30,000 per year for Paris clothes—
more than most United States professional buyers.

*—Women's Wear Daily,* July 13, 1960

*NOW IT CAN BE TOLD—MRS. JOHN F. KENNEDY, WIFE OF*
the Democratic Presidential candidate, has been diplomatically told that
for political expediency—'no more Paris clothes, only American fashion.'

*—Women's Wear Daily,* September 1, 1960

❧ *The senator's wife at the April in Paris Ball in New York, in 1955.*

*Jacqueline Kennedy's Fashion Philosophy:*
When Jacqueline Kennedy moves into the White House, she will wear only American clothes and she is looking forward to it. They will have a Balenciaga and Givenchy look of utmost simplicity:

She will not order a great many clothes.

She will wear simple and fairly timely fashions which will do hard work for her.

Mrs. Kennedy appreciates good clothes, and will continue to dress her type, but will strive to be appropriately dressed for official life. As a young and active woman, she simply does not have the time to be always shopping, and besides, this kind of extravagance has always been abhorrent to her.

She does expect interest to be taken in the 'Kennedy Fashion Look,' but is determined her husband's administration not be plagued with fashion stories of a sensational nature.

<div align="right">—<em>Women's Wear Daily,</em><br>November 23, 1960</div>

This last statement issued by the future first lady was wishful thinking. Nevertheless, it was an intelligent move on her part. The controversy that had erupted over her Paris creations while Pat Nixon campaigned in a Republican cloth coat wasn't limited to *Women's Wear Daily,* then an obscure trade newspaper. Once *Women's Wear* broke the story, it was picked up by the

Associated Press. Overnight, fashion entered politics, and the Republicans made Jackie's French couture clothes a campaign issue.

Mrs. Kennedy was soon as inundated with questions about her clothes as her husband was about his policies. The nation quickly learned that her famous red campaign coat was a Givenchy copy from Ohrbach's (it was never revealed that Pat Nixon's was from Elizabeth Arden in New York, where prices were far higher than at French couture houses). Mrs. Kennedy's coat generated the right response; once during the campaign, *Women's Wear Daily* ran as its headline "Jacqueline Kennedy: Potential Style Leader." The paper predicted that if Senator Kennedy was to win the election, his wife "promises to be the most photogenic, fashion-conscious, and chic occupant of the White House since Dolley Madison."

*Jacqueline Bouvier, age five, with her parents.*

In the weeks that followed the 1960 election, the calls that the press secretaries were fielding about the future first lady's wardrobe, particularly her inaugural attire, rivaled the inquiries about the president-elect. By the middle of November, Mrs. Kennedy had had enough. It was then, at the suggestion of *Women's Wear Daily* owner John Fairchild, that she issued a public statement detailing her fashion philosophy in an attempt to keep the press at bay.

Every day, however, brought another delicious tidbit. First came the announcement that

Oleg Cassini was to be her official designer. Then came the wave of disapproval and criticism. Norman Norell, who was then the country's premier designer, would have been the obvious choice, many people thought. The kings of American high fashion were perplexed that the first lady would choose a designer who was known for his curvaceous and sexy silhouettes. And then there was Jackie's selection of a designer for the inaugural gown; she had appointed Bergdorf Goodman to make it from sketches that she had drawn herself.

The speculation over what Mrs. Kennedy would be wearing was given endless attention in the pages of *WWD*, with drawings of possible styles and suggestions from designers. For a trade paper read by few people outside the fashion industry, all this breaking Jackie news had a powerful effect. *WWD* suddenly became required reading for fashion-minded socialites and aspirants.

Some of the hoopla might have soon died down if it hadn't been for the next story that *WWD* broke.

"Jackie Orders Paris Dress in Cloak and Dagger Style," read the headlines in *WWD* on May 16, 1961, just a few weeks before Jackie was to accompany the president on their state visit to France. Apparently, according to the article, the first lady had been smuggling French couture clothes into the White House all along. Pierre Salinger, the president's press secretary, denied this rumor. But the story was too irresistible for the media mongers; newspapers, television, and radio stations across the country reported that arrangements had been made for Jackie to buy Paris couture through Bergdorf Goodman so that way she would still be buying "American." It was also rumored that Chez Ninon, the New York custom couturier of fine French copies, was buying Paris originals and then forwarding them to the White House.

All this fashion fracas was soon forgotten when the Kennedys arrived in Paris. As the motorcade moved through the streets of the city, almost half a million people lined the avenues chanting, "Vive Jacqui! Vive Jacqui!" The next day, thousands of Parisians crashed through police barricades chanting the same refrain. When she made her grand entrance at Versailles dressed in a heavy white silk faille dress and matching coat designed by Givenchy, the first lady looked more regal than any European monarch's consort.

In the end, *Women's Wear Daily* had to bend the knee. "Her Elegance," as it had dubbed her, was independent and was going to wear exactly what she pleased. And what did it matter, anyway; in the one hundred days that her husband had been in office, she had taken the world by storm. For the first time in history, a look had originated in America and had taken over the world. One woman had beefed up the sagging American fashion industry and convinced the snooty Paris couturiers that Americans *were* elegant. And because of her style, beauty, and grace, her own country was bursting with national pride.

Jacqueline Kennedy was thirty-one when she became first lady, a role that had been filled for the last sixty-four years by women old enough to be her mother. Her most recent predecessors, Bess Truman and Mamie Eisenhower, had been stereotypical homespun wives. "The time was right for her, no doubt

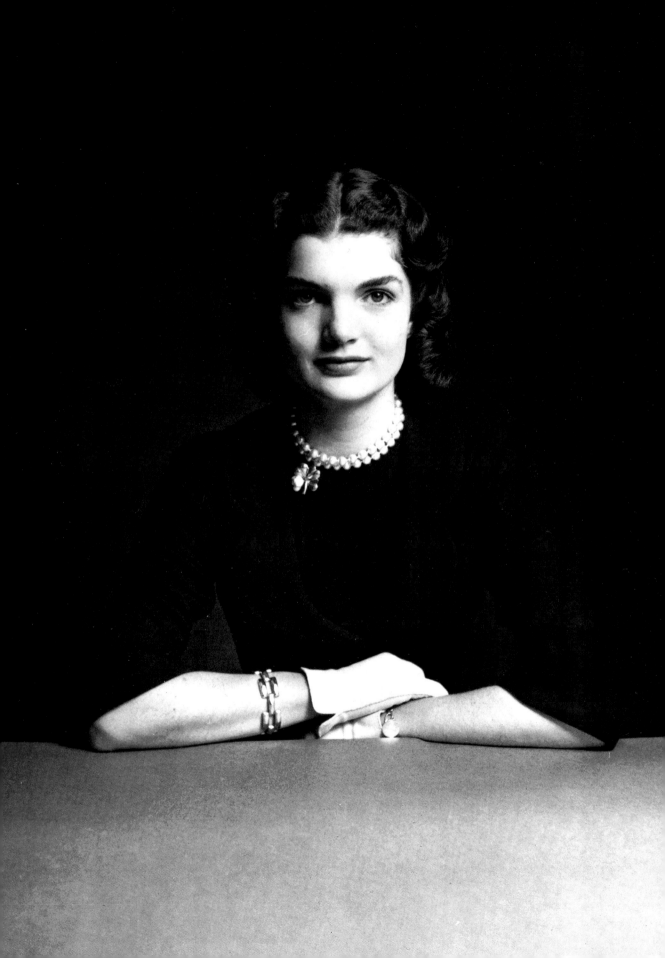

about that," said *Vogue* magazine in 1963. "We wanted to grow up. She came along, and suddenly we forgot about *the American girl*—that improbably golden never-never child who roved through the world's imagination with a tennis racket, an unmarred makeup, and some spotty phrase-book French—and fell in love instead with *the American woman.*"

There is never any shortage of explanations for a phenomenon. After all the punditry, however, what stands out in Jackie's case is that most mysterious of factors: timing. In November of 1960, the country was affluent, calm, optimistic, and bored. After fifteen years, the public had, without realizing it, reached a saturation level with the middle-class Bess and matronly Mamie. Jacqueline Kennedy gave Americans what they needed: glamour.

It was more than just youth, beauty, or her stylish clothes that captivated her fellow citizens. She radiated enviable qualities: confidence, independence, intelligence, and a wisdom far beyond her years. Well-bred and properly educated, she was the walking definition of class. Jackie, as the world soon learned to call her, set a new example of how a young American woman ought to be.

And yet she provided a startling contrast. She was "everything American women were not supposed to be or reveal—mercurial, willful, independent, self-centered, and unpredictable," wrote John Davis, Jackie's cousin and author of *The Bouviers.* Her wild, irregular looks were also the visual antithesis of the average American lady and her perception of beauty. Jackie looked like no one else. Her hair was dark brown, her eyes were dark and set a little too far apart, her face was wide, her cheekbones high, and her mouth was a little too full, a little too French. She was tall, her feet were a size ten—everything about

*A* Vogue *portrait of Jackie, taken in 1951 after she won first prize in the magazine's Prix de Paris writing competition.*

her seemed larger than life and slightly out of proportion.

But her appearance was only part of her attraction. She fascinated the public with her multifaceted, cultivated mind. Jackie spoke three languages fluently, she could discuss Greek or Roman history, she read Proust—and she could dance the twist. She rode to the hounds, her voice was soft and patrician, she wore the dignified clothes of the Paris haute couture, and yet she would appear at church elegantly relaxed in a casual sleeveless dress, sunglasses unselfconsciously pushed on top of her head, bare legs, and a mantilla clutched in her hand. And although she projected glamour, she was quite clear that she believed her first duty was to her husband and her children. "If you bungle raising your children, I don't think whatever else you do well matters very much. And why shouldn't that be an example, too?" she once commented.

The average American housewife basked in Jackie's motherhood, her elegance, and her lofty pursuits. The middle-class dream of the blond sex kitten was replaced by the cultured, feminine brunette. "She convinced the women of the world to look and feel better," John Fairchild once wrote.

Soon the Jackie look was everywhere. She was responsible for a mass adoption of styles such as the pillbox hat, the bouffant hairdo, the little throwaway shift, low-heeled pumps, the one-shoulder evening dress, the minaudiere for an evening bag. Even what she wore in leisure was cause for imitation: jodhpurs, bulky sweaters, riding boots, and neckerchiefs became fads, as did the vogue for riding in English saddle.

"The most significant lesson that Jacqueline Kennedy imparted to the public was the simplicity of fashion editor taste," wrote Marilyn Bender in *The Beautiful People.* "Within a year after she moved into the White House, women all across the United States had memorized the high-fashion mathematics of multiplying chic by subtrac-

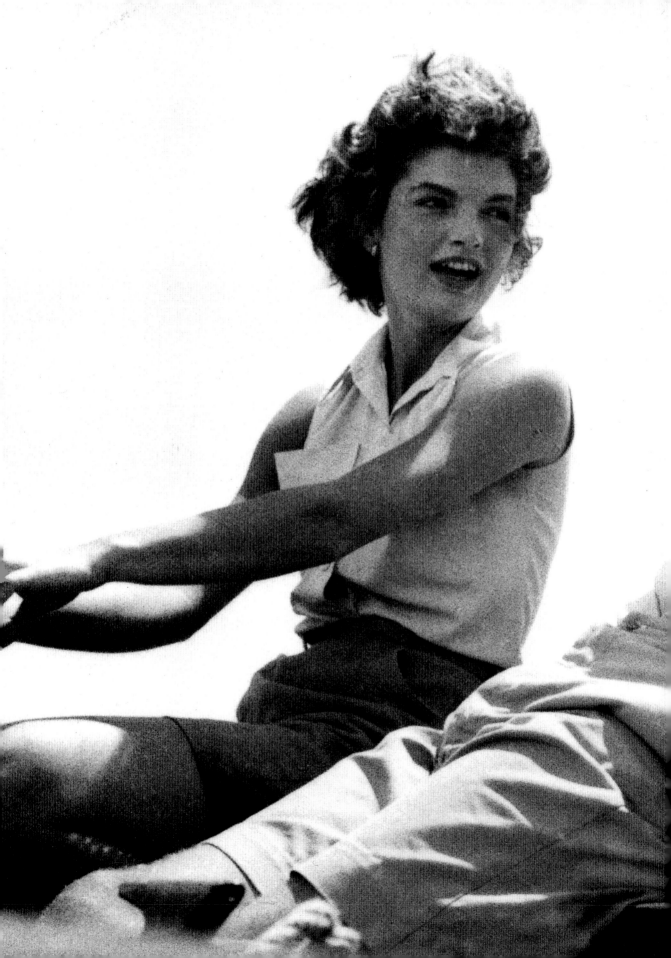

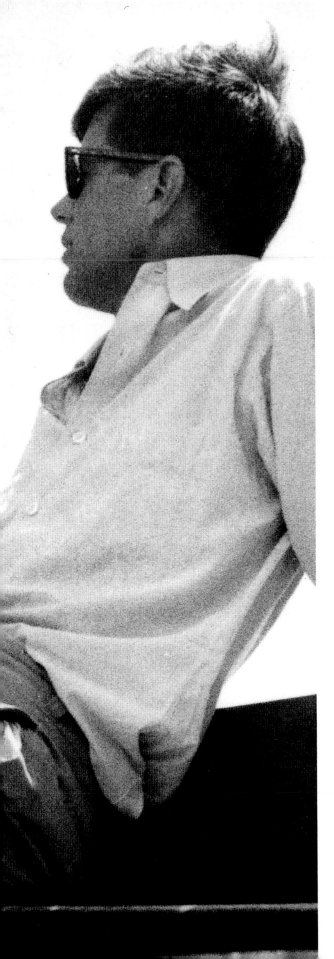

tion. Her little nothing dresses, her unadorned cloth coats, pillboxes, and pumps, once upper-crust specialties, they were now fads." It was not that Jackie was a fashion original, it was that she kept up with new styles, and by wearing them, certified them for the masses.

The look during the White House years was strictly from the Balenciaga school. "It was dignity, not novelty, that Mrs. Kennedy wanted," Oleg Cassini has recalled. The styles were elegantly understated and the emphasis was placed on fine workmanship and good fabrics. It was a look, as *Women's Wear* discovered, that had been carefully monitored by Givenchy.

Once all the frenzy had died over whether she was buying French or American, the fashion press settled into a rhythmic reporting pattern. *WWD* might easily have been renamed *What Jackie Wears Daily*, for in her three years as first lady, it was a rare day when the paper didn't chronicle her clothes down to the minutest detail of her shoes. The excitement before each state occasion or foreign visit would mount as the *WWD* tantalized its readers with speculations of what Jackie might wear or how many dresses she would pack; on big occasions there would even be front-page sketches.

Just three months after her husband took office, "the first lady look," "the Jackie look," and "the White House look" had become an integral part of the retail-ad language. Seventh Avenue manufacturers hungrily waited for the latest news release and quickly put into production a cheaper copy of whatever she wore. When Jackie brought sari material back from India and later wore one at the White House, sari fashions were rapidly produced. When she returned from a trip to Italy and was photographed wearing skinny Pucci pants, cheaper copies were instantly available. Her strapless evening sheaths worn at the glittering White House dinners were knocked off. If

᛭᛭ *Sailing off Cape Cod as a young senator's fiancée.*

᛭ 195

Jackie thought she might get a break when she was pregnant, she was wrong. Lane Bryant, the leading manufacturer of maternity clothes, copied hers and advertised them as First Lady Maternity Fashions.

Her influence was not limited to America. When she visited London, English milliners worked through the night to fill their orders for the Jackie pillbox. Her influence was as far-flung as the Iron Curtain. *Mody*, a Leningrad fashion magazine, carried ads for "Jackie look" clothes. The Polish magazine *Swait* wrote that "Jackie has entered the group of a few women in the world who, today, as in times past, set the style and tone of their epoch . . . but never before has her influence been so far-flung or so quickly disseminated. The face and silhouette of Jackie are known to all people all over the civilized world."

For the first time in history, the first lady of the United States had a press secretary. "Jackie was news twenty-four hours a day," wrote a UPI reporter. The press came to respect no boundaries when it came to Jackie; reporters used spyglasses and even bribed quotes out of servants in hope of gleaning any nugget about her. If she was thrown from her horse or went waterskiing, you could be sure it was on the evening news.

The media's insatiable appetite for stories of her private life was a source of constant annoyance for Jackie, a very private woman who preferred that the spotlight focus on the cultural projects she initiated. And her contribution to American culture and the arts is, in the end, her greatest influence in the realm of style. In her role as first lady, she set a national standard of taste and style, manners, form, and ceremony.

This was not the standard cause of a first lady; the norm was to choose an undemanding project of a civic nature. But being an independent spirit, Jackie had to do what interested her, and one of her main interests had always been the arts and aesthetics.

She had only to walk into the White House to discover her mission, for the executive mansion was a dismal place. The vast halls and rooms lacked warmth, there were no flowers in vases, no objects on tables. The rooms were dutifully filled with standard portraits, and the furnishings —most of them dating from 1900—no longer corresponded to the eighteenth-century architecture. How could it be that the official residence of America, visited by masses of tourists every year, displayed little of its splendid history and the legacy of the families who had inhabited it?

Jackie's goal was to make the White House "the most perfect house in America," the showplace of a great heritage and an inspiration to Americans. She felt the mansion was more than the official center of the executive branch of the government and a place to entertain. Instead, she believed, it must represent to visitors— whether they were tourists or visiting heads of state—the proud tradition of the nation.

That called for more than just refurbishing. Shortly after her husband's inauguration, Jackie founded the White House Fine Arts Committee,

*Two portraits from a Mark Shaw sitting at Hyannis Port that appeared in Vogue in 1961. Never before had a first family been photographed so intimately—quite an irony considering Jackie's desire for privacy.*

and the White House Historical Association was also formed. An exploration of the warehouse that stored discarded White House furnishings unearthed important pieces of furniture that she had seen in the books she'd been studying. She discovered thousands of forgotten treasures: James Monroe's chairs, Teddy Roosevelt's Aubusson rugs, Lincoln's china. Her campaign for private donations received a huge response; contributions of period furniture, paintings, wallpaper, and rugs found a home at the White House. She launched a nationwide appeal in newspapers, which produced donations from descendants of presidents, and collectors and history buffs. When the restoration was completed, two million dollars—mostly from private sources—had been spent, and Jackie's project had become the catalyst for the historical preservation movement that first flowered in the early sixties.

But Jackie didn't stop there. If the White House was going to represent American excellence, the level of entertaining had to improve. The cook who had prepared both private and official meals since the days of Franklin and Eleanor Roosevelt was replaced by an inventive and properly trained chef. Jackie discarded stiff, conventional flower arrangements in favor of a country garden look; flowers were most often arranged in small white wicker baskets. She did away with the formal rectangular tables and implemented the Jeffersonian round table because it was better for conversation. Caterers picked up on the idea and began to copy her dinner menus, round tables, and wicker baskets. Thanks to Jackie, anemones, freesias, apple blossoms, and daisies became the status flowers of the sixties.

Now when the guests arrived, they stepped into more than just the executive mansion. They entered the incandescent Kennedy home—burning fireplaces, dimmed lights, and flowers that looked effortlessly arranged. This was now a house that deeply reflected the personal style of its inhabitants.

These haute standards didn't end with the cuisine, the decor, and the first lady's couture; they were aesthetic backdrops for the performing artists she invited to dine and entertain at the White House. Although the cultural touchstone of her years in the White House will always be Pablo Casals's legendary performance, it shouldn't be forgotten that Jackie's main goal was to present the best of the performing arts in America at White House state dinners: Jerome Robbins staged a ballet, the actor Fredric March read excerpts of Ernest Hemingway's unpublished novel, the American Shakespeare Festival performed. But big names were only part of her agenda. She also had her staff find unrecognized artists like the opera singer Grace Bumbry, who was famous in Europe but unknown in America. Bumbry's performance at the White House launched her career in the United States.

By asking American artists to perform at the White House, she was calling attention to our living culture and using culture to make a political statement. As someone who looked to Europe for inspiration in all areas, she believed that American artists should be honored by society and that the government should play a role in supporting the arts, just as it did in France.

"The arts had been treated as a stepchild in the U.S.," Jackie later recalled. "When the government had supported the arts, as in many WPA projects, artists were given a hand and some wonderful things emerged. I had seen in Europe how proud those countries were of their arts and artists. Of course, they had a longer tradition of patronage, going back to kings, Popes, and princes, but modern governments continued this support. Our great museums and great performing companies should be supported, but the experimental and the unknown should also be thrown a line."

The president shared his wife's vision, but it was Jackie who set the wheels in motion to establish the National Endowment for the Arts and

the National Endowment for the Humanities.

By showing Americans the best of what their country had to offer, she impressed upon them that they need not accept the European assumption that they were a bourgeois and uncultivated lot. By the end of 1961, a Gallup poll reported that Jackie was the most admired woman in America, and she would head that list for five consecutive years.

"A Tour of the White House with Mrs. John F. Kennedy," the television special CBS created to show the nation the restored White House rooms, took her almost to monarch status. It turned Jackie, who was as glamorous, photogenic, and as charismatic as a film star, into the first non-movie-star media personality. The show, viewed by 80 million people in America was also distributed to 106 countries. Although it was the height of the Cold War, the film was shown in six Iron Curtain nations.

☙ *Even strolling barefoot on Capri in 1970,
Jackie possessed an unerring sense of stardom.*

Jackie no longer had admirers, she now had fans. NBC News produced a special called "The World of Jacqueline Kennedy." When she went on a goodwill mission to India, the trip was filmed and shown as a short in movie theaters. She replaced celluloid stars on the covers of movie magazines. The pinnacle of her stardom was when she seeped into advertising and television imagery. Jackie look-alikes could be found in ads for cigarettes, water skis, and whiskey.

Her breathy, little-girl voice was parodied in an ad for the Rambler station wagon. Her cartoon likeness appeared on "The Flintstones"—Jackie Kennelrock. The "brainy brunette" replaced the "dumb blonde," with characters like Laura Petrie of "The Dick Van Dyke Show," who had a Jackie bouffant and wore skinny ankle-length pants and flats.

Mrs. John F. Kennedy had become America's first pop-culture queen.

In India they had crowned her Durga, "goddess of power." A private vacation to Ravello, Italy, was a paparazzi field day. Photographs of Jackie, relaxed and elegant, sitting in outdoor cafés in dark sunglasses, Pucci pants, and sandals, and on the beach in her skimpy bathing suit, sold in supermarket tabloids and magazines around the world. When André Malraux, the French minister of arts, visited the White House, he was so blinded by her radiance that he promised to send the Mona Lisa to America. When the painting arrived at the National Gallery of Art the following year, the loan was "not officially to the American government, but personally to Jacqueline Kennedy."

At the time of his death, John Kennedy was both an inspiring and a divisive figure in American life. For all those who loved him there were many others who hated him and feared him and wished his power and influence to evaporate.

# VOGUE

Dress designed by
de Givickly

© VICKY—"LONDON EVENING STANDARD"

## VOGUE'S EYE VIEW OF A LOOK

In the first weeks of June this year,
Europeans had a whole new image of the
young American woman—gentle, informed,
attractive—and Jacqueline Kennedy was
its prototype. The clothes she wore played
a particularly pleasant rôle in all of this.
Distinctive enough to provoke the amusing
Vicky cartoon in *The London Evening Standard*
reproduced above, dashing enough
to cause newspapermen to ask their wives
what-do-you-call-a-dress-with-no-sleeves-
that-comes-in-two-parts-and-isn't-tight?—
the clothes were still so
unobtrusive that the wearer was far
more significant than what was worn.
And while the applause sounds lovely, we're
fully aware that the look being applauded
isn't essentially new. Mrs. Kennedy has
always dressed as she did in Europe—more
or less. So have great numbers of young
American women—more or less. One unvarying
point about this now world-famous American
look is that it does vary—from year to
year, from woman to woman, from look to
look. That theme—and the variations—
are what this issue of Vogue is about.

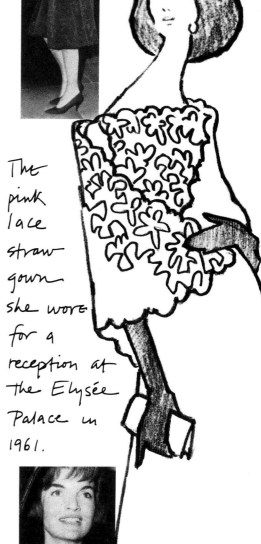

The pink lace straw gown she wore for a reception at the Elysée Palace in 1961.

The many facets of Jackie's style made an impact on women all over the world.

Jackie look-alikes.

Jackie, by contrast, hadn't generated such heated controversy. Those few who disliked her seemed mostly to be fueled by envy. Because she was beloved, her husband's murder seemed like a double tragedy for America, the end not only of a vibrant presidency but of a sparkling era that this radiant woman had magically created.

This double sense of loss was crystallized in one unforgettable moment: the swearing in of Lyndon Johnson on the president's plane on that runway in Dallas. There, the woman who had entered the White House as the youngest first lady left it in the grandest tradition of all tragic heroines— standing beside the new president, wearing a dress stained with her husband's blood. She wore it all the way back to Washington. And she was still wearing it when she returned to the White House long after midnight. "I want them to see what they have done to Jack," Jackie later explained to the press.

In that refusal to change her clothes, Jackie Kennedy transformed her attire into an expression of character that became an indelible memory for Americans. In this and in all other aspects of the president's funeral, "she gave an example to the whole world of how to behave," said Charles de Gaulle.

☙ H*er youth and beauty made her the most appealing first lady for the press since Mrs. Frances Cleveland, seventy-five years earlier.*

☙ J*ackie's "up" hairstyle was news when she appeared at an official dinner in 1962.*

And yet, shortly after Kennedy's funeral, de Gaulle told his ministers, "Jackie is a star. She will wind up on the yacht of some *petrolier.*" Alone among her admirers, he correctly read that the pressure and loneliness of life as the president's widow would be almost impossible to bear. Because that wasn't generally understood —after the assassination, she'd become a cross between Mother Courage and the Queen Mother for many Americans—her countrymen would be astounded by almost every move she made for the next decade. They were shocked that she neither attended the 1964 Democratic Convention nor voted in that presidential election, at her refusal to assume a public role in the years after the assassination, and, worst of all, at what was perceived to be her loveless marriage to Aristotle Onassis.

Although she would, by 1968, drop to seventh place in the Gallup poll's list of most respected women and would consider herself a so-called private person, Jackie was still a trendsetter. When she wore a miniskirt in 1966, the *New York Times* noted that "the future of the miniskirt is assured." Having helped put the understated and elegant clothes of French designers on the map, she now did the same for Valentino's more jet-set look. Her oval sunglasses were copied everywhere. She popularized the Hermès shoulder bag with its gold *H*, an

evergreen item that had no previous mass appeal.

"Her style was the style of greatness, and because she was unrivaled, her influence was felt around the world," says Carolina Herrera, the designer who dressed Jackie for the last twelve years of her life.

Jackie may have been a style icon, but she consistently avoided the most obvious aspect of that role: since the early 1960's she was never photographed by Horst, Penn, or Avedon. Our visual image of her was limited to the flash of her smile as she entered or exited an event for some worthy cause. Like her early portraits, those shots reveal very little of her character; her smile may be magnetic, but it is also fixed and studied.

For real insight, we owe a debt to the only photographers who have caught Jackie unaware —the paparazzi she so loathed. They alone caught her eating lunch in a coffee shop, running like a doe through the park, or hailing a taxi cab. Emotions we can only guess at play across her face in those pictures. Perhaps that is why Jackie went to court to keep one paparazzi photographer, Ron Galella, at a safe distance from her person. In addition to her concerns about his alleged invasion of her privacy, she may have been bothered by the way he caught her femininity, her vulnerability, and even her sexiness.

Nearly forty years after she first appeared on the national scene, Jackie remained a woman of immense appeal. Although she never spoke to the press, the *Reader's Guide* consistently listed more articles about her than any other American woman. With good reason—she was as glamorous pushing her grandaughter's carriage in Central Park as she was when she would walk Caroline to school on Fifth Avenue wearing a white Valentino suit. The difference was that we had accepted Jackie on her own terms. Like

many of her admirers, she rose early, speed-walked around Central Park reservoir, doted on her grandchildren, and stayed home a lot.

All that obscured how very special her life really was. Not many women who work as editors get to do so only three days a week. And few women could carry off her discreet relationship with Maurice Templesman, a charming and wealthy businessman who seemed to be on good terms with the wife he never divorced.

Jackie, without any apparent strain, made every transition in the most graceful way possible. Or so we have been led to believe. In fact, we know almost nothing about her private life. Writers have spent three decades analyzing her Sphinxlike character. Was she a sensitive, affectionate, and lively connoisseur? Or was she the original material girl, greedy, spiteful, and snooty? The answer is unavailable. But we do know Jackie's public persona, which, for a public that was never asked to dinner, is the most interesting and all that really matters.

And this persona, in the end, is about style. That would seem to diminish her. After all, we are always told style is the ultimate ephemera. But if you were watching during those four days in November of 1963, or if you've ever seen the footage, you know that you will never forget that woman, that time, that place. By her impeccable conduct, Jackie Kennedy, thirty-four years old, transformed personal style into sublime content.

Although diagnosed with cancer in early 1994, Jackie continued to present the same inscrutable face to the world, alternating her radiation treatments with walks in the park. She was last seen in public only five days before her death, on May 19. Just as she had, thirty years earlier, given the nation some of its finest moments, her final walk into history was both gallant and elegant.

⚜ A *1965 paparazzi photo. For three decades, there was a media frenzy wherever Jackie went.*

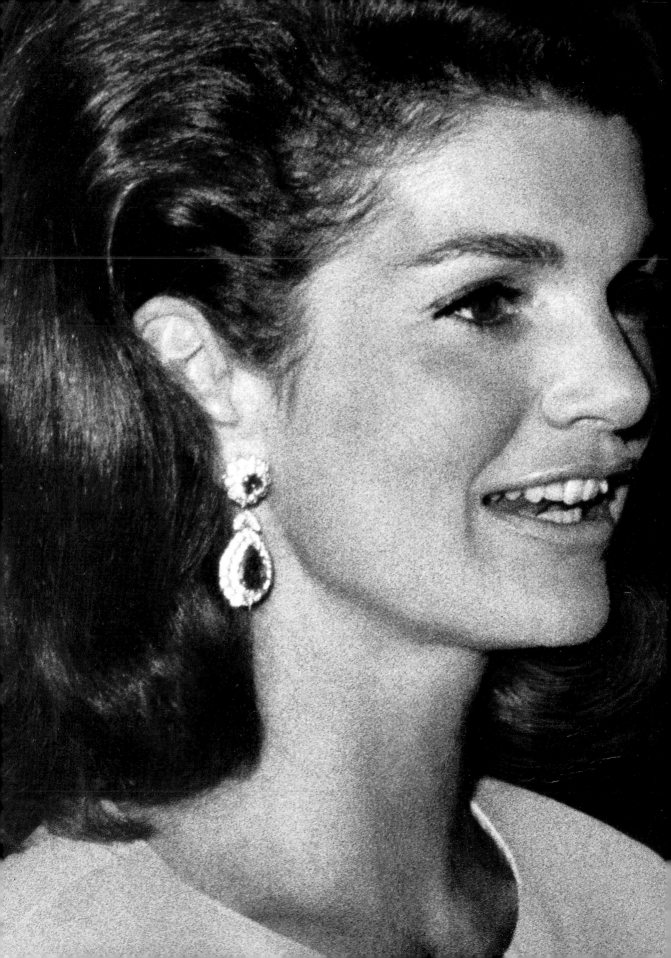

And then there was Chanel.

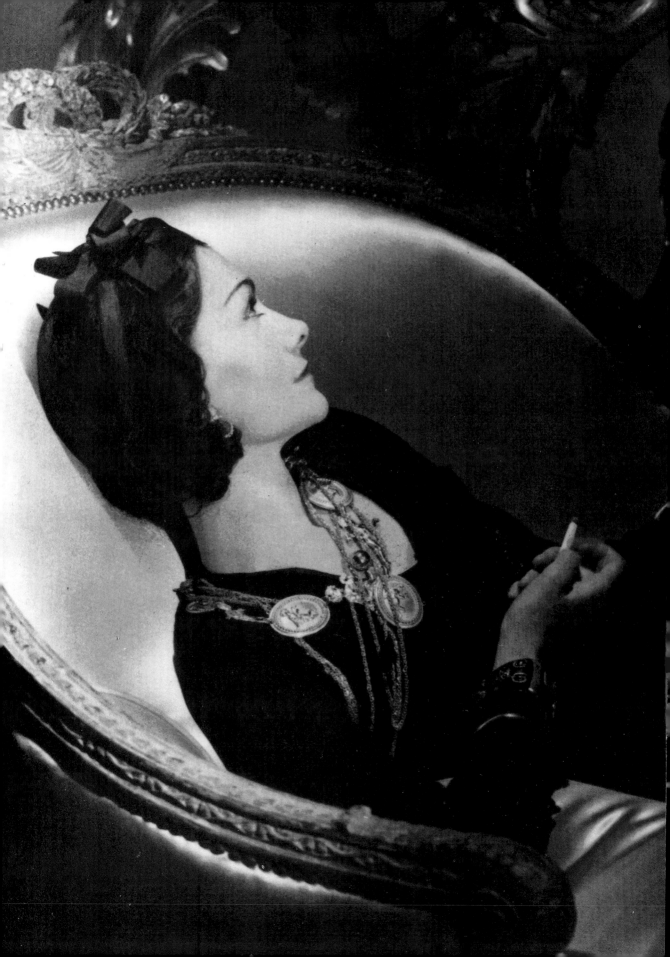

We have placed Coco Chanel at the end of this book—wildly out of chronological order—because of all the great twentieth-century women of style, she was the greatest. Alone of these women, she not only defined her time, she transcended it. As the century draws to a close, her name still resonates. Jacqueline Kennedy was wearing one of Chanel's suits on the day her husband was murdered. Two decades later, Madonna chose an updated Chanel for one of her videos. Embodying class, panache, and effortless chic, Chanel's signature look is still viable. And she is still the blueprint for twentieth-century style.

Chanel the icon stands above all other fashion designers of this century. As her life story is generally presented, we have been encouraged to see a woman who successfully confronted numerous issues that preoccupy females more than half a century later. In this updated version, Chanel is celebrated as the archetypal career woman—independent, feisty, equally adept in the male world of business and the female world of style. It's an appealing characterization, particularly to those women who find themselves highly credentialed, economically secure, and alone. But Chanel was vastly more complicated than that.

If Chanel was the quintessential working woman, it was because the opportunities for a woman of humble origins were quite limited. And Chanel's origins were humbler than she ever acknowledged. Her mother died when she was twelve, and because her father was an itinerant peddler, she was sent to an orphanage. In her teens, she was admitted, as a charity case, to a finishing school for ladies in Moulins, where she worked as a maid in exchange for instruction.

At twenty, she worked as a tailor's apprentice by day and sang in dance halls at night. She

☞ *Coco Chanel's favorite photograph was this portrait by Horst.*

knew just two songs; one of them, "Qui Qu'a Vu Coco," gave her her nickname. It was in this garrison town that she met Etienne Balsan, a wealthy, aristocratic infantry officer. Becoming his mistress was more of a career move than a romantic inclination, as a liaison with an upper-class gentleman was one of the few ways for a woman of her background to get ahead.

Her next lover, a charismatic, rich Englishman named Boy Capel, took her to Paris and, in 1910, set her up—with the help of Balsan—in a millinery business. "I was able to open a high-fashion shop because two gentlemen were outbidding each other for my hot little body," she told Salvador Dalí years later. This business was somewhat less respectable than it sounds. At that time, it was fairly common for men to reward their demimondaine mistresses by turning them into proprietors of hat shops. Her creations, however, gave not the slightest hint that they were designed by a cocotte. The straw boaters she trimmed with ribbons and lace were so astonishingly simple, they bordered on eccentricity.

Chanel was too talented and ambitious to remain a hatmaker. Three years later, she opened her first dress shop in Deauville, where she created loose-fitting clothes that were ideal for the sporty, casual life of this fashionable resort. Yachting inspired her to adapt for everyday wear the peacoat, striped maillots, berets, and sailor

❧ *"If I cut my hair, others did. If I shortened my dresses, so did everyone else."*

pants and blouses. From watching Boy Capel play polo, she stole the man's polo sweater and threw a sash around it. And because she was a natural businesswoman, she astutely charged her wealthy and prominent clients astounding prices, which only added to the allure of her clothes.

It was in Deauville, in 1913, that Chanel was first regarded as a revolutionary designer. Her ingenuity lay in creating chic clothes made from utilitarian fabrics like the wool flannel of Boy's English blazers, and most notably, wool jersey, a modest material that until then had been used only for men's underwear. "Poverty deluxe" is how Poiret described Chanel's style. The secret of these expensive clothes was that, in contrast to the stuffy fashions of the time, they looked young and casual.

While it is true that Chanel was the pioneer of sportswear, the revolution that is often synonymous with her name is not as far-reaching as it is often said to be. Chanel is credited with banishing corsets; actually, Paul Poiret and Madeleine Vionnet showed corset-free clothes as early as 1907. Chanel is almost universally regarded as the designer who liberated women from the tyranny of skirts; Poiret designed trousers for women in 1906. And when Chanel introduced her perfume in 1920, she was not even the first designer to create a scent—that too was Poiret. During her life, she would be credited with inventing everything from bobbed hair to

suntans to the color beige to backless shoes. All that is somewhat inflated. Rather, Chanel was someone who, because her image was so powerful, was able to popularize whatever she wore.

What Chanel did deliver, with an intensity that dwarfed all competitors, was presence. When women bought her clothes, they were buying the image of the woman who had designed them. She may not have been the first designer to market a perfume, but she was the first to do so under her own name, and, in her case, it was the name that assured the product's success. It was the same with her clothes; what lured the customers was the identification between her and her designs.

Chanel's look reflected an understanding of the world she had penetrated. Her clothes were inspired by practicality, not ideology. Long before she opened her hat shop, she was looking for ways not to dress like a typical decorative courtesan of the Belle Epoque.

❧ To cocktails at the home of Princess de Faucigny-Lucinge, she wore a doeskin vest.

But Chanel didn't mimic the clothes of Parisian society women—that look was abhorrent to her. From the beginning, she raided the closets of her rich lovers and adapted those clothes for herself. And therein lay her originality. It wasn't so much that her appreciation of male fashion was ideally suited to other women as that these clothes looked absolutely right on her.

Nothing helped Chanel's career more than World War I. Here, her timing and instinct were absolutely in sync with the times. With every available man at the front, women were thrown into the work force, where frilly and cumbersome dresses would not do. The pared-down style that Chanel had been refining now became the norm. And as for the aristocrats who remained in the safety of Paris, it was only correct that they adjust their attire to suit the seriousness of the times.

"The first war made me," Chanel once proclaimed. "In 1919, I woke up famous." In that year, she opened her *maison couture* in Paris. Popular belief has it that—with the exception of a hiatus from 1939 to 1954—Chanel's business was an instant and uninterrupted success. Not so. In the twenties, she was overshadowed by Poiret, Vionnet, and her major competitor, Patou. Chanel and Patou appealed to the same clientele: young and sporty women, the nouveau riche, and the café society. What Chanel is said to have "invented" in the twenties—skirt and sweater ensembles, the little black dress, short hemlines, and less complicated styles—was in the air and in the sketchbooks of every major designer.

What she did do, single-handedly, was exemplify the twenties look. For Chanel had something that other female designers of the era did not: youth. Madame Lanvin was a great couturier, but regrettably ancient. Vionnet, though only seven years older than Chanel, was prematurely gray and reclusive. The rest of her compet-

🙖 ABOVE: *In 1937, Chanel showed her peasant roots when she played on her kid and mother-of-pearl accordion.* BELOW: *The showcase at her shop on the rue Cambon.* OPPOSITE: *An illustration that Chanel submitted anonymously to* Harper's Bazaar *in 1938.*

itors were men. So Chanel was the only designer who could be her own best model. This singular strength set her apart, and, more important, gave her a sustainable media image.

What was that image? "Chanel's success was due as much to her personality as to her skill and hard work," observed Edna Woolman Chase. She not only looked modern, she had a very modern—and public—personal life that seemed to epitomize what twenties women aspired to be: free to choose their lovers, to work if they wanted to, to follow their instincts but still maintain a healthy element of feminine mystique.

In the twenties, Chanel had love affairs with Grand Duke Dmitri of Russia and the Duke of Westminster. In addition, never before had a designer become so involved in the arts; Chanel's circle included Stravinsky—whom she bankrolled and bedded—Diaghilev, Picasso, Cocteau, and Misia Sert. As she became celebrated, the press recorded her witticisms, chronicled the originality of her houses and the jewels bestowed on her by her glamorous lovers, and established her as a flinty, independent spirit.

Ironically, the "creator of modern women" was heavily influenced by her romances. During her affair with Dmitri, Chanel's style became more luxurious. She introduced furs, embroidery, and her most famous accessory, yards of pearls, both real and fake, jumbled with red or green stones. Later, she became so enthusiastic about the Duke of Westminster's English tweeds that he gave her a mill to do her own versions.

The photographs taken of Chanel during the thirties seem timeless. Images of her bathed in jewelry, or in her berets and close-fitting suits, or wearing trousers leap out and speak to us sixty years later. "By a kind of miracle, she applies to fashion the laws that up until now were only applicable to painting, to poetry, to music," Jean Cocteau recalled in the 1930s. "She has surpassed all fashions to create a style."

The reality is slightly different. For in that

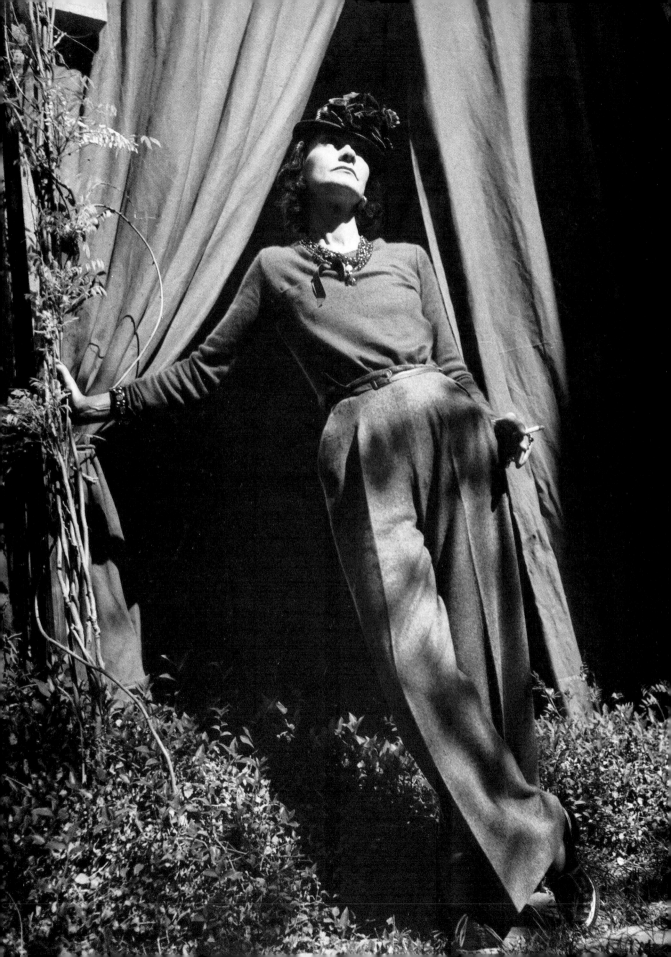

decade, she was confronted with a big problem. Her name was Elsa Schiaparelli, and with her tongue-in-cheek, ground-breaking clothes, she was very much the darling of the fashion press. In contrast to Schiap's razor-sharp look, Chanel's feminine ankle-length lace evening dresses —then her leading item—were considered conventional. Schiap's surrealist-inspired designs appealed to women who had the self-confidence to be on the cutting edge of fashion: Daisy Fellowes, Millicent Rogers, and a handful of movie stars. Chanel, on the other hand, appealed to less self-assured women who feared being badly dressed and wanted to buy safe.

The outbreak of World War II in 1939 prompted Chanel to close the doors of her *maison couture*. "This is no time for fashion," she said. She ensconced herself at the Ritz and took a German Nazi officer as her lover. Chanel might have returned to work after the war, but the French had no use for collaborators. Though she always denied it, declassified documents reveal that she cooperated with high-ranking Nazi officials in "Operation Modelhut," a plot that would have had Chanel influence Winston Churchill, an old acquaintance from her days with the Duke of Westminster. In 1939, she claimed she was "well and full of ideas for making things in the future," but after the war, she remained exiled in Switzerland for nearly ten years until some of the stigma of her wartime tryst had worn off.

All those years in retirement only entrenched her more deeply in a style that was acutely her own. "Although she has not designed clothes for many years," Cecil Beaton recalled during that period, "she appeared today to be ahead of fashion, so incredibly spruce she was, in a Beau Brummel way—yet totally French—in a navy blue serge over white linen blouse. The simplicity of her perfectly tailored suit was paradoxically overwhelmed by a fantastic array of jewels;

⋘ "I *am first and, finally, my only model.*"

strings of pearls hanging in cascades among chains of rubies and emeralds and gold links around her incredibly thin, stringy neck, and her mushroom hat and a lapel of her coat were each adorned with a vast sunburst of diamonds."

When she reopened the House of Chanel in 1954, it was this look that the public saw on models who were nothing but younger versions of herself. In 1939, she had been eclipsed by Schiaparelli; now she was reentering it in the shadow of Christian Dior, the creator of the New Look. The French press deemed Chanel's reopening a disaster. Her boxy, casual suits in nubby wools and tweeds with skirts that stopped just below the knee were light-years away from Dior's voluminous interlined frocks with pinched bone-bodiced waists that grazed the ankle.

Despite the initial icy response, her timing was perfect. Women had begun to tire of the postwar look that Dior had championed. Just as she had offered women comfortable jersey suits without corsets four decades earlier, Chanel's brilliance lay, once again, in giving women an alternative. By 1957, the press labeled her a revolutionary. Her suits with the two-pocket jewel-buttoned cardigan jacket and contrast braid were a style copied around the world. Today, when we speak of the Chanel look, we mean this legendary little suit. "It was an idea of her own past adapted to a changed life in another reality twenty-five years later," observes Karl Lagerfeld.

She was seventy when all the elements of her style came together. But she was not like Jeanne Lanvin, who had been too old to project an image during the twenties. Photos of Chanel— in her cardigan suits, her brimmed hat tilted back on her gamine-style hairdo, and strands of pearls—reveal that she was still her own best model because her style was still uniquely hers.

History did, however, repeat itself. She was eclipsed by midsixties stars like André Courreges and Yves St. Laurent. The Chanel suit was considered the uniform for older bourgeois women,

for younger women wanting respectability, and, ironically, for a new breed of cocotte—the top-drawer prostitutes in the stable of Madame Claude. "She was a fighter, a survivor," observes Karl Lagerfeld. "For a woman who tried to create a revolution in the beginning, she later became the most classic person in the world."

Chanel, though in decline, was not forgotten. St. Laurent translated her style into something new, and even dubbed one of his late sixties collections "Homage à Chanel." She held court in her famous apartment above the shop on the rue Cambon that was the symbol of a life of style and refinement. There she entertained the few cronies who still survived and hosted a new generation of celebrities: Marlon Brando, Roger Vadim, and Romy Schneider. She gave spicy interviews and lambasted the miniskirt, the maxi length of 1970, new designers, and Seventh Avenue. She tossed off epigrams on life, love, taste, and fashion, never stopping to notice that her declarations were a mass of contradictions.

Age had not mellowed her; as ever, she was notoriously shrewd, petty, and jealous. All that only added to her mystique. The indomitable spirit combined with her appearance likened her to a dowager empress. But above all else, she did what she knew best. She worked. Ruthlessly. Every day. Endlessly, she pulled apart the clothes she had made the previous day and reworked them until the next day. It didn't matter that the clothes might not be ready for the showing of her collection. She knew that she had said and done it all, and she now worked for herself, for work was all she had to relieve her of the cold reality of loneliness. And she toiled away until the day she died in 1971.

Today, Chanel handbag, Chanel pump, and Chanel suit are nearly generic terms that are synonymous with elegance, class, and respectability. Designers now continually redefine the things she popularized, and whether from the twenties, thirties, fifties, or sixties, it's clear that her designs best suit modern life. But the real proof of Chanel's endurance is not that she continues to influence the professionals, but that she still continues to *inspire women*. Although Karl Lagerfeld came to the helm in 1980 and correctly modernized the Chanel look, for women it is Chanel herself who is still the reference point. A snapshot of her taken sixty years ago on the Côte d'Azur wearing white trousers and a plain black sweater with ropes of pearls thoughtlessly tossed around her neck inspires both admiration and confidence—she made it look so easy.

As we approach the end of this century, the legend of Chanel's life becomes more confusing. So many myths surround her that we can turn her into whatever we like. But there is one assumption we can definitely discard: Chanel as feminist icon. Yes, she was a liberated woman, but Chanel was always guided by an unwavering sense of the power of femininity in clothes and in life. She felt that women should dress for men and urged women to bring a man along with them when choosing clothes.

Her great personal tragedy was that she never married. Boy Capel, the great love of her life, was too socially ambitious to marry her. The Grand Duke Dmitri was a gambler whom she supported. And because Chanel was unable to bear children, the Duke of Westminster, needing an heir, married someone else. But she was not embittered by her unlucky love life. She believed more than ever in the power of love and that nothing enhanced a woman's beauty more than to be loved by a man. As she neared death, the key fact of her life wasn't her professional accomplishment, it was that she was alone. "I'd rather be married to a fat, bald man than be alone." That was like so many other Chanelisms —a line that only she could have uttered.

*After this portrait appeared in* Harper's Bazaar, *she used it in an ad for Chanel No. 5—the first time a designer had promoted her own product.*

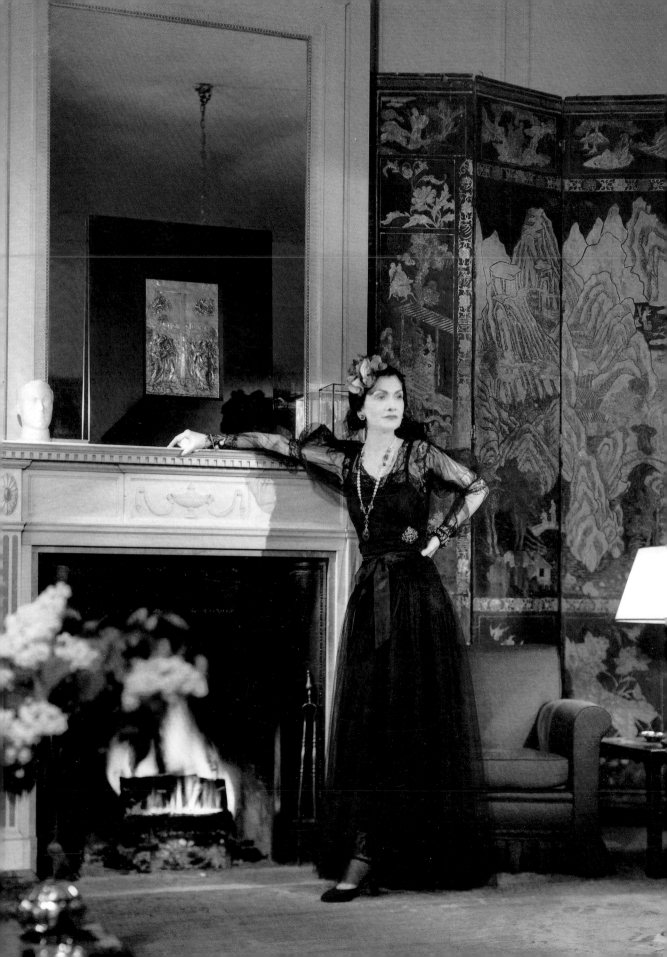

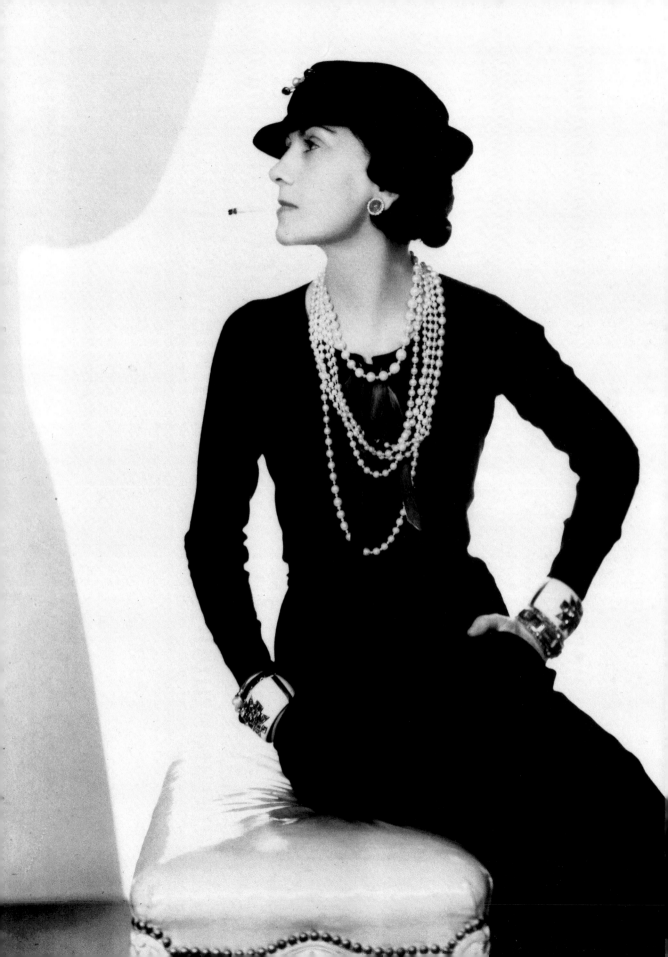

# The World According to Chanel

" I can't understand how a woman can leave the house without fixing herself up a little, if only out of politeness. And then, you never know, maybe that's the day she has a date with destiny and it's best to be as pretty as possible for destiny. I like fashion to go down into the street, but I can't accept that it should originate there. To my mind, simplicity is the keynote of all true elegance. . . . A really well-dressed woman in her afternoon clothes should be able to pass through a motley crowd unnoticed, but should create a mild sensation on entering a drawing room among the knowing elite. All men are children, and if you understand that, a woman understands everything. Anyone past the age of twenty who looks into the mirror to be pleased is a fool. You see the flaws, not the beauty. Beauty is charm. It's not houses I love, it's the life I live in them. I would never weigh heavier than a bird on the man I loved. After fifty you have to deserve your face. Fashion changes—style remains. A woman's unhappiness is to rely on her youth. Youth must be replaced by mystery. He who does not enjoy his own company is usually right. Jewelry isn't meant to make you look rich, it's meant to adorn you, and that's not the same thing. I won't be here forever, but my spirit will be and my style. They remain. "

# E P I L O G U E

Fourteen women of style make for a very rich meal. How do we feel about that feast? It's easy to look through the prism of all the changes that have occurred in the status of women in the decades since these exemplars of style came to public notice and declare that they are all museum pieces, as remote from contemporary experience as the European nobility of the eighteenth century. It's equally facile to romanticize these women and, decrying modernity, believe they embody a grace and elegance that the world has lost forever.

No matter how we view their lives, we cannot leave them without projecting ourselves into their situations. How privileged these women were! How cosseted! Who among us wouldn't like—if only briefly—to press a button and up comes breakfast on a tray, with a packet of invitations in place of the tabloids? What woman has completely forgotten how, as a child, she took pleasure in dressing up? Who wouldn't now, if the opportunity presented itself, love to abandon herself to a closet filled with beautiful clothes and a strongbox overflowing with jewels? And who wouldn't like to confront danger in the style of, say, Coco Chanel, who entered an air raid shelter during World War II with her maid carrying her gas mask on a cushion?

That these women have the power to make us dream is testimony to their endurance as icons of style. Perhaps that says more about our time than about these women. "Adulation has given way to investigation and suspicion; juicy scandal is what everyone wants," John Fairchild has noted. "No one can really be or look that great. Does the New World really prefer Ivana Trump, Madonna, made-over movie stars and made-up models?"

In the end, the New World does not. "Elegance—the idea, anyway—is back," Jacqueline de Ribes told me. "It was in the dust for a long time. The thing was to be young, sexy, and fun. More and more, though, women are afraid of losing their mystery and their femininity—and they know elegance creates that."

Elegance, de Ribes also said, is research. It's knowing what and knowing when. What binds these women together is that, in every situation that mattered, they were masters of correct behavior. They, of course, would not have considered themselves part of any group; their struggle was to establish their individuality and, through style, obscure what was unpleasant or unattractive or outright tragic in their lives. There's a lot to be said for that.

ANNETTE TAPERT
NEW YORK, 1994

220

# BIBLIOGRAPHY

Aarons. Slim. *A Wonderful Time: An Intimate Portrait of the Good Life.* New York: Harper & Row. 1974.

Alsop. Susan Mary. *To Marietta from Paris.* New York: Doubleday & Co.. 1975.

Amory. Cleveland. *Who Killed Society?* New York: Harper & Row. 1960.

————. *The Last Resorts.* New York: Harper & Row. 1952.

Anthony. Carl Sferrazza. *First Ladies.* New York: William Morrow. 1991.

Antoine. *Antoine.* New York: Prentice-Hall. 1945.

Baillen. Claude. *Chanel Solitaire.* New York: Quadrangle. 1974.

Baldwin. Billy. with Michael Gardino. *Billy Baldwin: An Autobiography.* Boston: Little. Brown & Co.. 1985.

Ballard. Bettina. *In My Fashion.* New York: David McKay. 1967.

Barnes. Djuna. *I Could Never Be Lonely Without a Husband.* London: Virago Press. 1987.

Beaton. Cecil. *The Glass of Fashion.* London: Weidenfeld & Nicolson. 1954.

————. *Memoirs of the 40s.* New York: McGraw-Hill. 1972.

————. *The Parting Years.* London: Weidenfeld & Nicolson. 1978.

————. *Self-Portrait with Friends.* London: Weidenfeld & Nicolson. 1979.

————. *The Wandering Years.* London: Weidenfeld & Nicolson. 1967.

Behrstock. Julian. *Countess Mona Bismarck.* Paris: The Mona Bismarck Foundation. 1989.

Bender. Marilyn. *The Beautiful People.* New York: Coward-McCann. 1967.

Brady. James. *Superchic.* Boston: Little. Brown & Co.. 1974.

Brady. Les. *Gone with the Windsors.* Philadelphia: John Winston Company. 1953.

Cameron. Roderick. *The Golden Riviera.* London: Weidenfeld & Nicolson. 1975.

Capote. Truman. *A Capote Reader.* New York: Random House. 1987.

Carter. Ernestine. *Magic Names of Fashion.* New Jersey: Prentice-Hall. 1980.

Charles-Roux. Edmonde. *Chanel.* London: Jonathan Cape Ltd.. 1979.

————. *Chanel and Her World.* London: The Vendome Press. 1979.

Chase. Edna Woolman. and Ilka. *Always in Vogue.* Garden City. N.Y.: Doubleday & Co.. 1954.

Clarke. Gerald. *Capote: A Biography.* New York: Simon & Schuster. 1988.

Coleman. Elizabeth Ann. *The Genius of Charles James.* New York: Holt Reinhart & Winston. 1982.

Core. Philip. *The Original Eve: Arbiters of Twentieth-Century Taste.* London: Quartet Books. 1984.

Davis. John. *The Bouviers.* New York: Farrar Straus & Giroux. 1969.

De Acosta. Mercedes. *Here Lies the Heart.* New York: Reynal & Company. 1960.

De Faucigny-Lucinge. Jean-Louis. *Legendary Parties.* New York: The Vendome Press. 1987.

De Wolfe. Elsie. *After All.* New York: Harper & Brothers. 1936.

————. *Recipes for Successful Dining.* New York: Appleton-Century. 1934.

Fairchild. John. *The Fashionable Savages.* New York: Doubleday & Co.. 1965.

Flanner. Janet. *Darlinghissima: Letters to a Friend.* New York: Harcourt Brace Jovanovich. 1985.

————. *Paris Was Yesterday, 1925–1939.* New York: Viking Press. 1972.

Galella, Ron. *Jacqueline*. New York: Sheed and Ward, 1974.

Gill, Brendan, and Jerome Zerbe. *Happy Times*. New York: Harcourt Brace Jovanovich, 1973.

Grafton, David. *The Sisters*. New York: Villard Books, 1992.

Herbert, David. *Second Son*. London: Peter Owen, 1972.

Huston, John. *An Open Book*. New York: Alfred A. Knopf, 1980.

Keith, Slim, with Annette Tapert. *Slim: Memories of a Rich and Imperfect Life*. New York: Simon & Schuster, 1990.

Keyes, Evelyn. *Scarlett O'Hara's Younger Sister*. New Jersey: Lyle Stuart, 1977.

Kochno, Boris. *Christian Bernard*. New York: Panache Press, 1988.

Lawford, Valentine. *Horst*. New York: Knopf, 1984.

Lees-Milne, James. *Ancestral Voices*. London: Chatto and Windus Ltd., 1975.

——. *Caves of Ice*. London: Chatto and Windus Ltd., 1983.

——. *Midway on the Waves*. London: Faber and Faber Ltd., 1985.

——. *Prophesying Peace*. London: Chatto and Windus Ltd., 1977.

Lewis, R. W. B. *Edith Wharton: A Biography*. New York: Harper & Row, 1975.

Leymarie, Jean. *Chanel*. New York: Rizzoli, 1987.

*Life* Editors. *Life in Camelot*. Boston: Little, Brown & Co., 1988.

Littlewood, Jan. *Baron Philippe*. New York: Ballantine Books, 1986.

Madsen, Axel. *Chanel: A Woman of Her Own*. New York: Henry Holt, 1990.

Maxwell, Elsa. *R.S.V.P.* Boston: Little, Brown & Co., 1954.

Menkes, Suzy. *The Windsor Style*. London: Grafton Books, 1987.

Mosley, Diana. *The Duchess of Windsor*. New York: Stein and Day, 1981.

O'Connor, Richard. *Golden Summers*. New York: G. P. Putnam & Sons, 1974.

Quennell, Peter. *Customs and Characters: Contemporary Portraits*. London: Weidenfeld & Nicolson, 1982.

Rasponi, Lanfranco. *The International Nomads*. New York: G. P. Putnam & Sons, 1966.

Riley, Robert. *Givenchy: Thirty Years*. New York: Shirley Goodman Resource Center, 1982.

Roosevelt, Felicia Warburg. *Doers & Dowagers*. Garden City, N.Y.: Doubleday & Co., 1975.

Ross, Josephine. *Beaton in Vogue*. New York: Clarkson N. Potter, 1986.

Schiaparelli, Elsa. *Shocking Life*. New York: E. P. Dutton, 1954.

Spender, Stephen. *Journals 1939–1983*. New York: Random House, 1986.

Smith, Jane. *Elsie de Wolfe: A Life in the High Style*. New York: Atheneum, 1982.

Smith, Sally Bedell. *In All His Glory*. New York: Simon & Schuster, 1990.

Snow, Carmel. *The World of Carmel Snow*. New York: McGraw-Hill, 1962.

Steele, Valerie. *Paris Fashion: A Cultural History*. New York: Oxford University Press, 1988.

——. *Women of Fashion: Twentieth Century Designers*. New York: Rizzoli, 1991.

Sternberg, Cecilia. *The Journey*. New York: The Dial Press, 1977.

Tornabene, Lyn. *Long Live the King*. New York: G. P. Putnam & Sons., 1976.

Vreeland, Diana. *Allure*. Garden City, N.Y.: Doubleday & Co., 1980.

——. *American Women of Style*. New York: The Costume Institute, The Metropolitan Museum of Art, 1975.

——. *D.V.* New York: Alfred A. Knopf, 1984.

# PHOTOGRAPH CREDITS

Photographs from *Vogue* courtesy *Vogue*. Copyright © 1920, 1924, 1928, 1929, 1933, 1935, 1936, 1937, 1938, 1939, 1940, 1941, 1943, 1944, 1945, 1946, 1947, 1949, 1951, 1952, 1953, 1954, 1956, 1959, 1961, 1963, 1964, 1965, 1966, 1967, 1969, 1970, 1972, 1973, 1980, 1988 (renewed 1948, 1952, 1956, 1957, 1961, 1963, 1964, 1965, 1966, 1967, 1968, 1969, 1971, 1972, 1973, 1974, 1975, 1977, 1979, 1980, 1981, 1982, 1984, 1987, 1989, 1991, 1992, 1993, 1994) by The Condé Nast Publications, Inc. Photographs from *House and Garden* courtesy *House and Garden*. Copyright © 1943, 1950, 1978, 1982, 1988 (renewed 1971, 1978) by The Condé Nast Publications, Inc. Photographs from *Architectural Digest* courtesy *AD*. Copyright © 1981, 1982, 1993 by The Condé Nast Publications, Inc. Photographs from British *Vogue* courtesy British *Vogue*. Copyright © 1931, 1935, 1940, 1951 by The Condé Nast Publications Ltd. Photographs from French *Vogue* courtesy French *Vogue*. Copyright © 1931 by Les Editions Condé Nast.

R I T A   L Y D I G  (1880–1929)  **Page 14.** Photograph by Baron Adolf de Meyer, 1913. Courtesy the Collection of the J. Paul Getty Museum, Malibu. **Page 19.** Painting by Giovanni Boldini, c. 1904. *Vogue*, April 1, 1940. **Page 20.** Shoes designed by Yantorny, Paris, c. 1912. Courtesy the Metropolitan Museum of Art, New York, Gift of Capezio, Inc., 1953. **Page 21.** Photographs by Peter Nyholm; *Vogue*, April 1, 1940, and British *Vogue*, November 1940. **Pages 24–25.** Rita, 1913. Photograph by Baron Adolf de Meyer. Courtesy the Collection the J. Paul Getty Museum, Malibu. **Page 26.** Photograph by Arnold Genthe. *Vogue*, April 1, 1940, and British *Vogue*, November 1940. Courtesy the Museum of the City of New York. **Page 29.** Alabaster sculpture by Malvina Hoffman, 1928. Photograph by Cecil Beaton. Courtesy Sotheby's, London.

E L S I E   D E   W O L F E  (1865–1950)  **Page 31.** Photograph by Edward Steichen. *Vogue*, April 1, 1924. **Page 33.** Photograph by Baron Adolf de Meyer. Courtesy the Elsie de Wolfe Foundation. **Page 35.** Christmas card sent to Diana Vreeland from Elsie, 1947. Courtesy Frederick Vreeland and Thomas R. Vreeland. **Page 36.** Photograph by George Hoyningen-Huene. French *Vogue*, September 1931. Courtesy the Frederick R. Koch Collection, Harvard Theatre Collection. **Page 38.** Photograph by George Hoyningen-Huene. *Vogue*, August 1, 1928. **Page 39.** Photograph by George Hoyningen-Huene. Courtesy the Frederick R. Koch Collection, Harvard Theatre Collection, and Horst. **Page 42.** Photograph by Gottlieb. *House and Garden*, September 1, 1943. **Page 43.** Photograph by Cecil Beaton, c. 1940. Courtesy Sotheby's, London. **Page 45.** Photograph by Cecil Beaton. *House and Garden*, April 1950. **Page 46.** Photograph by Lucien Eysserie. *Vogue*, November 24, 1928. **Pages 48 and 49.** Frontispiece and title page of *Recipes for Successful Dining*, New York: D. Appleton-Century Co., 1934. **Page 50.** Villa Trianon, c. 1981; photographs by David Massey; courtesy *HG*. Treillage music pavilion at the Villa Trianon; painting by William Rankin; courtesy the Elsie de Wolfe Foundation. A grapevine console and rococo desk by Tony Duquette in After All; photographs by Fred R. Dapprich; *House and Garden*, September 1, 1943. **Page 51.** Villa Trianon, c. 1981; photographs by David Massey; *House and Garden*, April 1982; courtesy *HG*. Octagonal sitting room, Villa Trianon; photograph by Derry Moore; *Architectural Digest*, June 1981; Courtesy the photographer and *AD*. Royal Elsie in a Mainbocher dress; watercolor by Cecil Beaton; *Vogue*, May 1, 1935. **Page 53.** Photo by François Kollar, 1939. Courtesy the Association Française Pour la Diffusion ou Patrimoine Photographique.

M I L L I C E N T   R O G E R S  (1904–1953)  **Page 55.** Millicent, 1948. Photograph by Horst. *Vogue*, February 1, 1949. **Page 56.** Millicent appearing in a picturesque fantasy given at Bel Marc, Southampton, L.I., 1919. Photograph by Charlotte Fairchild. *Harper's Bazaar*, December 1919. Courtesy the Millicent Rogers Foundation, Taos, and *Harper's Bazaar*. **Page 58.** Photograph by Baron Adolf de Meyer; *Vogue*, May 1, 1920. Dressed for Natica Nast's debutante party, New York, 1924; photograph by Edward Steichen; *Vogue*, March 15, 1924; courtesy of

Joanna T. Steichen. Wearing a faux 1830's costume by Mainbocher, 1949; photograph by Louise Dahl-Wolfe; courtesy Frederick Vreeland and Thomas R. Vreeland. Millicent in 1946; photograph by Louise Dahl-Wolfe; courtesy the Millicent Rogers Foundation, Taos. Millicent in Charles James, 1948; photograph by Gene Fenn; courtesy the photographer. **Page 59.** Felipe's Cross, re-creation of a design by Millicent, for sale at the Millicent Rogers Foundation; courtesy the Millicent Rogers Foundation, Taos. In her Schiaparelli suit, 1939; photograph by Horst; *Vogue*, July 1, 1939. In traditional Navajo costume dyeing velvet, 1948; photograph by Arturo Peralto-Ramos; courtesy the photographer and the Millicent Rogers Foundation, Taos. **Page 61.** In New York, 1947. Photograph by Serge Balkin. *Vogue*, February 15, 1947. **Pages 62 and 63.** La Mancha Farms; photographs by Robert Reck; *Architectural Digest*, June 1993; courtesy Arturo Peralto-Ramos and *AD*. **Page 65.** Shoes by Padova, 1938. Photograph by Baker. *Vogue*, February 15, 1939. **Page 66.** Photograph by Louise Dahl-Wolfe, 1948. Courtesy the Museum of F.I.T., New York. **Page 71.** Photograph by Richard Rutledge, 1945. *Vogue*, March 15, 1945.

D A I S Y   F E L L O W E S  (1890–1962)  **Page 73.** With Lady Juliet Duff on *The Sister Anne* off Cannes, 1931. Photograph by Cecil Beaton. British *Vogue*, September 2, 1931. Courtesy Sotheby's, London. **Page 74.** Photograph by George Hoyningen-Huene. British *Vogue* September 1931. **Page 76.** Photograph by Cecil Beaton, 1930. Courtesy Sotheby's, London. **Page 77.** *Harper's Bazaar*, March 1935. Courtesy *Harper's Bazaar* and the F.I.T. Library, New York. **Page 79.** Plumed hat by Alex, 1925. Photograph by Baron Adolf de Meyer. *Harper's Bazaar*, September 1925. Courtesy *Harper's Bazaar* and the F.I.T. Library, New York. **Pages 80–81.** Wearing a Dior gown and Cartier necklace, Venice, 1951. Photograph by Cecil Beaton. *Vogue*, October 15, 1951, and British *Vogue*, November 1951. **Page 82.** Daisy's bed, Paris, 1939. Photograph by François Kollar. *Harper's Bazaar*, March 15, 1939. Courtesy *Harper's Bazaar* and Frederick Vreeland and Thomas R. Vreeland. **Page 83.** Daisy's dining room, Paris, 1936. Photograph by Dora Maar. *Arts and Decoration*, February 1937. **Page 84.** Schiaparelli's breastplate jacket, 1934. Photograph by Cecil Beaton. Courtesy Sotheby's, London. **Page 85.** Jean Cocteau's drawing for *Les Filles du Diable*. Also used in *Harper's Bazaar*, August 1933. Courtesy *Harper's Bazaar* and F.I.T., New York. **Page 86.** Photograph by Cecil Beaton, c. 1930. Courtesy *Vogue*. **Page 89.** Photograph by Cecil Beaton, 1941. *Vogue*, July 15, 1941.

D U C H E S S   O F   W I N D S O R  (Wallis Warfield, 1896–1986) **Page 90.** In London, 1935. Photograph by Cecil Beaton. British *Vogue*, July 10, 1935, and *Vogue*, October 15, 1935. **Page 93.** Photograph by Man Ray. British *Vogue*, May 1935. Courtesy British *Vogue* and the Man Ray Estate. **Page 94.** The duke and duchess at the April in Paris Ball, Waldorf Astoria, March 1955. Photograph by Slim Aarons. **Page 95.** At home at Moulin de la Tuilerie, 1967. Photograph by Patrick Lichfield. *Vogue*, November 15, 1967. **Page 96.** The royal dispatch box. Photograph by Horst. *Vogue*, April 1, 1964. **Page 97.** The duke's dressing table, 1986. Photograph by Derry Moore. **Page 98.** In Cap D'Antibes, 1938. Photograph by Roger Schall. *Vogue*, October 15, 1938. **Page 99.** Wallis, the day before her historic wedding, 1937. Photograph by Cecil Beaton for *Vogue*, June 1, 1937. **Page 100.** At home in Paris, 1964; photograph by Horst; *Vogue*, April 1964. Living room; photograph by Agneta Fischer; *Vogue*, 1940. Illustration by Cecil Beaton, 1936; *Vogue*, February 1, 1937. Exterior of her Paris house, 1986; photograph by Derry Moore. **Page 101.** Tablesetting at her Paris home, 1940; photograph by Johan; *Vogue*, September 1940. The duchess's bedroom and living room, Paris, 1986; photographs by Derry Moore. **Page 102.** Photograph by Horst, 1937; *Vogue*, December 15, 1937. **Page 103.** Photograph by Roger Schall, 1937; *Vogue*, December 15, 1937.

M O N A,   C O U N T E S S   O F   B I S M A R C K  (1897–1983) **Pages 104–105.** Photograph by Erwin Blumenfeld, 1939. Courtesy Frederick Vreeland and Thomas R. Vreeland and Yvettes Georges. **Page 106.**

Photograph by Edward Steichen, 1928. *Vogue*, November 10, 1928. Courtesy Joanna T. Steichen. **Pages 108–109.** Capri, 1985; photographs by Henry Clarke; *Connaissance des Arts*, November 1985. Illustration by Alajalov; *Vogue*, April 15, 1933. Painting by Salvador Dalí, 1943; courtesy the Mona Bismarck Foundation, Paris. Photograph by Cecil Beaton; *Vogue*, February 1, 1938. Illustration by Cecil Beaton; *Vogue*, March 1929. Mr. and Mrs. Harrison Williams; photograph by Cecil Beaton; *Vogue*, June 15, 1935. **Page 110.** Countess de Zoppola, Mrs. Harrison Williams, Mrs. Robert H. McAdoo, Miss Jane Sanford, New York, 1936. Photograph by Remie Lohse. *Vogue*, February 1, 1936. **Page 112.** Illustration by Cecil Beaton, 1937. *Vogue*, February 15, 1937. **Page 114.** Photograph by Cecil Beaton, 1956. *Vogue*, July 1959. **Page 117.** Photograph by Cecil Beaton, 1934. Courtesy Sotheby's, London. **Page 118.** Photograph by Cecil Beaton, 1955. Courtesy Frederick Vreeland and Thomas R. Vreeland. **Page 119.** Photograph by Cecil Beaton, c. 1954. Courtesy Frederick Vreeland and Thomas R. Vreeland. **Page 120.** Capri, 1985. Photograph by Henry Clarke. *Connaissance des Arts*, November 1985. **Page 121.** Photograph by Horst, 1967. *Vogue*, April 1, 1967.

PAULINE DE ROTHSCHILD (1908–1976) **Page 123.** With her Mennecy china and one of her Vuillards, c. 1940. Photograph by Louise Dahl-Wolfe. Courtesy Christie's, New York. **Page 125.** Photograph by George Platt Lynes, c. 1940. Courtesy Estate of George Platt Lynes. **Page 128.** Photograph by Cecil Beaton. *Vogue*, November 15, 1972. **Page 131.** Photograph by Horst, 1969. *Vogue*, June 1969. **Page 132.** Photograph by Cecil Beaton, 1956. *Vogue*, February 15, 1956. Courtesy Frederick Vreeland and Thomas R. Vreeland. **Pages 134–135.** Mouton, 1963; photographs by Horst; *Vogue*, July 1963. Living room, New York apartment; photograph by Peter Nyholm; *Vogue*, April 15, 1943. "Table landscapes" at Mouton, 1973; photographs by Horst; *Vogue*, December 1973. **Page 136.** Photograph by Horst. *Vogue*, December 1973. **Page 139.** Photograph by Henry Clarke, 1963. *Vogue*, December 1963. Courtesy the photographer.

DIANA VREELAND (1903–1989) **Page 6.** Photograph by George Platt Lynes, c. 1939. Courtesy Frederick Vreeland and Thomas R. Vreeland and the Estate of George Platt Lynes. **Page 140.** Photograph by Martin Munkacsi. *Harper's Bazaar*, November 29, 1935. Courtesy Frederick Vreeland and Thomas R. Vreeland. © Joan Munkacsi. **Pages 144–145.** Diana's watch, suitcases, shoes, and living room at 550 Park Avenue; photographs by Oberto Gili; *HG*, May 1988. Slim Keith with Diana and Reed Vreeland, 1954; photograph by Slim Aarons. Diana, 1980; photograph by Deborah Turbeville; *Vogue*, December 1980. Diana in Mainbocher; drawing by Rene Bouet-Willaumez; *Vogue*, November 1, 1933. In white tweed dyed bright parlor pink; photograph by Louise Dahl-Wolfe, 1937; *Harper's Bazaar*, April 1937; courtesy Frederick Vreeland and Thomas R. Vreeland. Arizona, 1941; photograph by Louise Dahl-Wolfe; *Harper's Bazaar*, January 1942; courtesy *Harper's Bazaar* and Frederick Vreeland and Thomas R. Vreeland. Other photographs by Louise Dahl-Wolfe, 1941; courtesy Frederick Vreeland and Thomas R. Vreeland. **Page 147.** Diana, 1909. Courtesy Frederick Vreeland and Thomas R. Vreeland. **Page 148.** At El Morocco, 1938. Photograph by Jerome Zerbe. Courtesy Frederick Vreeland and Thomas R. Vreeland and the Jerome Zerbe Estate. **Page 149.** Photographer unknown. **Page 151.** Photograph by George Hoyningen-Huene, 1941. Courtesy Frederick Vreeland and Thomas R. Vreeland and Horst. **Page 154.** Drawing by Rene Bouet-Willaumez. *Vogue*, November 1, 1933. **Page 155.** Photograph by George Platt Lynes, 1934. Courtesy Estate of George Platt Lynes. **Page 156.** Satin pumps by Dal Co., 1980. Photograph by Deborah Turbeville. **Page 159.** Diana, age 79, November 1982. Photograph by Priscilla Rattazzi.

THE SWANS **Pages 160–161.** Mrs. Stanley Grafton Mortimer, 1946; photograph by Clifford Coffin; British *Vogue*, September 1946, and *Vogue*, October 1946. Gloria Guinness, 1960; photograph by Henry Clarke; *Vogue*, January 15, 1961. Slim Keith, c. 1946; photograph by John Engstead; courtesy Leonard Stanley and Marjorie Richardson. Mrs. Winston Guest, 1953; photograph by Cecil Beaton; *Vogue*, April 1, 1953.

BABE PALEY (1915–1978) **Page 163.** Photograph by Horst. *Vogue*, March 1946. **Page 164.** Photograph by Irving Penn, 1954. *Vogue*, March 15, 1954. **Page 165.** Photograph by Erwin Blumenfeld, 1946. *Vogue*, February 1, 1947. **Page 166.** Photograph by John Rawlings, 1946. *Vogue*, November 15, 1946. **Page 167.** Photograph by John Rawlings. *Vogue*, September 1, 1944. **Pages 168–169.** In London as a *Vogue* editor, 1946; photograph by Clifford Coffin; British *Vogue*, September 1946. Modeling in Paris, 1946; photograph by Clifford Coffin; British *Vogue*, December 1946. Babe and Slim, 1952; photograph by Leland Hayward; *Vogue*, May 1, 1952. At Kiluna Farms, Manhasset, Long Island; photograph by Horst; *Vogue*, December 1964. Photograph by Leland Hayward, n.d.; courtesy the Leland Hayward estate. Her apartment at the St. Regis; photograph by Snowdon; *Vogue*, March 1, 1959. Photograph by William Paley, n.d.; courtesy the William Paley Estate.

SLIM KEITH (1917–1990) **Page 170–173.** Photographs by John Engstead, 1945. Courtesy Leonard Stanley and Marjorie Richardson.

GLORIA GUINNESS (1915–1980) **Page 174.** Photograph by Horst, 1948. *Vogue*, January 1949. **Page 175.** In Paris, 1945. Photograph by Cecil Beaton, December 15, 1945. **Page 177.** Photographs by Slim Aarons, 1965. *Vogue*, April 1965. **Page 178.** Her house above the Bay of Acapulco, 1972; photograph by Horst; *Vogue*, July 1972. The bathroom in her Paris apartment; photograph by Henry Clarke, n.d.; **Page 179.** Photograph by Henry Clarke, 1960. *Vogue*, January 15, 1961. **Page 181.** In Mexico, 1970. Photograph by Cecil Beaton. *Vogue*, April 15, 1970.

C. Z. GUEST (1920–   ) **Page 183.** Photograph by Snowdon, 1959. *Vogue*, April 1, 1959. **Pages 184–185.** Photograph by Cecil Beaton; courtesy Sotheby's, London. Photograph by Cecil Beaton; *Vogue*, 1952. At Villa Artemis, Palm Beach, 1969; photograph by Slim Aarons. Illustrations by Rene Bouché; *Vogue*, December 1956 and July 1961. Photograph by Bruce Weber; *Harper's and Queen*, September 1990. *Time*, 1962; courtesy Time Warner. Photograph by Irving Penn; *Vogue*, March 15, 1954. **Page 187.** Photograph by Louise Dahl-Wolfe, 1952. Courtesy F.I.T. and *Harper's Bazaar*, October 1952.

JACQUELINE KENNEDY ONASSIS (1929–1994) **Page 188.** Photograph by Slim Aarons, March 1955. **Page 190.** With her parents, 1934. Courtesy Bettmann Archive. **Page 192.** Portrait by Richard Rutledge, 1951. *Vogue*, August 15, 1951. **Pages 194–195.** Photograph by Hy Peskin, 1953. *Life*, July 1953. Courtesy *Life*. Copyright © Time Warner. **Pages 196–197.** Photographs by Mark Shaw. Photographed exclusively for *Vogue*, July 1961. Copyright © The Mark Shaw Collection, Photo Researchers. **Page 199.** Photograph by Elio Sorci. *Vogue*, November 15, 1970. **Pages 200–201.** In Spain, 1966; *WWD*; courtesy Fairchild Publications. "Jackie lookalikes"; Yale Joel; *Life*; copyright © Time Warner. At Sun Valley; photograph by Curt Gunther; *Vogue*, February 1, 1966. Photo in *Vogue*, August 1, 1961. Gown designed by Oleg Cassini; Courtesy Oleg Cassini. **Page 202.** Photograph UPI Telephoto, September 15, 1962. Courtesy Bettmann Archive. **Page 203.** March 25, 1961. Photograph UPI Telephoto. Courtesy Bettmann Archive. **Page 205.** Photograph by Lawrence Fried. *Vogue*, December 1965, courtesy Image Bank.

COCO CHANEL (1884–1971) **Pages 206–207.** Wrapping paper courtesy Chanel. **Page 208.** Photograph by Horst, 1937. **Page 210.** Photograph by Baron Adolf de Meyer, 1922. *Harper's Bazaar*, February 1923. Courtesy *Harper's Bazaar*. **Page 211.** Courtesy *Vogue*. **Page 212.** Top photograph by François Kollar, 1937. Courtesy Association Française Pour la Diffusion ou Patrimoine Photographique. Bottom photograph by Roger Schall, 1938. **Page 213.** *Harper's Bazaar*, June 1938. Courtesy *Harper's Bazaar*. **Page 214.** Photograph by Roger Schall, 1937. **Page 217.** Photograph by François Kollar, 1937. *Harper's Bazaar*, September 15, 1937. Courtesy Association Française Pour la Diffusion ou Patrimoine Photographique. **Page 219.** Photograph by Man Ray, c. 1935. Courtesy Lucien Treillard and the Man Ray Estate.